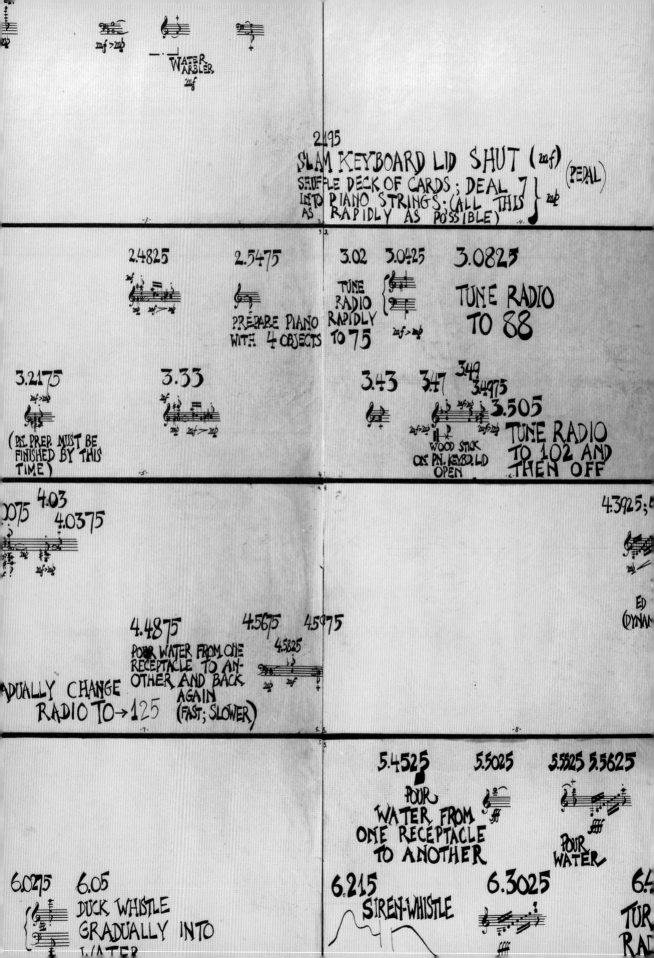

Views from Abroad

European Perspectives on American Art 2

Die Entdeckung des anderen

Ein europäischer Blick auf die amerikanische Kunst 2

Jean-Christophe Ammann & Adam D. Weinberg

in collaboration with/in Zusammenarbeit mit
Mario Kramer & Rolf Lauter

Whitney Museum of American Art, New York

Distributed by / im Vertrieb von Harry N. Abrams Inc., New York

Exhibition Itinerary
Whitney Museum of American Art
October 18, 1996– January 5, 1997
Museum für Moderne Kunst, Frankfurt
January 31 – May 4, 1997

These exhibitions are sponsored by Lufthansa.

The exhibition in New York is made possible by grants
from the Ministry of Foreign Affairs of the Federal
Republic of Germany through the German Consulate
General in New York, the Murray and Isabella Rayburn
Foundation, and Peter and Eileen Norton.

Special funding for the exhibition in Frankfurt has
been provided by Goldman, Sachs & Co. oHG.
Additional funding has been provided by the
Hessische Kulturstiftung, Helaba Landesbank
Hessen-Thüringen, J. Walter Thompson GmbH,
Steigenberger Frankfurter Hof, Flughafen Frankfurt
Main AG, Ali and Dr. Kurt Kressin, and Ulrike Crespo.

Research for the exhibition and publication was
supported by income from an endowment established
by Henry and Elaine Kaufman, The Lauder Foundation,
Mrs. William A. Marsteller, The Andrew W. Mellon
Foundation, Mrs. Donald A. Petrie, Primerica
Foundation, Samuel and May Rudin Foundation, Inc.,
The Simon Foundation, and Nancy Brown Wellin.

Library of Congress Cataloging-in-Publication Data
Weinberg, Adam D.
N6512.W39 1995
709'.73'0747471 – dc20 95-16525 CIP

ISBN 0-87427-101-0 (second volume)

Cover image: Stephan Balkenhol, *57 Pinguine*
(*57 Penguins*), 1991, and installation view, Whitney
Museum of American Art, 1984
Frontispiece: John Cage, *Water Music*, 1952

Ausstellungsdaten
Whitney Museum of American Art
18. Oktober 1996 – 5. Januar 1997
Museum für Moderne Kunst, Frankfurt
31. Januar – 4. Mai 1997

Beide Ausstellungen wurden von der Lufthansa gefördert.

Die Ausstellung in New York wurde durch Zuschüsse
des Auswärtigen Amtes der Bundesrepublik
Deutschland, Bonn, vertreten durch das Deutsche
Generalkonsulat in New York, der Murray and Isabella
Rayburn Foundation und von Peter und Eileen Norton
ermöglicht.

Die Ausstellung in Frankfurt wurde großzügig von
Goldman, Sachs & Co. oHG gefördert. Für weitere
Unterstützung danken wir der Hessischen
Kulturstiftung, der Helaba Landesbank Hessen-
Thüringen, der J. Walter Thompson GmbH, dem
Steigenberger Frankfurter Hof, der Flughafen
Frankfurt Main AG, Ali und Dr. Kurt Kressin und
Ulrike Crespo.

Die wissenschaftliche Recherche für Ausstellung und
Katalog wurde durch einen Betrag aus dem Fonds von
Henry und Elaine Kaufman, der Lauder Foundation,
Mrs. William A. Marsteller, der Andrew W. Mellon
Foundation, Mrs. Donald A. Petrie, der Primerica
Foundation, der Samuel und May Rudin Foundation,
Inc., der Simon Foundation und Nancy Brown Wellin
ermöglicht.

Contents Inhalt

Director's Foreword

The curatorial act is far from neutral; it is, rather, a series of intellectual constructions that have a profound impact on how works of art come to be known and understood by museum visitors. I state this obvious museological fact in order to celebrate what it is that makes the best art museums wonderfully different from one another. When curators build collections and construct exhibitions, they are engaging in a series of complex creative acts that over a period of time form the museum's public identity. Curators initiate a three-way dialogue among works of art, themselves, and the viewing public; as such prominent intermediaries, they must remain aware of the serious responsibilities carried by this profound authority.

It is a defining pleasure of the experienced museum-goer to be able to distinguish between and delight in the different museological conditions created by curators (and directors acting as curators) in the astonishing variety of museums around the world, or even around town.

This exhibition, the second in a series of "Views from Abroad," presents a remarkable opportunity to understand and celebrate our museum collections both as an idea and as a physical reality. Once again, we have invited a distinguished museum director from abroad to work with the Whitney Museum's Permanent Collection, merging it with works from his own institution's collection to create a new hybrid — a novel curatorial entity that reveals how American art is seen and understood from a different vantage point. In fact, the exhibition celebrates the ways in which our experience of art is continually transformed by thoughtful and meaningful recontextualization.

We expected that Jean-Christophe Ammann and his colleagues at the Museum für Moderne Kunst in Frankfurt would respond to this idea with great seriousness, invention, and intellectual rigor. They have done far more. In working closely with Adam Weinberg, curator of the Permanent Collection, and the Whitney staff for nearly two years, Ammann and his Frankfurt colleagues Rolf Lauter and Mario Kramer have organized an exhibition that revels in the differences between our museums and our quite distinct approaches to collecting and exhibiting postwar art. In this sense, their efforts happily run counter to a growing museological trend, in which collection exhibitions, no matter where or by whom curated, seem to be increasingly alike — a practice that effectively neutralizes the individuality of each collection. Without compromising this individuality, Ammann, Lauter, and Kramer have also succeeded in revealing the artists' commonalities and shared aesthetic responses to a changing world, despite the international character of Frankfurt's collection and the exclusively American orientation of the Whitney's.

The New York and the Frankfurt installations of this exhibition will appear and feel quite different from one another. For one thing, the Whitney's distinctively modernist

Vorwort des Direktors

Bei der Arbeit eines Kurators gibt es keine Neutralität. Sie vollzieht sich vielmehr als Folge geistiger Prozesse, die die Rezeption und das Kunstverständnis der Museums·besucher ganz wesentlich beeinflussen. Indem ich dieses museologische Moment betone, möchte ich herausstellen, was die besten Kunstmuseen von anderen auf eine besondere Art und Weise unterscheidet. Wenn Kuratoren Sammlungen auf·bauen und Ausstellungen zusammenstellen, sind sie auf vielfältige Weise kreativ tätig und prägen damit die öffentliche Identität eines Museums über einen längeren Zeitraum. Kuratoren stiften einen Dialog zwischen drei Beteiligten: den Kunstwerken, sich selber und den Besuchern. Als derart wichtige Vermittler müssen sie die Ernsthaftigkeit und Verantwortung ihrer Tätigkeit stets im Auge behalten.

Erwiesenermaßen genießt es der erfahrene Museumsbesucher, den unterschied·lichen museologischen Bedingungen auf die Spur zu kommen, die Kuratoren und Direktoren—in ihrer Funktion als Kuratoren—bei der erstaunlichen Vielfalt der Museen weltweit und oft sogar innerhalb einer einzigen Stadt legen.

Diese Ausstellung, die zweite in der Folge der "Views from Abroad," bietet eine außergewöhnliche Möglichkeit, unsere Sammlungen sowohl in der physischen Präsenz der Werke, als auch in der diese verbindenden und hinter ihnen liegenden Vorstellungen von Kunst besser zu verstehen und zu genießen. Zum zweiten Mal haben wir einen angesehenen Museumsleiter aus dem Ausland eingeladen, mit der ständigen Sammlung des Whitney Museums zu arbeiten, und das, was er zeigt, soll mit Arbeiten aus der Sammlung seines eigenen Museums in Beziehung gesetzt wer·den, um so zu einer neu geformten, von einem Kurator zu einer Einheit verbunde·nen Sammlung zu gelangen, die dem Besucher verdeutlicht, wie die amerikanische Kunst aus einem anderen Blickwinkel gesehen und verstanden werden kann. Diese Ausstellung würdigt vor allem auch die Tatsache, daß sich unsere Erfahrung von Kunst dadurch ständig und auf immer wieder neue Weise ändert, daß sie in neue, wohlüberlegte Zusammenhänge gestellt wird.

Wir hatten erwartet, daß Jean-Christophe Ammann und seine Kollegen aus dem Museum für Moderne Kunst in Frankfurt diese Idee mit größter Ernsthaftigkeit, Phantasie und intellektueller Konsequenz aufgreifen würden. Aber sie sind noch viel weiter gegangen. In enger, fast zweijähriger Zusammenarbeit mit Adam Weinberg, dem Kustos der ständigen Sammlung, und den Mitarbeitern des Whitney Museums haben Jean-Christophe Ammann, seine Kustoden Rolf Lauter und Mario Kramer eine Ausstellung zusammengestellt, die die Verschiedenartigkeit zwischen unseren Museen sowie unsere unterschiedlichen Vorgehensweisen beim Sammeln und Ausstellen von Kunst nach 1945 aufgreift. So gesehen, wenden sich ihre Bemühungen erfreulicherweise gegen eine immer stärker anwachsende Tendenz unter Kuratoren, bei Ausstellungen über Museumssammlungen—unabhängig davon,

wer sie kuratiert oder wo sie stattfinden — den Eigencharakter der jeweiligen Samm-
lungen auszulöschen und damit die Präsentation von Sammlungen immer ähnlicher
werden zu lassen. Ohne den jeweils eigenen Charakter unserer Sammlungen zu
verwischen, haben Ammann, Lauter und Kramer nicht nur die Gemeinsamkeiten
von Künstlern, sondern auch die von ihnen gemeinsam getragenen ästhetischen
Antworten auf eine sich verändernde Welt dargelegt, und das, obwohl die Frankfurter
Sammlung international ausgerichtet ist, die Sammlung des Whitney Museums sich
dagegen auf die amerikanische Kunst konzentriert.

Die Ausstellung in New York wird sich ganz anders präsentieren und ein anderes
Gefühl vermitteln, als die Frankfurter Ausstellung. Zum einen tragen die ver-
schiedenartigen Museumsarchitekturen unterschiedliche und sehr spezifische
Elemente zu den Ausstellungen bei, was im Fall des von Marcel Breuer entworfenen
Whitney Museums eindeutig auf eine Verpflichtung der Moderne gegenüber, im Fall
von Hans Holleins Frankfurter Museums auf einen brillanten Bezug zur Postmoderne
zurückzuführen ist. Zum anderen führen die Verschiedenartigkeit der beiden Städte
und das unterschiedliche Programm der Museen, in das die jeweilige Ausstellung
eingebunden ist, den Betrachter zu einer umfassenden Erfahrung einer jeden
Ausstellung. Wirklich glücklich kann sich derjenige Besucher schätzen, dem es
möglich ist, beide Ausstellungsversionen zu sehen, da er Vergleiche und Gegenüber-
stellungen anstellen kann und er sich dadurch der Unterschiede bewußt wird. Die
meisten Besucher werden jedoch nur die eine Seite des Austausches sehen.
Dennoch glauben wir, daß beide Ausstellungen auch ihnen inhaltlich bedeutsame
und erfrischende Erfahrungen vermitteln werden.

Für alle Mitarbeiter des Whitney Museums ist dieses Projekt eine wichtige
Erfahrung geworden, was in dieser Form hoffentlich auch für die verschiedenen
Besuchergruppen und Öffentlichkeiten gelten wird. Wir jedenfalls sind dankbar dafür,
daß wir die Möglichkeit hatten und erleben konnten, wie zwei so unterschiedliche
Museen derart eng zusammenarbeiten können, denn dadurch sind wir zu einem
tieferen Verständnis unserer eigenen Sammlung gelangt und Können diese nun
einander und der Öffentlichkeit gegenüber besser verdeutlichen. Dem Museum für
Moderne Kunst sind wir zutiefst dankbar, daß es sich für dieses Ausstellungsprojekt
so engagiert eingesetzt hat. Es war eine Freude, mit Jean-Christophe Ammann und
seinen Kollegen zusammenzuarbeiten. Auch Thomas Meister von Deutschen
Generalkonsulat in New York möchte ich herzlich danken. Das Generalkonsulat hat
diese Ausstellung im Namen des Auswärtigen Amtes in Bonn unterstützt. Mein Dank
gilt auch Raymond W. Merritt von der Murray and Isabella Rayburn Foundation
sowie Peter und Eileen Norton.

Schließlich möchte ich mich noch bei der Lufthansa bedanken, die die
Ausstellung als Sponsor unterstützt hat.

David A. Ross
Alice Pratt Brown Director
Whitney Museum of American Art

Marcel Breuer facility and Frankfurt's brilliantly postmodern Hans Hollein building each add a significantly distinct element to this project. In addition, the two cities themselves, as well as the museum programs into which each exhibition is embedded, will seriously affect the total experience of each show. The truly fortunate visitor will be able to see both versions of the exhibition, compare and contrast, and savor the differences. But for the majority of visitors, who will see only one side of this exchange, we expect the exhibition to provide a significant and refreshing learning experience.

For all of us at the Whitney, this project has proved a meaningful experience which we hope will be shared by our varied viewing publics. Indeed, we are grateful for the opportunity to work closely together, as two distinct museums, in an attempt to understand our individual collections more fully and to better define ourselves to each other and our publics. We are deeply indebted to the Museum für Moderne Kunst for its extraordinary commitment to this project, and for the pleasure of working with Jean-Christophe Ammann and his colleagues. We would like to extend special thanks to Thomas Meister at the German Consulate General in New York for support of this exhibition through the Ministry of Foreign Affairs of the Federal Republic of Germany; Raymond W. Merritt at the Murray and Isabella Rayburn Foundation; and Peter and Eileen Norton.

Finally, a grateful acknowledgment to the exhibition's sponsor, Lufthansa.

David A. Ross
Alice Pratt Brown Director
Whitney Museum of American Art

Acknowledgments

Five years after opening, the Museum für Moderne Kunst will be holding its first major special exhibition, at the invitation of the Whitney Museum of American Art. We are honored to participate in the Whitney's "Views from Abroad" series.

Without the intense, creative interaction between my colleagues Rolf Lauter and Mario Kramer on the one hand, and Adam Weinberg and his colleagues at the Whitney Museum on the other, without the thought-provoking discussions among us all, it would not have been possible to work as equal, and equally productive, partners.

I wish to thank the Whitney Museum of American Art and director David A. Ross for the courage they have shown in launching such an exhibition. Willard Holmes, deputy director, made a key contribution with his farsighted supervision of the organizational work. Adam Weinberg was at all times a competent and critical partner and gave my staffers exemplary support during the scholarly and organizational preparations. And I would like to thank Joanna Dreifus, Adam's longtime assistant, for her exceptional help in all areas. The difficult task today of finding additional sponsors for the project in the United States fell to Steve Dennin, former development director at the Whitney, and he handled it masterfully.

We are most grateful to John G. Hanhardt, the Whitney's curator of film and video, for conceiving an extraordinary program for New York and Frankfurt. And my thanks also go to Constance Wolf, associate director for public programs, for her efforts in making the content of the exhibition accessible, as well as to Mary DelMonico, head, publications, Nerissa Dominguez, production coordinator, and the entire publications department, for the coordination and production of the catalogue. During the many visits my staff members paid to the storerooms and archives of the Whitney Museum, Barbi Spieler, Nancy Roden, Jennifer Gibbons, and Anita Duquette provided essential assistance. Christy Putnam and Nancy McGary must also be thanked for their untiring support in all organizational and insurance-related procedures. In her design for the New York installation, Janet Cross has succeeded in creating spaces which greatly enhance the dialogues among the works. Bruce Mau and his team have done an exemplary job of designing the catalogue to match the character of the exhibition.

Needless to say, my thanks also go to all my staff members who have been involved in the project. I am very happy that, following our tenth "Change of Scene" installation at the Museum für Moderne Kunst, we have squared up to the challenges of a major project and have together managed to master them.

Rolf Lauter was in charge of the contentual end of the Frankfurt exhibition. Together with his colleagues Thomas Köhler and Christian Kaufmann, as well as Kristin Walker, Pia Neumann, Claudia Schubert, Ursula Haberkorn, and Karoline

Dank

Fünf Jahre nach Eröffnung des Museums für Moderne Kunst findet in unserem Haus erstmals eine große Sonderausstellung statt. Dies ist einer Einladung des Whitney Museum of American Art zu verdanken, das uns mit der Teilnahme an der Ausstellungsserie "Views from Abroad" eine besondere Ehre zuteil werden läßt.

Ohne den intensiven, kreativen Austausch meiner Mitarbeiter Rolf Lauter und Mario Kramer mit Adam Weinberg und anderen Mitarbeitern des Whitney Museums, ohne die motivierenden inhaltlichen und organisationsbedingten Diskussionen und ohne einen großen Respekt und Verständnis füreinander wäre eine solche Herausforderung, die in einer echten gleichberechtigten Zusammenarbeit liegt, zum Scheitern verurteilt gewesen.

Dem Whitney Museum of American Art und seinem Direktor David A. Ross möchte ich für die besondere Einladung und den Mut zu einem solchen Projekt danken. Willard Holmes hat mit seiner konzisen und weitblickenden Betreuung der organisatorischen und inhaltlichen Arbeiten Wesentliches zum Gelingen der Ausstellung beigetragen. Adam Weinberg war zu allen Zeiten ein kompetenter und kritischer Gesprächspartner und hat meinen Mitarbeitern bei den wissenschaftlichen und organisatorischen Vorarbeiten beispielhafte Unterstützung gegeben. Seiner langjährigen Assistentin Joanna Dreifus gebührt für ihre in allen Belangen hervorragende Hilfe ebenfalls unser Dank.

Steve Dennin hat die in der heutigen Zeit schwierige Aufgabe, zusätzliche Sponsoren für das Projekt in Amerika zu gewinnen, mit großem Einsatz gemeistert.

John G. Hanhardt hat dankenswerterweise für New York und Frankfurt ein außergewöhnliches Film- und Videoprogramm konzipiert. Constance Wolf gebührt für ihren Einsatz bei der inhaltlichen Vermittlung der Ausstellung ebenso mein Dank wie Mary DelMonico für die Koordination und Redaktion und Nerissa Dominguez und der gesamten Abteilung für Publikationen des Kataloges. Bei den vielen Besuchen meiner Mitarbeiter in den Depots und Archiven des Whitney Museums waren Barbi Spieler, Nancy Roden, Jennifer Gibbons und Anita Duquette von überaus wertvoller Hilfe. Christy Putnam und Nancy McGary sei hier für ihren Einsatz bei den organisatorischen und versicherungstechnischen Abläufen gedankt.

Janet Cross ist es mit der Ausstellungsarchitektur in New York gelungen, imaginäre Werke in gestalteten Räumen gleichzeitig zu Gruppen zusammenzuschließen und die Dialogfähigkeit dieser Gruppen untereinander zu wahren. Bruce Mau hat mit seinem Team eine dem Charakter der Ausstellung entsprechende Gestaltung des Kataloges hervorragend umgesetzt.

Selbstverständlich gebührt allen meinen Mitarbeitern, die an dem Projekt beteiligt waren, großer Dank. Es freut mich sehr, daß wir uns nach dem zehnten 'Szenen-

wechsel' als Team der Herausforderung eines großen Projektes gestellt haben und es gemeinsam meistern konnten.

Während Rolf Lauter die Frankfurter Ausstellung inhaltlich betreut hat und zusammen mit seinen Mitarbeitern Thomas Köhler und Christian Kaufmann sowie Kristin Walker, Pia Neumann, Claudia Schubert, Ursula Haberkorn und Karoline Gottschalk neben der allgemeinen Organisation auch die schwierige Aufgabe der Suche nach einer finanziellen Absicherung der Ausstellung übernommen hat, erarbeitete Mario Kramer die New Yorker Ausstellung und meisterte Dank der Hilfe von Anna Fasold alle Probleme. Beiden Kuratoren gilt mein herzlichster Dank.

Thomas Köhler wurde von uns für 9 Monate zur Vorbereitung der Ausstellung und zur Koordination der Arbeit mit dem Whitney Museum nach New York entsandt. Er hat dort hervorragende Arbeit geleistet.

Erich Gantzert-Castrillo und Uwe Glaser haben wie immer in herausragender Weise die Kunstwerke beider Sammlungen konservatorisch betreut und die Organisation der Transporte und den Aufbau der Ausstellung übernommen. Marie-Luise Ziegler und Silvia Bandow waren und sind zu jeder Zeit die kompetenten Ansprechpartner und organisatorischen "Zentralen" meines Mitarbeiterstabes. Ihnen und Andreas Bee, der zahlreiche "Freunde des Museums" für einen Besuch in New York zu gewinnen wußte, danke ich herzlich.

Ohne die großzügige Unterstützung von Freunden des Museums für Moderne Kunst, Sponsoren und Spendern wäre dieses großartige Projekt nicht realisierbar gewesen.

Dies gilt in besonderer Weise für die Lufthansa, die beide Ausstellungen gefördert hat.

Mit dem Unternehmen Goldman, Sachs & Co. oHG konnte ein Finanzinstitut gewonnen werden, das die Ausstellung in Frankfurt in großzügiger Weise unterstützt hat.

Mein Dank geht auch an die Hessische Kulturstiftung und die Helaba Landesbank Hessen-Thüringen für ihr finanzielles Engagement.

Ihnen, dem Auswärtigen Amt Bonn, dem Unternehmen J. Walter Thompson GmbH, dem Steigenberger Frankfurter Hof und der Flughafen Frankfurt Main AG sind wir zu großem Dank verpflichtet.

Ali und Dr. Kurt Kressin sowie Ulrike Crespo waren bei der Realisierung des Projektes von großer Hilfe. Ihnen möchte ich dafür ganz herzlich danken.

Jean-Christophe Ammann
Direktor
Museum für Moderne Kunst

Gottschalk, he not only carried out the general organization, but also the difficult task of seeking financial support for the exhibition. Mario Kramer devised the exhibition as it stands in New York, and, with the able assistance of Anna Fasold, handled all the problems involved. I would like to cordially thank both curators.

We sent Thomas Köhler to New York for nine months to prepare the exhibition and to coordinate all details with the Whitney Museum. His work there has been out-standing. Erich Gantzert-Castrillo and Uwe Glaser have been dedicated conservators for the art works in both collections and have organized the transport of the works and overseen the works' installation. Marie-Luise Ziegler and Silvia Bandow ably staffed the Frankfurt headquarters. I wish to thank them and Andreas Bee, who persuaded many of Frankfurt's "Friends of the Museum" to pay a visit to New York.

Without the support of the Friends of the Museum für Moderne Kunst, and the generous assistance of sponsors and donors, we would not have been able to realize this magnificent project. This is especially true for Lufthansa, the sponsor of both exhibitions.

This list would not be complete without expressing our deepest gratitude to Goldman, Sachs & Co. oHG. Through their office in Frankfurt, Goldman, Sachs has provided special support for the exhibition in Germany.

Thanks is also due to the other supporters of the exhibition: the Hessische Kulturstiftung, the Helaba Landesbank Hessen- Thüringen, the Ministry of Foreign Affairs of the Federal Republic of Germany, J. Walter Thompson GmbH, Steigenberger Frankfurter Hof hotel and the Flughafen Frankfurt Main AG.

And, finally, a heartfelt thank you to Ali and Dr. Kurt Kressin and Ulrike Crespo. All three have been of great assistance in the realization of this project.

Jean-Christophe Ammann
Director
Museum für Moderne Kunst

Acknowledgments

Organizing an exhibition as complex and experimental as "Views from Abroad" obviously requires hard work. However, it also demands a degree of blind faith, especially as this exhibition emerged gradually as part of a process and not as an *a priori* concept. Knowing that a collaborative project usually takes far more work than an independent one, I greatly appreciate the patience of all those involved.

From the Whitney Museum, I would like to thank David A. Ross for his enthusiasm and encouragement and Willard Holmes for his guidance and good judgment at times of critical importance. Steve Dennin has been of great help in finding support for the project, whose unorthodox character made the task more difficult. I am also grateful to Christy Putnam for her help in dealing with the intricacies of the exhibition exchange itself; Nancy McGary, Barbi Spieler, and Ellin Burke for their assistance with registration and insurance issues; and Anita Duquette, who tirelessly worked to find images for research and reproduction.

The Whitney's Publications Department accomplished the miraculous by producing a bilingual catalogue in record time and with good humor. Accordingly, I would like to express my sincerest gratitude to Mary DelMonico, Sheila Schwartz, Nerissa Dominguez, José Fernández, Heidi Jacobs, and Melinda Barlow for their persistence and diligence. Connie Wolf has been an enthusiastic supporter of "Views from Abroad" from its inception. Her insights and her educational philosophy have informed all aspects of the exhibition. I am also indebted to John G. Hanhardt for his advice and for the creation of the film and video component of the exhibition in Frankfurt. My assistant, Joanna Dreifus, has shared in each and every vicissitude of this venture. I am deeply grateful for her enduring support.

The staff of the Museum für Moderne Kunst has taken to this project with incredible verve and excitement. They have been undaunted by the seemingly endless obstacles thrown in their path. I am grateful to them for their part in creating and realizing the vision of this exchange. Jean-Christophe Ammann guided this project with deft grace and good humor. Rolf Lauter bore the brunt of the pressures of organization and funding in Frankfurt, with single-mindedness and coolness "under fire"; I admire the scope of his conceptual and administrative talents. Mario Kramer oversaw the exhibition in New York with precision and poetry, and helped produce a bicultural installation that provides unexpected insights into American art. Thomas Köhler, who has been in residence at the Whitney Museum for nine months, knows firsthand what it is to be at the nexus of an international collaboration. We are grateful that he provided such a strong link between the institutions. His role has greatly enriched the exhibition itself as well as its educational components.

The design of the exhibition in New York was absolutely essential to the conception of the exchange as a whole. Janet Cross worked with all the curators to realize

14

Dank

Eine solch komplexe und experimentelle Ausstellung wie die "Views from Abroad" zu organisieren ist ein Stück harter Arbeit.

Jedoch verlangt es auch bis zu einem gewissen Grad nach blindem Vertrauen, ganz besonders weil die Konzeption der Ausstellung nicht a priori feststand, sondern vielmehr Resultat eines Prozesses ist. Wenn man bedenkt, daß es im allgemeinen noch aufwendiger ist, ein Gemeinschaftsprojekt zu organisieren, als eines in eigener Regie durchzuführen, so danke ich vor allem für die Geduld all jener, die an der Planung beteiligt waren.

Vom Whitney Museum möchte ich David A. Ross für seinen Enthusiasmus und seine Unterstützung danken, Willard Holmes für seinen Rat und seine umsichtige Leitung in kritischen Momenten.

Steve Dennin war von großer Hilfe bei der Suche nach finanzieller Unterstützung, was bei dem unorthodoxen Charakter des Projektes kein leichtes Unterfangen war.

Ebenso möchte ich Christy Putnam dafür danken, daß sie sich mit all den Details dieses Ausstellungsaustausches befaßt hat; Nancy McGary, Barbi Spieler und Ellin Burke für ihre Hilfe bei Fragen bezüglich der Sammlung und der Versicherung. Ebenso bedanke ich mich bei Anita Duquette, die sich unermüdlich dafür eingesetzt hat, Abbildungsmaterial für Reproduktion und Recherche zu finden.

Das Publication Department des Whitney Museums vollbrachte Wunderbares, indem es in Rekordzeit und überdies gutgelaunt einen zweisprachigen Katalog zur Ausstellung erstellte. Daher möchte ich meinen herzlichsten Dank Mary DelMonico, Sheila Schwartz, Nerissa Dominguez, José Fernández, Heidi Jacobs, und Melinda Barlow für ihre Ausdauer und Sorgfalt aussprechen. Connie Wolf hat die "Views from Abroad" von Anfang an enthusiastisch unterstützt. Ihre Kenntnisse und ihre Ideen zur Vermittlungsarbeit haben alle Aspekte der Ausstellung maßgeblich beeinflußt. Weiterhin danke ich John G. Hanhardt für seinen Rat und für die Konzeption einer Film- und Videoreihe, die die Ausstellung in Frankfurt begleiten wird. Meine Assistentin Joanna Dreifus hat alle wechselvollen Entwicklungen bei diesem Vorhaben entscheidend mitgetragen. Ich bin ihr für ihre ausdauernde Unterstützung zutiefst dankbar.

Die Mitarbeiter des Museums für Moderne Kunst in Frankfurt sind dieses Projekt mit unglaublichem Elan und Engagement angegangen. Sie ließen sich von den immer wieder auftauchenden Hindernissen nicht entmutigen. Jean-Christophe Ammann hat dieses Projekt geschickt, souverän und mit guter Laune geleitet. Rolf Lauter hat all dem organisatorischen und finanziellen Druck bei der Planung der Ausstellung in Frankfurt standgehalten. Ich bin ihm für seine Gradlinigkeit und seine Besonnenheit auch "unter Beschuß" dankbar und bewundere sein konzeptuelles und administratives Talent. Mario Kramer hat die Ausstellung in New York mit Präzision und Poesie

betreut und dazu beigetragen, eine dialogische Ausstellung zweier Institutionen zusammenzustellen, die unerwartete Perspektiven auf die amerikanische Kunst eröffnet. Thomas Köhler, der für neun Monate "in residence" am Whitney Museum war, weiß aus erster Hand, was es bedeutet am Knotenpunkt einer internationalen Zusammenarbeit tätig zu sein. Wir sind ihm sehr dankbar, daß er eine so starke Verbindung zwischen den beiden Institutionen gewährleistet hat. Seine Mitarbeit hat die Ausstellung selbst sowie die Museumspädagogik und Öffentlichkeitsarbeit enorm bereichert.

Das Ausstellungsdesign für New York war entscheidender Bestandteil der Idee eines Austauschs und Dialogs zweier Institutionen. Janet Cross arbeitete mit allen Kuratoren zusammen, um einen Raum zu entwerfen, der ebenso konzeptuell durchdacht, wie ästhetisch schön ist. Bruce Mau hat eine passende Gestaltung für den Katalog entworfen, der die Komplexität der Ausstellung reflektiert. Ich möchte darüber hinaus das Engagement von Gabriele Becker vom Goethe Haus New York hervorheben, die in Verbindung mit der Ausstellung ein Veranstaltungsprogramm zusammengestellt hat.

Natürlich konnte dieses Projekt nur mit der großzügigen finanziellen Unterstützung von mehreren Sponsoren realisiert werden. Dank des Mutes ihrer Vertreter wurden die "Views from Abroad" mehr als eine Idee. Das Whitney Museum würdigt hier besonders Thomas Meister vom Generalkonsulat der Bundesrepublik Deutschland, Charles Croce von der Lufthansa und Raymond Merritt von der Isabella und Murray Rayburn Foundation.

Für die Unterstützung der Ausstellung in Frankfurt sind wir der Goldman, Sachs & Co. oHG, der Hessischen Kulturstiftung, der Helaba Landesbank Hessen-Thüringen, der Lufthansa, der J. Walter Thompson GmbH, dem Auswärtigen Amt der Bundesrepublik Deutschland, dem Steigenberger Frankfurter Hof, der Flughafen Frankfurt Main AG, Ali und Dr. Kurt Kressin sowie Ulrike Crespo zu tiefem Dank verpflichtet.

Obwohl beide Ausstellungen keine Leihgaben von anderen Museen beinhalten, so gibt es doch Leihgeber, die uns gestattet haben, wichtige Werke in die Ausstellung miteinzubeziehen, um bestimmte Vorstellungen zu verwirklichen, die wir sonst nicht hätten umsetzen können. Wir danken Emily Fisher Landau und Raymond Learsy, die seit langem Mitglieder der "Whitney-Familie" sind, für ihre Unterstützung bei unseren Bemühungen und ebenso Alex Katz, Claes Oldenburg und Coosje van Bruggen, die Werke aus ihren Sammlungen zur Verfügung gestellt haben.

Adam D. Weinberg
Kurator, Permanent Collection
Whitney Museum of American Art

a space that is as conceptually resonant as it is aesthetically beautiful. Bruce Mau has developed a fitting design for the catalogue which reflects all of the complexities of the exhibition's approach. I also appreciate the involvement of Gabriele Becker and the Goethe House for developing related exhibition and educational events.

This project, of course, could not have been realized without the generous financial support from several key sources. Thanks to the courage of their representatives, "Views from Abroad" became more than an idea. The Whitney Museum would like to acknowledge Thomas Meister at the Consulate of the Republic of Germany, Charles Croce of Lufthansa, and Raymond Merritt of the Isabella and Murray Rayburn Foundation. For the support of the exhibition in Frankfurt, we are deeply indebted to Goldman, Sachs & Co. oHG, Hessische Kulturstiftung, Helaba Landesbank Hessen-Thüringen, J. Walter Thompson GmbH, Steigenberger Frankfurter Hof, Flughafen Frankfurt Main AG, Ali and Dr. Kurt Kressin, and Ulrike Crespo.

Although these exhibitions are not loan exhibitions, there are several lenders who have permitted us to include important works that help realize certain ideas in the exhibition. We are grateful to Emily Fisher Landau and Raymond Learsy, two longtime members of the Whitney Museum "family," for their participation in this effort, and to Alex Katz, Claes Oldenburg, and Coosje van Bruggen, for lending objects from their collections.

Adam D. Weinberg
Curator, Permanent Collection
Whitney Museum of American Art

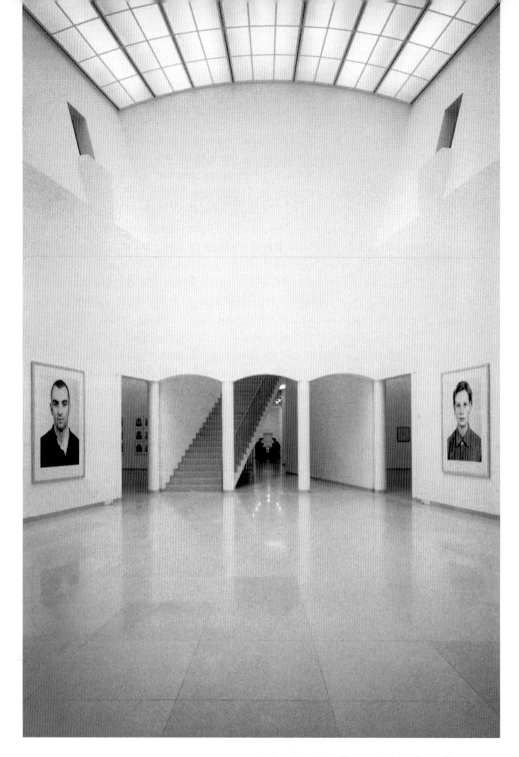

Installation view, Museum für Moderne Kunst,
Central Hall with works by Thomas Ruff, 1991

Eröffnungsausstellung, Museum für Moderne Kunst,
Zentrale Halle mit Werken von Thomas Ruff, 1991

How Do You Assemble a Collection of Contemporary Art?
Jean-Christophe Ammann

Wie macht man eine Sammlung von Gegenwartskunst?
Jean-Christophe Ammann

The weakness of European art after World War II was a result of fascism, the Holocaust, destruction, suffering, and guilt. Confronted by a gaping and oppressive void, art sought to liberate itself from its chains. However, as we know, such a liberation does not necessarily spawn viable art. It was American artists who liberated European art in the form of Abstract Expressionism, which immigrated to Europe in a considerably diluted form in the material aesthetics of Tachisme and Art Informel. Abstract Expressionism opened the floodgates in Europe, letting in the unprecedented influence of American art, an influence that only ebbed in the early 1970s with the end of the historical avant-garde.

Only those European artists who had already found their own paths before World War II were able to create truly independent art works after 1945; Alberto Giacometti, Jean Fautrier, Jean Dubuffet, and Lucio Fontana come to mind here.

The awareness of the importance of American art was strongest in Germany, the Netherlands, and the German-speaking sections of

Die Schwäche der europäischen Kunst nach dem Zweiten Weltkrieg war eine Folge von Faschismus, Holocaust, von Zerstörung, Leid und Schuld. Konfrontiert mit einer gähnenden und bedrückenden Leere, wußte sich die Kunst aus ihren Fesseln zu befreien. Jedoch, wie wir wissen, schafft eine solche Befreiung nicht notwendigerweise eine tragfähige Kunst. Es waren amerikanische Künstler, die die europäische Kunst mit dem Abstrakten Expressionismus befreiten, der in Europa beträchtlich abgeschwächt in der Materialästhetik von Tachismus oder Informel seinen Ausdruck fand. Der Abstrakte Expressionismus öffnete das Schleusentor für einen unerhörten Einfluß der amerikanischen Kunst, der erst Anfang der siebziger Jahre mit dem Ende der historischen Avantgarden versiegen sollte.

Nur jene europäischen Künstler, die bereits vor dem Zweiten Weltkrieg zu sich selbst gefunden hatten, konnten nach 1945 ein souveränes Schaffen entwickeln. Ich erinnere an Alberto Giacometti, Jean Fautrier, Jean Dubuffet, Lucio Fontana.

Switzerland, not least because many of the ideas spawned by Europeans, ranging from Kandinsky via Brancusi and Schwitters to the Bauhaus and the De Stijl group, were there transformed or given a more radical form. By way of reminder: as early as 1955 Arnold Rüdlinger organized a major exhibition of Jackson Pollock's oeuvre in the Kunsthalle Basel. Contemporary European art did not gain a real foothold in the United States (that is to say, New York) until the 1970s, at a point in time when the influence of Minimalism and Conceptual Art, with their formalist thrust and roots in a philosophy of language, had waned in the United States.

The end of the decisive influence of US art on Europe was, on the one hand, an upshot of the end of the historical avant-garde, and, on the other, the result of a change in thought, triggered directly by both the publication of the Club of Rome's "Second Report" in 1972 and the oil crisis of 1973. The demise of the historical avant-garde also ended an era in the history of art, music, and theater, as well as in a specific category of masculinity. Avant-gardes, by their very nature, exclude more than they incorporate. The end of the avant-garde brought with it an inversion of this principle: henceforth efforts were devoted to including, rather than excluding. The women's movement, born in the later 1960s, proved to be an especially important factor in this connection, for it contributed most to the changes in consciousness and processes of perception. Above all, however, the women's movement broached the domain of the intimate as a source of archaic power.

Accessing the intimate makes clear what it is that determines the creative nature of us all: on the one hand, time, fear, death, and sexuality; on the other, generative principles — order and disorder, chance and necessity (regularity), searching and finding, the similar and the dissimilar.

We can say of fear that it is the opposite of fright; and of death that we can constantly repress it. And with sexuality, the case is the same as that of language: both are functionally determined, unlike eroticism and poetry, which can be considered a waste, although, to paraphrase Octavio Paz, they are a waste which ensures the survival of the species. Order is related to disorder the way chance is related to regularity. Whoever only searches gets lost at the horizon, whoever only finds is abandoned to chance. The similar and the dissimilar are both based on repetition, that transformational process which in 1834 Kierkegaard termed "repetition forward" (as opposed to repetition backward, which stresses the primacy of the idea instead of that of life).

Against this backdrop, let us assume that each and every artist today has to determine form and content, beyond issues of style — in other words, artistic statements are not intrinsic to a particular style but transcend all styles. And let us assume further that the power of the major cities to exert an influence on style has ceased, because information and knowledge, whenever and wherever, have become immediately accessible. The mandate, therefore, is to link them

Die Bedeutung der amerikanischen Kunst wurde vor allem in Deutschland, den Niederlanden und der deutschsprachigen Schweiz am stärksten wahrgenommen, nicht zuletzt auch deshalb, weil viele Ideen, von Kandinsky über Brancusi und Schwitters bis zum Bauhaus und De Stijl, sowohl eine Radikalisierung als auch eine Transformation erfuhren. Zur Erinnerung: Bereits 1955 zeigte Arnold Rüdlinger in der Kunsthalle Basel in einer großangelegten Ausstellung das Schaffen von Jackson Pollock. Die europäische Gegenwartskunst konnte erst in den siebziger Jahren in Amerika (sprich: New York) Fuß fassen, zu dem Zeitpunkt, als die sprachphilosophisch-formalistische Prägung von Minimal Art und Conceptual Art in den USA selbst an Einfluß verlor.

Das Ende des maßgebenden Einflusses der amerikanischen Kunst in Europa ist zum einen bedingt, wie schon erwähnt, durch das Ende der historischen Avantgarden, zum anderen durch ein Umdenken, dessen unmittelbare Auslöser der Zweite Bericht des "Club of Rome" (1972) und die Ölkrise (1973) waren. Mit dem Ende der historischen Avantgarden fand eine bestimmte Geschichte der Kunst, der Musik und des Theaters ein Ende und ebenso eine bestimmte Kategorie von Männlichkeit. Naturgemäß schlossen die Avantgarden mehr aus, denn ein. Mit ihrem Ende kehrte sich das Prinzip um: Jetzt ging es darum, mehr ein- denn auszuschließen. Als ein besonders wichtiger Faktor erwies sich die Frauenbewegung. Denn sie war es, die ab Ende der sechziger Jahre mit zu den stärksten Veränderungen in Bewußtseins- und Wahrnehmungsprozessen beigetragen hat. Vor allem aber öffneten sie den Weg zum Intimen als eine archaische Kraft.

Der Zugriff zum Intimen macht deutlich, daß zum einen Zeit, Angst, Tod und Sexualität, zum anderen, im Sinne von generativen Prinzipien, Ordnung und Unordnung, Zufall und Notwendigkeit (Gesetzmäßigkeit), Suchen und Finden wie das Ähnliche und Verschiedene das schöpferische Dispositiv eines jeden bestimmen.

Von der Angst kann man sagen, daß sie das Gegenteil von Furcht ist; vom Tod, daß wir ihn kontinuierlich verdrängen. Und mit der Sexualität verhält es sich wie mit der Sprache: Beide sind funktionsbedingt, im Unterschied zur Erotik und Poesie, die als Verschwendung gelten können, jedoch, wie Octavio Paz sinngemäß sagt, eine arterhaltende Verschwendung konstituieren. Ordnung verhält sich zur Unordnung wie der Zufall zur Gesetzmäßigkeit. Wer immer nur sucht, verliert sich am Horizont, wer immer nur findet, überläßt sich dem Zufall. Dem Ähnlichen und Verschiedenen liegt die Wiederholung zugrunde, jener transformatorische Prozeß, den Kierkegaard 1834 als die "Wiederholung nach vorne" bezeichnet hat (im Unterschied zur rückwärts gerichteten Wiederholung, die das Primat der Idee statt jenem des Lebens hervorhebt).

Wenn es denn so ist, daß jeder Künstler heute selbst Form und Inhalt zu bestimmen hat, jenseits von verbindlichen Stilen, seine Aussagen demzufolge

nicht stilimmanenter, sondern stilübergreifender Natur sind, und wenn es denn im weiteren so ist, daß die stilbildende Kraft der Metropolen obsolet geworden ist, weil Information und Wissen, wann und wo auch immer, abrufbar geworden sind und zur Verfügung stehen und das Gebot darin besteht, diese mit den eigenen biographischen Voraussetzungen, wo auch immer, zu verbinden, dann stellt sich die Frage: *Wie macht man eine Sammlung von Gegenwartskunst?*

Ganz offensichtlich ist es unmöglich, heute einen allgemeinen Überblick über das Schaffen der Gegenwartskunst zu vermitteln. Man stelle sich vor, von "überall her" würden Einzelwerke anerkannter Künstler zusammengetragen. Das Resultat müßte ziemlich deprimierend ausfallen, weil die Voraussetzungen, welche diese Werke hervorgebracht haben, viel zu verschieden sind, um eine Dialogfähigkeit an den Tag zu legen. Das ist der eine Aspekt. Der andere besteht darin, daß diese Einzelwerke nicht mehr Teil eines linearen, Schritt für Schritt entwickelten Diskurses sind, sondern vielmehr einem diskontinuierlichen, ja diachronischen Verfahren gehorchen, auch wenn dieses Verfahren demselben schöpferischen Dispositiv eines Künstlers zugrunde liegt.

Nun kann ich das Gesagte umdrehen und es positiv ausdrücken: Es ist sehr wohl möglich, von "überall her" Einzelwerke zusammenzubringen, die letztlich dialogfähig sind, dann, wenn ich die Werke unter dem Aspekt dieser Dialogfähigkeit eruiere. Das Entscheidende dabei ist, die Werke nicht zu einem Dialog zwingen zu wollen, denn dieser hätte wahrscheinlich eine qualitative Einbuße zur Folge. Vielmehr geht es darum, vergleichbare Haltungen in Verbindung zu bringen.

Im besten Fall wird dies in Museen sichtbar, die über einen großen, in Jahrzehnten geschaffenen Fundus verfügen, wo keineswegs nur die sogenannten Meisterwerke in Dialog treten, sondern jene, die durch eine vergleichbare, intensive und obsessive Haltung ein spannungsgeladenes Energiefeld zu schaffen wissen.

Die andere Möglichkeit besteht darin, sich für einzelne Künstler auf Zeit zu engagieren. Mit anderen Worten: Wenn man sich für ein Werk entscheidet, dann entscheidet man sich auch für den Künstler in einer gewissen Periode seines Schaffens. Das heißt, man versucht über eine Werkgruppe sein bildnerisches Denken zu visualisieren, um damit beispielhaft Positionen der Gegenwartskunst festzumachen.

Wie bekannt oder unbekannt auch immer die Künstler sind, deren Werke wir erwerben, sie, die Künstler besitzen den Status eines "Botschafters" unseres Hauses. Ob bekannt oder unbekannt, sie treten mit ihren Werken gleichrangig in den Museumsräumen auf. Und was immer, temporär, im Lager verschwindet, taucht früher oder später in einer völlig neuen Konstellation wieder auf.

Das Engagement für einzelne Künstler und das Festhalten an der Werkgruppe einzelner Künstler stellt für das Museum und für den Museumsleiter eine neue Form der Herausforderung dar. Vorbei sind die Zeiten, in denen Museen

in any way whatsoever with your own biographical forces. Then the question arises: How should one go about assembling a collection of contemporary art?

Today, it has obviously become impossible to convey a general overview of the output of contemporary art. Imagine what it would be like if individual works by acknowledged artists were to be gathered together from "all quarters." The result would inevitably be distinctly depressing, because the creative exigencies of these works are so different that they cannot enter into a dialogue. Moreover, these individual works are no longer part of a linear discourse that has developed step by step, but are subject rather to a discontinuous, if not diachronic, process, even if this process is based on the same creative disposition of the artist.

Now, I could turn what I have just said around and put it positively: it is indeed possible to bring together individual works from all quarters, works that can enter into a dialogue with one another—if I select the works according to their ability to participate in this dialogue. In this selection process, the works must not be forced into a dialogue; instead, the objective must be to interconnect comparable stances.

This is best visible in museums with large collections that have grown over decades and where the participants in the dialogue include not only the so-called masterpieces, but also those works with a highly charged energetic field generated by a comparably intensive stance.

The other possibility is a long-term commitment to individual artists. In other words, you attempt by means of a group of works to visualize the thought of one artist and in so doing pinpoint *exemplary* positions in contemporary art. The artists whose works we acquire, whether unfamiliar or well known, serve as "ambassadors" of our museum; in this sense, all the works in the MMK's galleries have the same status. And whatever disappears, even if temporarily, into our storage rooms, emerges sooner or later in a completely new constellation.

A commitment to individual artists and to a policy of presenting groups of works by these artists confronts the museum and the museum director with a new challenge. Gone are the days when museums collected the works of the same artists and operated in competition with one another. In the future, every museum will have a different face, in keeping with the subjective decision of its respective director. I believe it is essential that museum visitors today encounter small groups of works by individual artists—although I do not advocate museums dedicated to a specific artist or artists. The standard for collecting such groups of works was set decisively by Heiner Friedrich, when he served as a consultant to Karl Ströher, whose collection forms the core of the MMK holdings, and when he co-founded the Dia Foundation in New York.

Many visitors to larger museums have probably noticed just how pitiful contemporary art often appears when viewed at the end of a large number of splendid rooms in which historical, stylistically connected art works hang. This effect is by no means the result of qualitative distinctions; it arises because

works of contemporary art that are themselves stylistically varied are bundled together simply because they happen to be contemporary.

Art historians are above all historians, who think more in categorical concepts than in terms of levels of intensity. Why should a work by Beuys not be installed in a room alongside medieval art? Why should a sculpture — for example, a circular surface with various large branches created by Richard Long — not engage in a dialogue with Cubist works? One of the shows that left the greatest impression on me was the exhibition in the "Consortium de Dijon," which in 1989 brought together the creative works of Alberto Giacometti and On Kawara: the sculptor compresses space to such a degree that "it falls out of time," and the producer of the *Date Paintings* delimits and particularizes time.

Museums still need to learn how to handle their treasures. They keep on showing them to us as if we were still at school, as if we had to retrace the path from Original Sin right through to the nineteenth century. If today I had to give lessons on Ancient Rome and the Romans, I would do so from the point of view of the present: I would talk about engineering — aqueducts and road construction — about the capacity for assimilation, about organizational forms, laws, ethics, sensual enjoyment, strategic thinking, and the economy. I would certainly not neglect the arts and literature, but I would bring all these areas as close as possible to our modern consciousness. In this comparative context, there is still much to be discovered in the art of the past and the present. If reality means communication, then we must link the knowledge of the past with that of the present, remaining fully aware, however, that art always begins where communication ends.

Translated by Jeremy Gaines and Rebecca Wallach

sich in gegenseitiger Beobachtung die gleichen Künstler teilten, ja, sich gegenseitig zu überbieten trachteten. In Zukunft wird sich jedes Museum gemäß der subjektiven Entscheidung seines Leiters anders präsentieren. Ich glaube, es ist wichtig, daß wir heute kompakten Werkgruppen begegnen können. Ich möchte damit gerade nicht für Künstlermuseen plädieren, sondern für solche, die sich an einer überschaubaren Anzahl von Künstlern orientieren und durch die Konzentration auf größere zusammenhängende Werkgruppen das bildnerische Denken der Künstler deutlich machen. Heiner Friedrich beispielsweise hatte einst mit seiner Beratertätigkeit für Karl Ströher und seinem Engagement für die Dia-Foundation in New York entscheidende Akzente gesetzt.

Vielen Besuchern größerer Museen dürfte aufgefallen sein, wie trübselig sich oft am Ende einer Reihe prächtiger, die Stilkunst vereinender Räume die Gegenwartskunst offenbart. Dies hat keineswegs primär mit qualitativen Gründen zu tun. Vielmehr ist es so, daß man Werke der Gegenwartskunst, ganz unterschiedlicher Natur, nur weil sie der sogenannten Gegenwart angehören, beliebig zusammenführt.

Kunsthistoriker sind eben zuerst Historiker, sie denken mehr in Begriffen von Kategorien statt in Begriffen von Intensitäten. Weshalb sollte ein Werk von Beuys nicht in einem Raum mit mittelalterlicher Kunst seinen Standort finden? Weshalb sollte eine Skulptur, zum Beispiel eine Kreisfläche mit verschieden großen Ästen von Richard Long, nicht einen Dialog mit kubistischen Werken eingehen können? Die Ausstellung im "Consortium de Dijon", die 1989 das Schaffen von On Kawara und Alberto Giacometti vereinte, gehörte mit zu meinen stärksten Erlebnissen, komprimiert doch der Bildhauer den Raum derart stark, daß die Zeit "herausfällt", während der Maler der Datumsbilder die Zeit zugleich entgrenzt und partikularisiert.

Die Museen müssen noch lernen, mit ihren Schätzen umzugehen. Sie zeigen uns ihre Schätze immer noch wie weiland in der Schule, als ob wir den Weg von der Erbsünde bis ins 19. Jahrhundert abschritten. Müßte ich heute über das antike Rom und die Römer unterrichten, würde ich dies aus einem Gegenwartsbewußtsein heraus tun: Ich würde über Logistik, z. B. Aquädukte und Straßenbau, Assimilationsvermögen, über Organisationsformen, über Recht, über Ethik und Sinnesfreuden, über Urbanistik, strategisches Denken, und Ökonomie referieren, ich würde die Kunst und Literatur sicherlich nicht vernachlässigen, aber ich würde alle diese Bereiche ganz nahe an unser Gegenwartsbewußtsein heranführen. Insofern gibt es in der Kunst der Vergangenheit und der Gegenwart noch viel zu entdecken. Wenn Realität Kommunikation bedeutet, dann müssen wir die Erkenntnisse der Vergangenheit mit jenen der Gegenwart koppeln, vor allem im Bewußtsein, daß Kunst immer dort beginnt, wo die Kommunikation ein Ende hat bzw. kraft der Werke erfunden werden muß.

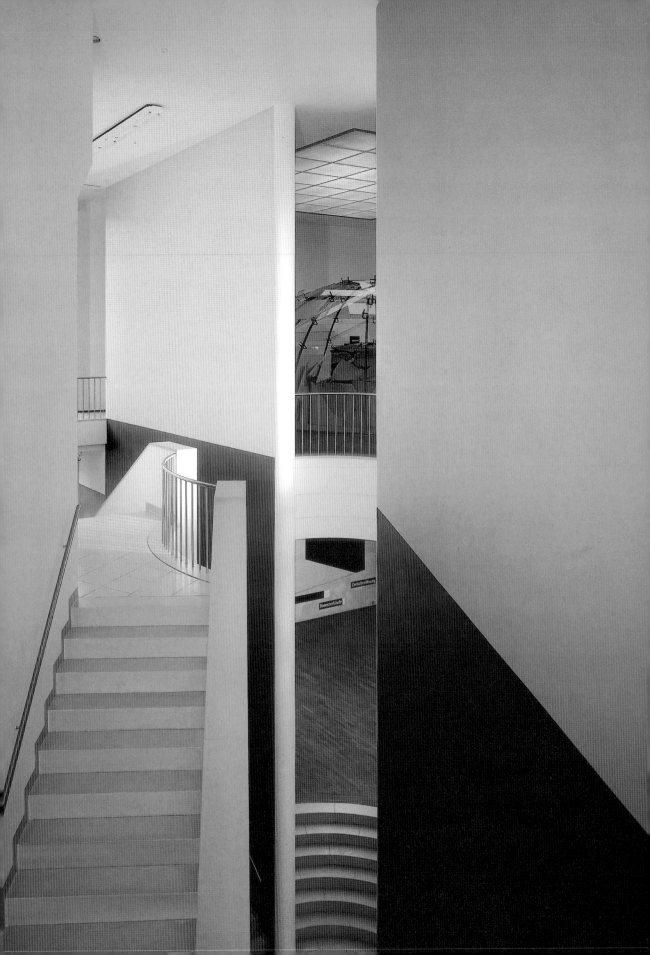

Display as Discourse
Adam D. Weinberg

Darstellung als Diskurs
Adam D. Weinberg

"Dem Reichen übergibt der Baumeister mit dem Schlüssel des Palastes alle Bequemlichkeit und Behäbigkeit, ohne irgend etwas davon mitzugenießen. Muß sich nicht allgemach auf diese Weise die Kunst von dem Künstler entfernen ..."
— Goethe, *Wahlverwandtschaften*[1]

Als das Whitney Museum Jean-Christophe Ammann einlud, eine Ausstellung mit Werken aus der Sammlung des Whitney und des Museums für Moderne Kunst in Frankfurt (MMK) zusammenzustellen, wußten wir, daß wir einen Ausstellungskuratoren von hoher Sensibilität mit dieser Aufgabe betraut hatten. Ammann ist eine schillernde und rätselhafte Persönlichkeit und hat sich seit dreißig Jahren als risikofreudiger Kurator profiliert, der seiner Zeit immer ein wenig voraus war. Inzwischen ist sein Name zu einer Art unverwechselbarem Warenzeichen geworden. Charakteristisch für seine Herangehensweise sind seine leichte Hand, seine Aufgeschlossenheit und seine Fähigkeit, sich jedem Problem als einer neuen Situation zu stellen, die eine neue Lösung erfordert.

With the keys of the palace the architect hands over all its comforts to the wealthy man, and has not the least part in them. Surely in this way art must little by little grow away from the artist....
— Goethe, *Elective Affinities*[1]

When the Whitney Museum invited Jean-Christophe Ammann to curate an exhibition using works from its collection and from the collection of the Museum für Moderne Kunst in Frankfurt (MMK), we knew that we were engaging a curator with a distinct, indelible sensibility. While Ammann is a colorful and enigmatic personality who for thirty years has distinguished himself as an adventurous and prescient curator, the mark that he makes is anything but a brand name. What is distinctive about his curatorial approach is his light touch, his open-mindedness, and his capacity to address each problem as a new situation that demands a fresh solution.

In planning the "Views from Abroad" series, we imagined that each curator would organize an exhibition for the Whitney that would in large

Museum für Moderne Kunst, Frankfurt
Level Three, view into rooms on second and third floors. Ebene 3, Blick in Räume auf der zweiten und dritten Ebene.

Bei der Planung der "Views from Abroad"-Reihe hatten wir uns vorgestellt, daß jeder Kurator für das Whitney eine Ausstellung organisieren würde, die im großen und ganzen unverändert auch im eigenen Museum des Betreffenden gezeigt würde. Aber wie bei so manchem wohlausgedachten Plan, wuchs das Projekt über seinen Rohentwurf hinaus — sowohl, was die Größenordnung, als auch, was die Komplexität anging. Die erste Ausstellung in dieser Reihe, zusammengestellt von Rudi Fuchs vom Amsterdamer Stedelijk Museum, wuchs um das Doppelte, als sie New York verließ, und wurde im Stedelijk in erheblich größeren Räumen installiert. Obwohl Fuchs seiner poetischen, diachronischen Sicht der amerikanischen Kunst des Zwanzigsten Jahrhunderts viele weitere amerikanische und europäische Werke hinzufügte, bewahrte die Ausstellung in Amsterdam jedoch im wesentlichen den Charakter der New Yorker Installation. Man hatte den Eindruck, als würde das Stedelijk eine sinfonische Version eines Werks für Kammerorchester aufführen, das für das Whitney komponiert wurde.

Die beiden von Ammann zusammengestellten Ausstellungen weisen insofern eine Familienähnlichkeit auf, als ihnen einige Werke und Präsentationsstrategien gemeinsam sind. Ansonsten aber muß man sie als zwei unterschiedliche Einheiten betrachten. Jede Ausstellung ist auf ihr besonderes Publikum und den Schauplatz zugeschnitten. Das MMK verfügt über eine außergewöhnliche Sammlung amerikanischer Pop Art von Künstlern wie George Segal, Claes Oldenburg und Andy Warhol, aber Ammann ging davon aus, daß man das amerikanische Publikum nicht noch mehr über Themen aufklären sollte, die ihm ohnehin geläufig sind. Statt dessen entschloß er sich, in New York eine Auswahl zeitgenössischer europäischer — zumeist deutscher — Werke im Kontext der amerikanischen Kunst aus dem Whitney Museum zu präsentieren. Das Museum in Frankfurt hat sich der Sammlung bestimmter Nachkriegs- und vor allem zeitgenössischer Künstler verschrieben und geht daher in die Tiefe anstatt Wert auf einzelne Meisterwerke zu legen. Dementsprechend besteht einer der wichtigen Grundzüge der MMK-Installation in der Gruppierung von Werken einzelner Künstler, die aus den Sammlungen beider Museen stammen. Und da im MMK keine Räume für Wechselausstellungen zur Verfügung stehen, werden die Werke aus dem Whitney im gesamten Haus unter jene integriert, die zum Dauerbestand des MMK gehören. Ein Sammlungsergebnis sind Installationen im Geist von André Malraux' 'imaginärem Museum'.

Ammann hat diese Installationen nicht nur entsprechend seinen Vorlieben für bestimmte Kunstwerke oder Künstler gestaltet, vielmehr sollen sie dem Zweck dienen, den Auftrag, die Architektur und die Sammlung eines jeden der beiden Museen darzustellen, von der Sensibilität des MMK-Direktors gar nicht zu reden. Gleichzeitig ist es Ammann gelungen, kunstfertig und intuitiv Makro- und Mikro-Dialoge in Gang zu setzen, die Beziehungen zwischen der europäischen und amerikanischen Kunst und den Künstlern nahelegen.

Es ist noch eine weitere Reihe von Beziehungen hierbei festzustellen, die

measure remain intact for its second viewing in the curator's own museum. As with many a well-laid plan, the project outgrew its blueprint—as much in scale as in complexity. The first exhibition in the series, curated by Rudi Fuchs of the Stedelijk Museum, Amsterdam, doubled in size when it left New York and was installed in much larger quarters at the Stedelijk. Although Fuchs added many more American and European works to his poetic, diachronic view of twentieth-century American art, the exhibition in Amsterdam preserved the essential framework of the New York installation, as if the Stedelijk showing were an orchestral version of the chamber work composed for the Whitney.

The two exhibitions curated by Ammann have a familial resemblance in that they share some of the same works and strategies of presentation. Otherwise, they must be seen as two distinct entities. Each exhibition is tailored for its specific audience and site. The MMK has an extraordinary collection of American Pop Art by such masters as George Segal, Claes Oldenburg, and Andy Warhol, but Ammann thought that American audiences need not be told more about what they already knew. Instead, in New York, he has opted to present a selection of contemporary European—mostly German—works in the context of American art from the Whitney collection. The Frankfurt museum is devoted to collecting certain postwar and particularly contemporary artists in depth rather than individual masterworks. Accordingly, one of the salient features of the MMK installation is the grouping of works by individual artists, some from both collections. And since the MMK does not have galleries devoted to temporary exhibitions, the Whitney works will be integrated with those on permanent display throughout the entire museum, creating installations in the spirit of André Malraux's "imaginary museum."

Ammann organized these installations not simply according to preferences for certain art works or artists over others. Rather, they are conceived to reveal each museum's mission, architecture, and collection, not to mention the sensibility of the MMK's director. At the same time, Ammann has craftily and intuitively constructed macro- and micro-dialogues which suggest relationships between European and American art and artists.

There is also another set of relationships at work here, one that defines the "Views from Abroad" series itself: the relationships between cultures, museums, collections, and curators. The fundamental expression of these interconnections is the exhibition. Therefore, through an analysis of the exhibition structure we can discern larger institutional positions. Indeed, the New York and Frankfurt exhibitions organized by Ammann and his team of curators juxtapose the two museums as if they themselves were art works in a gallery.

To appreciate these curatorial decisions, one must begin with a brief sketch of each museum building. Although Ammann does not see himself as a critic of architecture and believes that a museum's architecture is the architect's business, he has strong feelings about the type of space a museum should provide.[2] Most important, he feels that exhibition spaces are made for and have

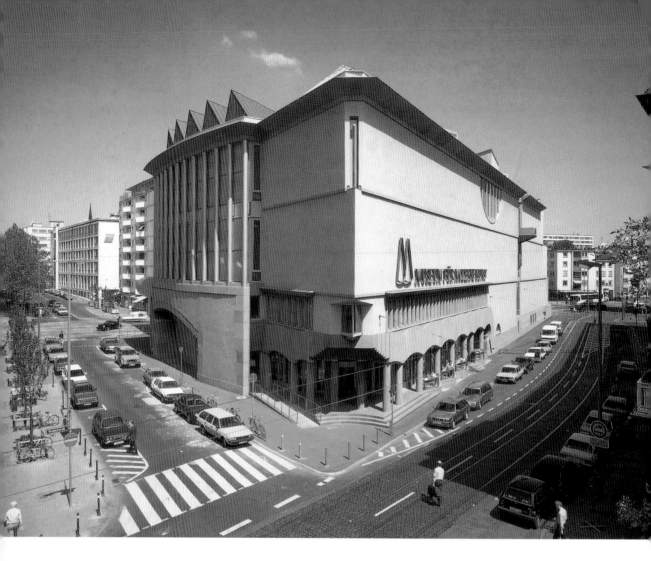

to be defined by the art. "Architecture in a museum has to serve the art and not the other way around."[3] In fact, when Ammann arrived in Frankfurt in late 1987 to assume his post as director of the newly founded museum, he made it known that he would have preferred a neutral factory or warehouse building over the new building being planned.[4] However, by the time he arrived, the building program for architect Hans Hollein, as laid out by Ammann's predecessor, had been largely established. The MMK building, a key example of a postmodern museum structure, is set on an architecturally challenging triangular site near the heart of Frankfurt. Hollein's knowledge of the future MMK's core collection of some eighty-one works of Pop Art from the former Ströher collection — one of the most significant German collections of contemporary art — also provided a schema around which to structure the design. The architecture's dominant characteristic is Hollein's superimposition of "an asymmetrical, diagonally oriented area of access on a symmetrical structure," which "puts the building into complex interrelationships."[5]

While Hollein acknowledged that the focus of attention is the art, he also stated: "This environment is in a dialectic relationship with the artwork, withdrawn but not without its own individuality and character. Considerations of

Museum für Moderne Kunst, Frankfurt
Southwest facade.
Südwestfassade.

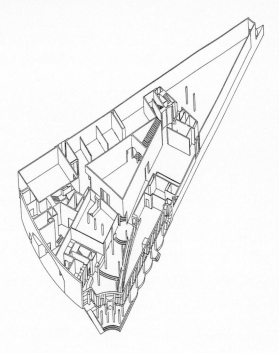

**Museum für
Moderne Kunst,
Frankfurt**
Isometric plan
of gallery spaces,
level one/
mezzanine level.
Isometrie der
Ausstellungsräume,
1. Ebene/
Zwischengeschoß.

für die gesamte "Views from Abroad"-Reihe gelten, nämlich jene zwischen Kulturen, Museen, Sammlungen und Kuratoren. Der grundlegende Ausdruck dieser vielfältigen Verbindungen ist die Ausstellung selbst, weshalb die Darstellungsstruktur es ermöglicht, die Grundauffassungen der jeweiligen Institutionen zu unterscheiden. Tatsächlich stellen die von Ammann und seinem Team für New York und für Frankfurt zusammengestellten Ausstellungen die beiden Museen einander gegenüber, als wären sie selbst Kunstwerke in einer Galerie.

Zum besseren Verständnis dieser Entscheidungen des Kurators soll hier kurz auf die beiden Museumsgebäude eingegangen werden. Obwohl Ammann sich nicht als Architekturkritiker betrachtet und davon ausgeht, daß die Architektur eines Museums Sache des Architekten ist, hat er klare Ansichten darüber, welche Art von Raum ein Museum zur Verfügung stellen sollte.[2] Vor allem geht er davon aus, daß Ausstellungsräume für die Kunst gebaut und von der Kunst definiert werden sollen. "Die Architektur hat der Kunst zu dienen, nicht umgekehrt".[3] Als Ammann Ende 1987 in Frankfurt eintraf, um seinen Posten als Direktor des neugegründeten Museums anzutreten, machte er deutlich, daß er dem neu geplanten Gebäude ein neutrales Fabrikgebäude oder Lagerhaus vorgezogen hätte.[4] Zu diesem Zeitpunkt war das Bauprogramm für den Architekten Hans Hollein, wie von Ammanns Vorgänger vorgesehen, allerdings bereits überwiegend festgelegt. Das Gebäude des MMK, ein Schlüsselbeispiel postmodernen Museumsbaus, befindet sich auf einem architektonisch herausfordernden dreieckigen Grundstück in der Frankfurter Innenstadt. Holleins Kenntnis der Kernsammlung des zukünftigen MMK — vierundachtzig Werke der Pop Art aus der ehemaligen Ströher-Sammlung, einer der bedeutendsten deutschen Sammlungen zeitgenössischer Kunst —, lieferte darüber hinaus bereits ein Schema, um das herum die Gebäudestruktur zu entwickeln

war. Der Hauptzug des Gebäudes besteht darin, daß Holleins Überlagerung "einer symmetrischen Struktur mit einer asymmetrischen, räumlich diagonalen Erschließung...das Gebäude in komplexere Bezüge"[5] setzt.

Hollein hat zwar der Tatsache Rechnung getragen, daß die Kunst im Mittelpunkt der Aufmerksamkeit stehen muß, aber er betonte auch, daß "dieses Umfeld...in einer Dialektik zum Kunstwerk [steht], zurücktretend, wenn auch nicht ohne Eigenständigkeit und Charakter. Fragen des Raumes und des Lichtes stehen im Vordergrund, Fragen optimaler Konfrontation [Hervorhebung durch den Autor] und Erlebnishaftigkit folgen...Fragen der Architektur, Fragen der Kunst."[6] Darüber hinaus merkte er an, daß es "keinen neutralen Raum [gibt], sondern nur charakteristische Räume unterschiedlicher Größenordnung (und ihre Erschließung), mit denen das Kunstwerk eine Dialektik eingeht—in gegenseitiger Potenzierung."[7] Mit anderen Worten, die Kunst übt einen Druck aus, dem die Architektur in ebenso hohem Maß einen Gegendruck entgegensetzen soll. Im MMK geschieht das durch eine dramatische zweistöckige Eingangshalle, dreieckige Räume, Säulenhallen, Zugänge über unterschiedliche Treppenhäuser, Durchblicke von einem Raum in den anderen, eine Brücke, Kombinationen natürlichen und künstlichen Lichts und viele andere theaterhafte Züge.

Für Hollein war der Entwurf bereits größtenteils durch die Baulage bestimmt: räumliche Begebenheiten mußten so gehandhabt werden, daß eine mehr oder weniger bestehende Sammlung von Werken bestmöglich dargestellt werden konnte. Als Ammann Sorgen äußerte, war Hollein gezwungen, sein Konzept zu erweitern und zusätzlich Ammanns Auffassungen in seinen Plan einzuarbeiten. "Werke jüngerer aktueller Künstler wurden inkludiert, das Schwergewicht mehr auf permanente, raumbezogene Installationen—in unterschiedlichsten Medien —verlagert;... Rückblick wich Ausblick."[8] Ammann war stets daran interessiert, mit den Künstlern zusammenzuarbeiten, er gestattet es dabei ihren Werken, die Form der Präsentation zu bestimmen. Unter seiner Leitung ist ein Museum ein Labor, in dem er mit den Künstlern zusammen an der Verwirklichung ihrer Installationen arbeitet. Seine Idee für das MMK zielte darauf ab, die kurzfristige, wechselhafte Qualität der althergebrachten deutschen Kunsthalle mit der historischen Dauerhaftigkeit des Kunstmuseums zu verbinden.

Es sieht so aus, als habe Ammann im Verlauf der letzten fünf Jahre einen Waffenstillstand mit dem Formalismus und der Hyperstilisierung des Hollein-Gebäudes geschlossen. Über sämtliche drei Stockwerke des MMK verteilt, präsentiert er ein komplexes Arrangement dauerhafter und kurzfristiger Installationen. Er nutzt das Spielerische und Theatralische des Gebäudes, um unerwartete Gegenüberstellungen, Annäherungen, Aussichten und Überblicke zwischen den einzelnen Werken, Werkgruppen und standortspezifischen Installationen zu schaffen. Indem er das Kurzfristige ins Dauerhafte integriert, bringt er die Besucher dazu, den gesamten Raum des Museums zu erforschen, nicht nur einzelne Räume für Sonderausstellungen (wie sie in anderen Museen

Museum für Moderne Kunst.
Level Three, view into rooms with
works by Frank Stella and Mario Merz.
Ebene 3, Blick in Räume rmit Arbeiten
von Frank Stella und Mario Merz.

space and light are of top priority; questions of optimum *confrontation* [emphasis added] and the capability of experiencing art follow.... Questions of architecture. Questions of art."[6] Furthermore, according to Hollein, "Neutral space doesn't exist: there are only characteristic spaces of different magnitude (and access to them), with which the work of art enters into a dialogue—in reciprocal intensification."[7] In other words, the art exerts a force and the architecture a counterforce of equal proportion. It does so at the MMK through a dramatic three-story entrance hall, triangular rooms, colonnades, multiple staircase entries, interior window overlooks, a bridge walk, combinations of natural and artificial light, and many other theatrical features.

For Hollein, the museum design was largely predicated on a highly manipulated architectural space to create optimum viewing of a more or less set body of works. When Ammann expressed concerns about the design, Hollein was forced to extend his concept and graft Ammann's approach onto the existing plan. "Works by young, current artists were included, the emphasis was shifted more to permanent installations—in the most varied media—created explicitly for rooms, ... retrospect made way for prospect."[8] Ammann's interest has always been in working with artists, in allowing their works to inform the presentation. In his hands, a museum is a laboratory in which he collaborates with artists to realize their installations. His idea for the MMK in effect combined the temporary, changing nature of the traditional German *Kunsthalle* with the historical permanence of the *Kunstmuseum*.

Over the last five years, it seems that Ammann has made a truce with the formality and hyperstylization of the Hollein building. Throughout the MMK's three floors, he intersperses a complex arrangement of permanent and temporary installations. He exploits the playfulness and theatricality of the building to create unexpected juxtapositions, adjacencies, prospects, and overlooks among individual works, groups of works, and site-specific installations. By integrating the temporary with the permanent, he compels viewers to explore the entire space of the museum, not just the separate temporary galleries (which in other museums are often visited to the neglect of the permanent collection galleries).[9] Similarly, for his installation in Frankfurt of the "Views from Abroad 2" exhibition, Ammann, together with his chief curator Rolf Lauter, has played a sly game of camouflage, presenting the two collections as one.

The evidence of Ammann's détente with the Hollein space is particularly noticeable in the installation of the exhibition at the Whitney, which Ammann executed with MMK curator Mario Kramer. The Whitney Museum building, designed by architect Marcel Breuer, was completed in 1966. It is as much the paradigm of a modernist museum building as Hollein's museum is a prime postmodern structure. While Breuer viewed this, his first museum building, as "an attempt to form the building itself as a sculpture," the interior was treated in an open, neutral fashion to provide for a flexible, large-scale space. Although the Whitney galleries are themselves not neutral, they inherently represent a

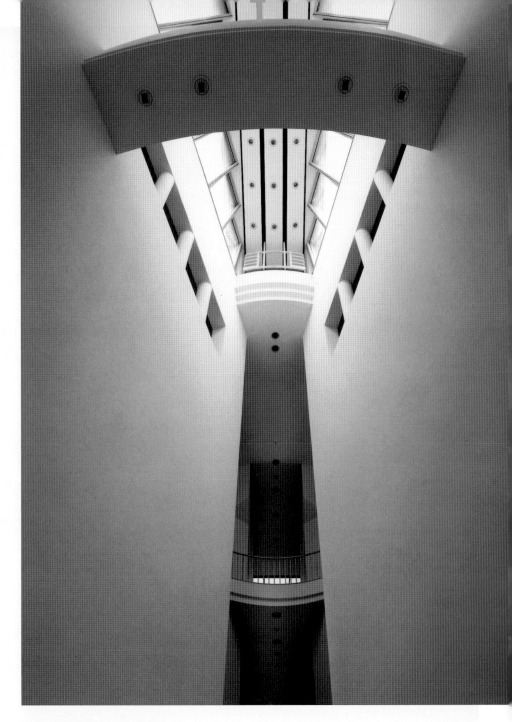

Museum für Moderne Kunst.
View from west and below to bridge linking
rooms on the third floor.
Unteransicht von Westen auf die Brücke der
Ebene 3.

oft zu einer Vernachlässigung der ständigen Sammlung durch die Besucher geführt haben).[9] Ähnlich hat Ammann bei seiner Installation der "Views from Abroad"-Ausstellung in Frankfurt, die er gemeinsam mit seinem Oberkustos Rolf Lauter erarbeitete, beide Sammlungen geschickt als eine einzige getarnt.

Ammanns Waffenstillstand mit dem Holleinschen Gebäude läßt sich vor allem in der Installation der Ausstellung im Whitney feststellen, die er gemeinsam mit dem MMK-Kustos Mario Kramer plante. Das Gebäude des Whitney Museums, entworfen vom Architekten Marcel Breuer, wurde 1966 eröffnet. Es stellt ebensosehr ein Musterbeispiel modernistischen Museumsbaus dar, wie Holleins Museum ein Hauptwerk postmoderner Architektur ist. Während Breuer dieses Bauwerk—sein erstes Museum—als "den Versuch [ansah], das Gebäude selbst als Skulptur zu betrachten", hielt er die Innenräume bewußt offen und neutral, um flexible, großzügige Räume zu ermöglichen. Und obwohl die Galerien des Whitney selbst nicht neutral sind, wohnt ihnen doch das historisch bestimmte Konzept des Bauhaus' von Raum, Entwurf und Material inne, die sich aus einer Struktur des Rasters, der zeitgenössischen Technologie und Techniken ableiten sollen. Dennoch bestand Breuers Herangehensweise generell darin, das zu schaffen, was der Kunsthistoriker William H. Jordy einmal ein "in den elementaren, 'reinen' Formen, die es verwendet, ästhetisch objektives"[10] Gebäude genannt hat. Wie Breuer selbst schrieb: "Es war unser Ziel, durch Schlichtheit der Innenarchitektur die Aufmerksamkeit der Besucher auf die ausgestellten Gegenstände zu richten."[11] Anders als in Holleins Gebäude gibt es keine Eingangshallen zu jeder Galerie, keine spitzen Winkel, keine Durchblicke und nur wenige Fenster. Jedes Stockwerk ist eine eigenständige Einheit. Ein Raum bei Breuer sagt im Grunde, daß man dort steht, wo man steht, während Holleins Entwurf einem mitteilt, wohin man gerade geht. Breuers Entwurf versucht, sich zurückzunehmen, während Holleins Credo einem bei jeder neuen Wendung abermals vor Augen geführt wird.

Man hätte erwartet, daß sich Ammann bei seiner Vorliebe für "neutralen" Raum in Breuers Gebäude befreit gefühlt hätte. Aber erstaunlicherweise verbindet der Entwurf für die Installation im Whitney Museum die asymmetrischen Unregelmäßigkeiten von Holleins Räumen mit den gradlinigeren Strukturen, die das Breuer-Gebäude vorschreibt. Der Installationsplan stellt damit eine Mischform dar, die die architektonische Sprache der jeweiligen Museen zusammenführt.

Die Aufteilung der Räume im Whitney Museum legt eine Anzahl von Parallelen zum Hollein-Gebäude nahe, während sie gleichzeitig die von Breuer vorgegebene Struktur akzeptiert. Der erste Ausstellungsbereich, in dem Stephan Balkenhols *57 Pinguine* aus dem MMK gezeigt werden, wird wie eine weiträumige Eingangsgalerie behandelt, wie die ausgedehnte Zentrale Halle des MMK, wo dasselbe Werk auf ähnliche Weise ausgestellt wurde. Eine der beiden Trennwände in der Installation steht in einem schrägen Winkel, der an den dreieckigen Grundriß des MMK erinnert, und bildet entsprechend fünf asym-

Exterior view of the Whitney Museum of American Art
Architect: Marcel Breuer, with Hamilton Smith. Michael Irving,
Consulting Architect. Designed 1963, built 1964–66.

Außenansicht des Whitney Museum of American Art
Architekt: Marcel Breuer mit Hamilton Smith.
Beratender Architekt: Michael Irving, entworfen 1963, erbaut von 1964 bis 66.

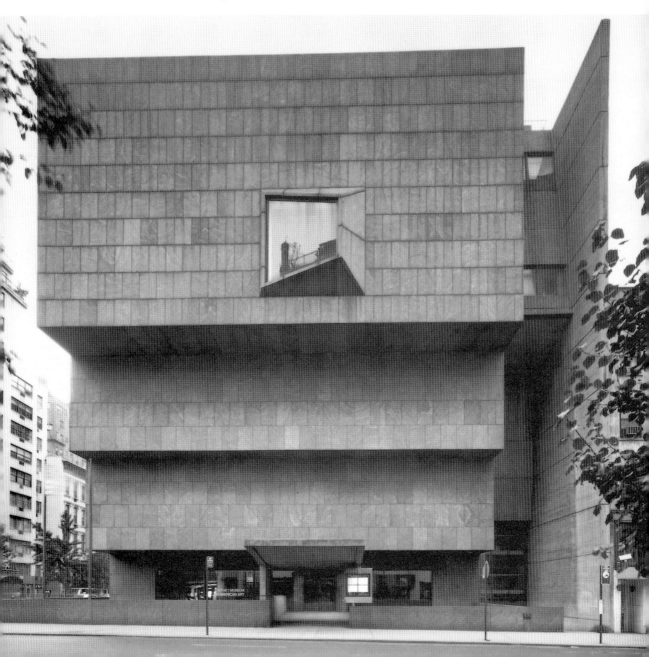

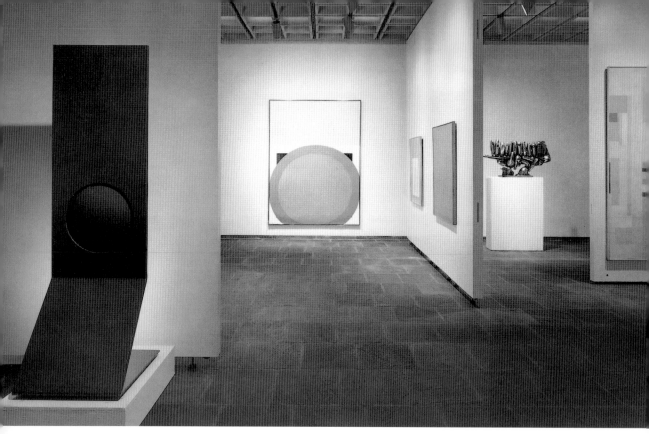

Whitney Museum of American Art

Installation view, inaugural exhibition of the Permanent Collection.

September 28, 1966.

Blick in die Eröffnungsausstellung der Permanent Collection.

28. September 1966.

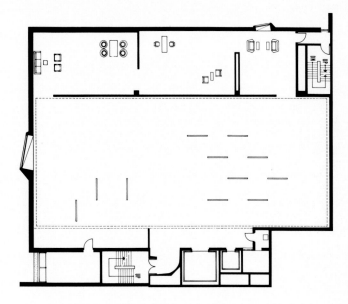

Whitney Museum of American Art
Fourth-floor gallery plan.
Grundriß der Fourth Floor Gallery.

metrische Räume. Im Gegensatz dazu verstärkt die zweite Wand, die parallel zur Außenwand verläuft, die blockartige Symmetrie des Breuerschen Entwurfs und läßt drei rechteckige Räume entstehen. Die Beziehung der asymmetrischen Räume zueinander ist nicht linearer Art, es führt mehr als nur ein einziger Weg hindurch. In diesen Galerien hat der Besucher also immer die Wahl zwischen mehreren Richtungen, ganz wie bei dem Arrangement der Räume im Hollein-Haus.

Ammann hat, indem er sich des Vokabulars des Architekten bediente, hier nicht nur gezeigt, daß er die Logik von Holleins Gebäude übernommen hat; die Überlagerung zweier architektonischer Systeme, die die Verbindung der beiden Sammlungen widerspiegelt, zeigt auch paradoxerweise eine bemerkenswerte Ähnlichkeit mit Holleins mehrschichtiger Auffassung, die dramatische, beinahe zueinander in Widerspruch stehende Räume schafft. Man darf dabei allerdings nicht übersehen, daß das Konzept für diese Ausstellung eher als intuitive Antwort auf die ausgewählten Werke denn als bewußtes theoretisches Konzept entstand.

Man sollte sich bei beiden Ausstellungen vergegenwärtigen, wie Bedeutung von den Ausstellungsräumen und der Art und Weise der Installation beeinflußt wird. Die Komplexität und Unterschiedlichkeit der Räume des MMK geben dem Kurator viele Möglichkeiten, Werke zu isolieren oder nebeneinanderzustellen, Reihungen und Verbindungen zwischen ihnen zu schaffen. Der Kurator muß die schwierige Dynamik und Dramatik von Holleins Grundriß bewältigen und zwischen der Kunst und der Architektur vermitteln, um ein Gleichgewicht zu finden, "auf daß die Architektur die Kunst nicht bedränge und sich die Kunst nicht gegen die Architektur wehren müsse."[12] Da das MMK-Gebäude über-

wiegend eine vorgegebene Struktur bietet, in der zusätzliche Wände nur selten hinzugefügt bzw. existierende Wände wenig verändert werden können, müssen die Werke aus dem Whitney ihren Platz in einem eher unflexiblen Raum finden und eine Übereinkunft mit der bereits vorhandenen Sammlung erreichen.

Die Einzelheiten des Frankfurter Ausstellungsplans sind zu komplex, als daß ich hier näher auf sie eingehen könnte, aber einige Grundvoraussetzungen sollten kurz umrissen werden. In Ammanns Installation wird der Gedanke einer eigenständigen Ausstellung der Sammlung des Whitney Museums auf dieselbe Art gebrochen, wie Holleins Architektur Raum dekonstruiert. Die Bedeutung der Whitney-Werke als Sammlungsbestände im Besitz dieses Museums wird heruntergespielt, um sie in einen größeren ästhetischen und historischen Diskurs zu stellen. Nur die Beschriftungen unterscheiden New York von Frankfurt. Ammann hat das Unerwartete getan und die "Sonderausstellung" in eine dezentralisierte Serie lokaler Ereignisse verwandelt. Die Werke sind nicht nach Kulturen geordnet und voneinander getrennt. Sie sind auch nicht in chronologischer Folge arrangiert. Werke eines und desselben Künstlers befinden sich jedoch im allgemeinen in einer Art Mini-Ausstellung vereint, Ammanns Prämisse folgend, daß an einer Werkgruppe desselben Künstlers "die Konsistenz seines bildnerischen bzw. skulpturalen Denkens konkreter sichtbar wird als an einem einzelnen Werk."[13] Die Installation weist hin und wieder auf Generationsparallelen hin (wie zwischen Francis Bacon und Willem de Kooning, Edward Ruscha und Alighiero e Boetti, Jochen Flinzer und Charles Ray), aber häufiger sprengen die angedeuteten Parallelen den Rahmen der Generationszugehörigkeit, sind idiosynkratisch und basieren auf einer Anzahl von Subthemen. So sind zum Beispiel einige Werke von Reginald Marsh und Jeff Wall nebeneinander plaziert worden, da beide Künstler soziale Themen ansprechen, während jene von Arthur Dove, Mario Merz und Georgia O'Keeffe zum Teil durch ihre implizite Thematisierung von Natur und Struktur verbunden sind. Ammann möchte das schaffen, was er als "Nachbarschaften"[14] bezeichnet. Diese bestehen aus einzelnen Kunstwerken, die über eine gewisse "Wahlverwandtschaft" verfügen, ein Konzept, das Ammann von Goethe entlieh:

> Wie jedes gegen sich selbst einen Bezug hat, so muß es auch gegen andere ein Verhältnis haben. Und das wird nach Verschiedenheit der Wesen verschieden sein ... Bald werden sie sich als Freunde und alte Bekannte begegnen, die schnell zusammentreten, sich vereinigen, ohne aneinander etwas zu verändern, wie sich Wein mit Wasser vermischt. Dagegen werden andere fremd nebeneinander verharren und selbst durch mechanisches Mischen und Reiben sich keineswegs verbinden; wie Öl und Wasser, zusammengerüttelt, sich den Augenblick wieder auseinandersondert.[15]

Für Ammann haben Kunstwerke ihre eigene Persönlichkeit und operieren innerhalb eines komplexen gesellschaftlichen Systems. Ein Kurator muß die Werke

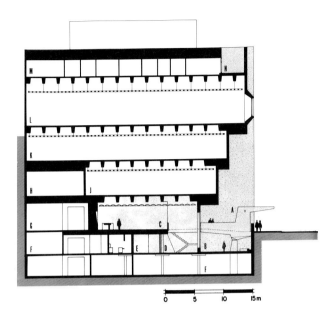

Whitney Museum of American Art
Elevation plan.
Aufriß.

historically rooted Bauhaus conception of space, design, and materials based on the structure of the grid and technological forms and techniques. Nevertheless, Breuer's general approach was to create what art historian William H. Jordy has called an *"esthetically* objective [building] in the elemental, 'pure' forms that it used."[10] As Breuer wrote, "Our purpose was to achieve a simplicity of interior design that would focus visitors' attention on the exhibits."[11] Unlike Hollein's building, there is no entrance hall to each gallery, no acute angles, no overlooks, and few windows. Each floor is a self-contained entity. The Breuer space in effect says you are where you are, while Hollein's space says you are where you're going. Breuer's design seeks to avoid editorializing, while Hollein's credo confronts you at every turn.

One would expect Ammann, given his preferences for "neutral" space, to feel liberated in Breuer's building. Curiously enough, the design that evolved for the Whitney installation combines the interior asymmetrical irregularities of Hollein's space with the more rectilinear forms dictated by the Breuer structure. The installation plan is thus a hybrid design that brings together the architectural language of both museums. The exhibition floor plan at the Whitney suggests a number of parallels to the Hollein building while simultaneously acknowledging the Breuer structure. The opening gallery, containing Stephan Balkenhol's *57 Penguins* from the MMK, is treated as a grand entrance gallery, like the large atrium of the MMK, where the work has been used in a similar manner. Of the two main dividing walls in the installation, one is set at an oblique angle, suggesting the triangular structure of the MMK, and consequently forms five asymmetrical rooms. In counterpoint, the other main wall, parallel to the perimeter wall, reinforces the blocklike symmetry of the Breuer design and

creates three rectangular rooms. The relationship of the asymmetrical spaces
to one another is not a linear one that proposes a single route. In these gal-
leries, the visitor is confronted with several choices of direction, similar to the
multiform arrangement of the Hollein building.

Not only has Ammann here shown his assimilation of Hollein's building
logic by using the architect's vocabulary, but the superimposition of two archi-
tectural systems to reflect the joining of the two collections has, paradoxically,
a marked resemblance to Hollein's layered approach, which creates dramatic,
almost contradictory spaces. One must keep in mind, however, that the design
for this exhibition came about more as an intuitive response to the work
selected than as a self-conscious theoretical plan.

In looking at both these exhibitions, it is important to consider how mean-
ing is shaped by the galleries and the way the art is installed in them. Given
the complexity and diversity of the MMK spaces, the curator has many options
for isolating works or creating sequences, juxtapositions, and connections
among them. The curator must master the difficult dynamics and dramatics of
Hollein's plan, mediating between the art and the architecture to find an equi-
librium so "that architecture might not encroach upon art and art not have to
arm itself against architecture."[12] Because the MMK building is largely a set
structure where walls are rarely added or altered, the Whitney works have to
find their place and reach an accommodation with the existing collection in a
rather inflexible space.

While the specifics of the Frankfurt exhibition layout are too complex to
address here, several general premises may be outlined. In Ammann's installa-
tion, the idea of a self-contained exhibition of art from the Whitney Museum
collection is fractured in the same way that Hollein's architecture deconstructs
space. And the significance of the Whitney works as Whitney-owned objects
is downplayed in order to situate them in a larger aesthetic and historical dis-
course. Only the labels distinguish New York from Frankfurt.

Ammann has done the unexpected and transformed the "special exhibi-
tion" into a decentralized series of local events. The works are not segregated
by culture. Nor are they arranged chronologically. Works by the same artist,
however, tend to be united in mini-exhibitions, following Ammann's premise
that "a *set of works* by the same artist allows us to see the line of his or her
pictorial or sculptural thinking more clearly than does an individual work."[13]
The installation periodically offers up generational parallels (as between
Francis Bacon and Willem de Kooning, Edward Ruscha and Alighiero e Boetti,
Jochen Flinzer and Charles Ray), but more frequently the parallels proposed
are intergenerational, idiosyncratic, and based on a number of subthemes.
For example, works by Reginald Marsh and Jeff Wall are brought together in
part because they both address social concerns, while those by Arthur Dove,
Mario Merz, and Georgia O'Keeffe are linked partially by their underlying
concern for nature and structure. Ammann is interested in creating what

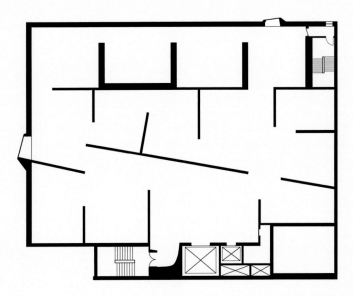

Whitney Museum of American Art
"Views from Abroad: European Perspectives on American Art 2." Provisional exhibition floorplan designed by Janet Cross.
Voraussichtlicher Grundriß für die Ausstellung, entworfen von Janet Cross.

"befragen", um herauszufinden, mit welchen anderen Werken sie zusammensein möchten. Bestimmte Arbeiten werden eine Beziehung untereinander eingehen, andere nicht. Wie Ammann geschrieben hat: "Man kann eine solche Nachbarschaft nicht erzwingen, denn sonst würde man sich gegen die Kunstwerke selbst stellen."[16]

In der MMK-Installation werden Nachbarschaften in einzelnen Ausstellungsräumen oder durch Gruppen von Räumen gebildet, die dann wieder in Beziehung zu anderen Nachbarschaften stehen. So muß man zum Beispiel den Raum, der Werke von Georgia O'Keeffe, Merz und Dove enthält, die ihrerseits in eine sehr spezielle Beziehung zueinander gesetzt wurden, als benachbart zu einer Reihe von Gemälden Gerhard Richters betrachten, die in einem anschließenden Raum präsentiert werden, und zu einem Wandgemälde von Günther Förg, das von einer Brücke aus sichtbar wird, wenn man einen weiteren benachbarten Ausstellungsraum mit Werken von On Kawara betritt. Gemeinsam bilden diese Nachbarschaften eine größere Gemeinschaft, eine Gemeinschaft, deren Beziehungen vom Gewebe architektonischer Räume bestimmt werden. Auf dem Weg durch das Hollein-Gebäude, erfährt man dann die Nachbarschaften als eine dynamische Reihe gesellschaftlicher Interaktionen, die sich nacheinander entwickeln, und es sind Wechselspiele, die man eher erleben und nicht beschreiben kann.

Die Installation im Whitney Museum teilt viele der Grundsätze des Konzepts für die MMK-Ausstellung. Sie wird jedoch, passend zum Entwurf des Gebäudes und zum Programm des Whitney, als konventionelle "Sonderausstellung" betrachtet. Auf vergleichsweise kleinerem Raum als die MMK-Ausstellung und auf der einfacheren Grundlage des Breuer-Gebäudes, kann die Installation in New York mehr als ein Ganzes und weniger als eine Reihe von Ereignissen erfahren

werden. Aber auch sie zielt darauf ab, immer nur ein Werk in den Mittelpunkt zu rücken und nutzt den Raum strategisch, um auf subtile Art eine Vielfalt an Erfahrungen zu schaffen und eine Reihe von Bedeutungen nahezulegen.

Schon wenn man den ersten Ausstellungsraum betritt, mit den Arbeiten dreier Künstler und diversen Möglichkeiten, sie zu betrachten, wird die Komplexität von Ammanns Unternehmung deutlich. In diesem Raum befinden sich die *57 Pinguine* von Stephan Balkenhol, *Studies for Unex Sign*, eine Serie von zweiundzwanzig Zeichnungen von Jenny Holzer, und zwanzig Zeichnungen von Silvia Bächli. Zunächst werden mit einiger Wahrscheinlichkeit die Pinguine Aufmerksamkeit erregen, danach tauchen vielleicht die Arbeiten Holzers aus dem Hintergrund auf. Strebt Ammann einen direkten Vergleich zwischen dem Werk Balkenhols und dem von Holzer an? Aber nein, wenn man sich nach links wendet, komplizieren die Bächli-Zeichnungen die ganze Angelegenheit zusätzlich. Und wenn man nach rechts geht, verschwinden die Arbeiten Holzers aus dem Blickfeld, und stattdessen wird man mit einem direkten Vergleich von Bächli und Balkenhol konfrontiert.[17] Jedes Werk kann ebensogut einzeln wie als Bestandteil einer Dreiecksbeziehung betrachtet werden. Will Ammann die Arbeit der amerikanischen Künstlerin in den Kontext der beiden europäischen Werke setzen? Deutet er eine Verbindung zwischen Balkenhols Bildhauerei und der Technik der Zeichnungen an? Oder schlägt er vor, stilistische und thematische Verbindungen herzustellen? Ich nehme an, daß Ammann keine dieser Möglichkeiten ausschließen würde.

Es ist unmöglich, jede rhetorische Nuance der ausgewählten Standorte zu bedenken, aufzuzeigen, wie visuelle Beziehungen sich verschieben, während man durch die Räume geht, und wie sich die Bedeutungen dadurch entsprechend verändern. Wir sollten es bei der Feststellung belassen, daß die der Installation zugrundeliegenden Überlegungen, die diversen Möglichkeiten von Beziehungen und die Wandlungen der Bedeutung für Ammann von größter Wichtigkeit sind. Alles wurde sorgfältig bedacht: wieviel Raum sich zwischen einzelnen Werken oder Werkgruppen befindet; was im Vorder- und was im Hintergrund zu sehen ist; die Werke innerhalb einer Galerie und in der Abfolge der Galerien; daß man beiläufig durch die Ausstellung schlendern oder alles sorgfältig betrachten kann; daß der Besucher die Erinnerung an das zuvor Gesehene mit sich nimmt, und seine Erwartungen an das, was er als nächstes sehen wird. Ammanns Stärke liegt in seiner Fähigkeit, Raum zu verstehen, unzählige unkonventionelle Kombinationen von Werken zu erwägen und darauf zu vertrauen, daß die Werke selbst verraten, was sie in einer bestimmten Situation benötigen. Die endgültige Anordnung beider Ausstellungen zeigt, wie sehr es Ammann darauf ankommt, die Kunst wieder mit der Architektur und die Kunst mit dem Künstler zu verbinden, so daß beide Museen und Sammlungen klarer ins Blickfeld rücken.

Aus dem Englischen von Regina Winter und Jeremy Gaines

he calls "neighborhoods."[14] These neighborhoods are established by individual art works that have certain "elective affinities," a concept borrowed from Goethe:

> Just as everything has an attraction to itself, so too there must be a relationship with other things. And that will vary according to the different natures of the things concerned.... Sometimes they will meet as friends and old acquaintances and come together quickly and be united without either altering the other at all, as wine for example mixes with water. But others will remain strangers side by side and will never unite even if mechanically ground and mixed. Thus oil and water shaken together will immediately separate again.[15]

To Ammann's thinking, art works have their own personalities and operate within a complex social system. A curator must "ask" the works which other works they wish to be with. Certain works will converse, while others will not. As Ammann has written, "You cannot force the creation of a neighborhood, otherwise you would act against the works of art."[16]

In the MMK installation, neighborhoods are formed by individual galleries and clusters of galleries which stand in relation to other neighborhoods. Thus the gallery containing works by O'Keeffe, Merz, and Dove, for example, which are themselves arranged in very specific relations to one another, must be seen as neighbors to Gerhard Richter's series of paintings presented in an adjoining gallery and to a Gunther Förg wall drawing visible from a bridge as one enters another adjoining gallery of works by On Kawara. Together these neighborhoods make up a larger community, a community whose relations are determined by the web of architectural spaces. As one moves through the Hollein building, one views the neighborhoods as dynamic series of social interactions unfolding in time, interactions that must be experienced rather than described.

The Whitney Museum installation shares many of the principles of the MMK exhibition. However, in keeping with the design of the building and the program of the Whitney, "Views from Abroad 2" is treated as a conventional "special exhibition." Given its comparatively small scale in relation to the MMK exhibition, and the simpler form of the Breuer building itself, the New York installation is experienced more as a whole and less as a series of events. But it too is constructed one work at a time, using the space strategically and subtly to create a variety of experiences and suggest a range of meanings.

One has to consider only the opening gallery, with works by three artists, and the various ways it can be viewed, to appreciate the complexity of Ammann's enterprise. In this gallery are the *57 Penguins* by Stephan Balkenhol; *Studies for Unex Sign #1*, a series of twenty-two drawings by Jenny Holzer; and twenty drawings by Silvia Bächli. As one enters, it is almost surely the penguins that demand attention. Then the Holzer drawings might emerge from the background. Is Ammann making a one-for-one comparison between the Balkenhol and Holzer works? But no, as one looks left, the Bächli drawings complicate

matters. And if, by walking to the right, the Holzers are eliminated from view, the result is a one-to-one comparison between Bächli and Balkenhol.[17] Each work can also be viewed on its own or within a triangulated relationship of three. Is Ammann contextualizing the American artist's work between the two European works? Is he suggesting a relationship between Balkenhol's process of sculpture and the process of drawing? Or is he proposing stylistic and thematic connections? I would venture that all these possibilities are in Ammann's realm of thought.

It is impossible to consider every rhetorical nuance of placement, how visual relationships shift as one moves through the space, and the consequent variability of meanings. Suffice it to say that these installation considerations, the contingency of relationships, and the permutations of meaning are of the utmost significance to Ammann. All is carefully composed: how much space exists between individual works or groups of works; what is in the foreground and the background, within a gallery and from gallery to gallery; how one might casually browse or carefully view the exhibition; how the viewer carries the memory of what has been previously seen and will anticipate what is about to be seen. Ammann's forte is his ability to comprehend space, to consider innumerable, unconventional combinations of works, and to trust that the works themselves will reveal the conditions that they require in a given situation. The ultimate disposition of both exhibitions reveals Ammann's intent to reconnect the art to the architecture and the art to the artist, so that both museums and collections can be seen more distinctly.

Notes

1. Johann Wolfgang von Goethe, *Elective Affinities*, trans. David Constantine (Oxford: Oxford University Press, 1994), p. 131.

2. Jean-Christophe Ammann, "Ein Haus für die Kunst," in *Bericht über die Jahre 1992 und 1993* (Cologne: Kulturkreis der deutschen Wirtschaft im Bundesverband der Deutschen Industrie, 1994).

3. Ibid, p. 20 from MMK.

4. Heinrich Klotz, "Duality," in *Museum für Moderne Kunst, Frankfurt am Main* (Frankfurt: Der Magistrat der Stadt Frankfurt am Main, 1991), p. 71.

5. Hans Hollein, "To Exhibit, to Place, to Deposit—Thoughts about the Task of the Museum of Modern Art," in *Museum für Moderne Kunst*, p. 31.

6. Ibid.

7. Ibid, p. 29.

8. Ibid, p. 30.

9. Aspects of the installation are changed twice a year during what is called Szenenwechsel ("Change of Scene"). The theatrical title is in keeping with the dramatic quality of Hollein's building.

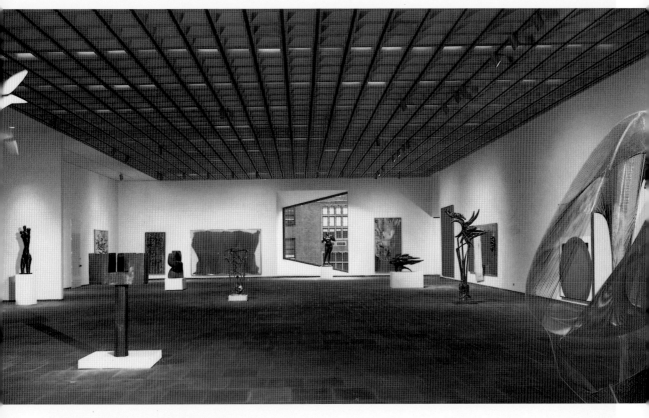

Whitney Museum of American Art
Installation view, inaugural exhibition of the
Permanent Collection. September 28, 1966.
Blick in die Eröffnungsausstellung der Permanent
Collection. 28. September 1966.

Anmerkungen:

1. Johann Wolfgang von Goethe: *Wahlverwandtschaften*. Werke in vier Bänden, Band II, Salzburg 1983, S. 452.

2. Jean-Christophe Ammann: "Ein Haus für die Kunst," in: *Kulturkreis der deutschen Wirtschaft im Bundesverband der Deutschen Industrie: Bericht über die Jahre 1992 und 1993*, Köln 1994, S. 20.

3. ebd., S. 20.

4. Heinrich Klotz: "Dualität," in: *Hans Hollein. Museum für Moderne Kunst Frankfurt am Main*. Frankfurt 1991, S. 64.

5. Hans Hollein: "Ausstellen, Aufstellen, Abstellen. Überlegungen zur Aufgabe des Museums für Moderne Kunst," in: *Hans Hollein. Museum für Moderne Kunst Frankfurt am Main*, S. 23.

6. ebd., S. 22/23.

7. ebd., S. 16.

8. ebd., S. 22.

9. Teile der Installation werden zweimal jährlich in einem sogenannten "Szenenwechsel" verändert. Die der Theaterwelt entnommene Bezeichnung paßt zur dramatischen Qualität des Hollein-Gebäudes.

10. William H. Jordy: "The Aftermath of the Bauhaus in America: Gropius, Mies and Breuer," in: Donald Fleming, Bernard Bailyn (Hrsg.): *The Intellectual Migration: Europe and American, 1930–1960*, Cambridge, Mass. 1969, S. 488.

11. Marcel Breuer: "The Architect's Approach to the Design of the Whitney Museum," 1966, Breuer Archives, Whitney Museum of American Art.

12. Jean-Christophe Ammann: "Auf daß die Architektur die Kunst nicht bedränge und sich die Kunst nicht gegen die Architektur wehren müsse," in: *Hans Hollein. Museum für Moderne Kunst Frankfurt am Main*, S. 66.

13. Jean-Christophe Ammann: "Aus der Sicht des inneren Auges," in: Jean-Christophe Ammann und Christmut Präger: *Museum für Moderne Kunst und Sammlung Ströher*, Frankfurt, Museum für Moderne Kunst 1991, S. 17.

14. Brief an den Autor vom 14. März 1996.

15. Goethe: *Wahlverwandtschaften*, S. 393.

16. Brief an den Autor vom 14. März 1996.

17. Meine Überlegungen zur Installation basieren auf dem vorläufigen Ausstellungsplan. In der fertigen Ausstellung könnten die Werke in anderer Reihenfolge installiert sein.

10. William H. Jordy, "The Aftermath of the Bauhaus in America: Gropius, Mies and Breuer," in Donald Fleming and Bernard Bailyn, eds. *The Intellectual Migration: Europe and American, 1930–1960* (Cambridge, Massachusetts: Harvard University Press, 1969), p. 488.

11. Marcel Breuer, "The Architect's Approach to the Design of the Whitney Museum," 1966, Breuer Archives, Whitney Museum of American Art.

12. Jean-Christophe Ammann, in *Museum für Moderne Kunst*, p. 67.

13. Jean-Christophe Ammann, "From the Perspective of My Mind's Eye," in Ammann and Christmut Präger, *Museum für Moderne Kunst und Sammlung Ströher* (Frankfurt: Museum für Moderne Kunst, 1991), p. 47.

14. Letter to the author, March 14, 1996.

15. Goethe, *Elective Affinities*, p. 31.

16. Letter to the author, March 14, 1996.

17. My observations on the installation are based on the preliminary floor plan. The actual juxtapositions may differ in the final exhibition.

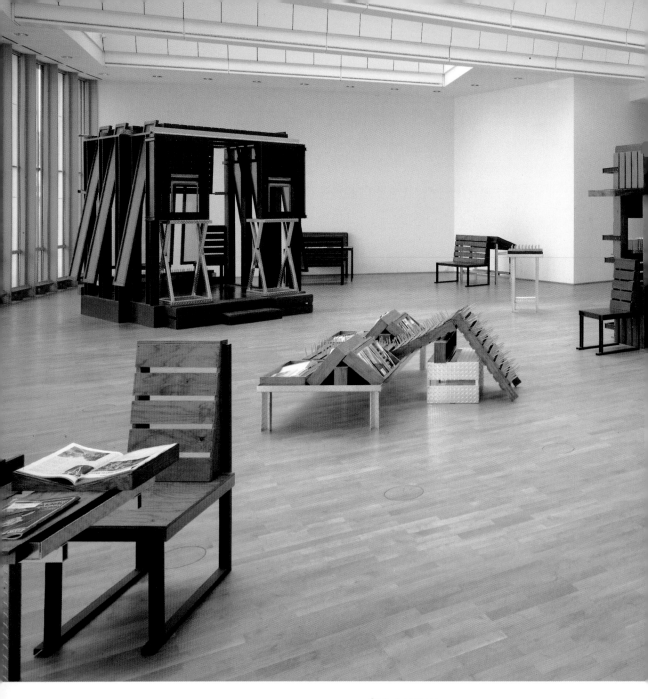

Siah Armajani
Sacco & Vanzetti Leseraum #3
(**Sacco & Vanzetti Reading Room # 3**), 1988

Ben Shahn
The Passion of Sacco & Vanzetti, 1931–32

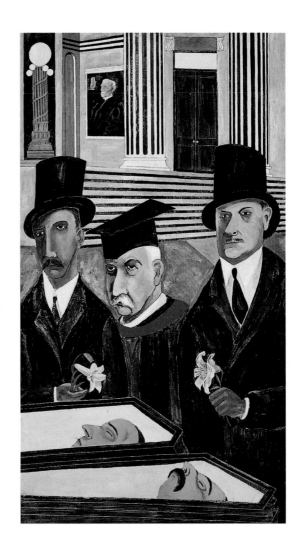

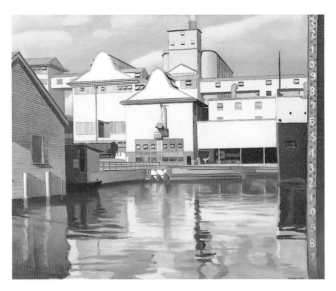

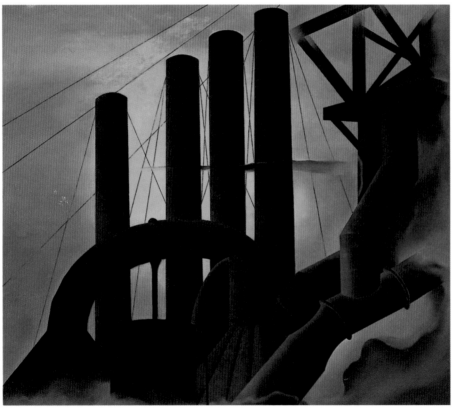

Charles Sheeler
River Rouge Plant, 1932

Elsie Driggs
Pittsburgh, 1927

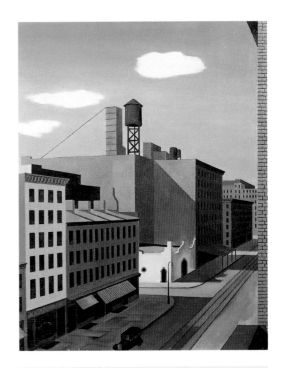

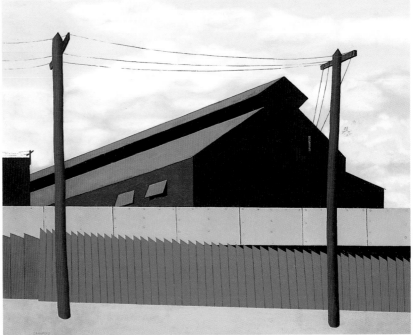

George C. Ault
Hudson Street, 1932

Ralston Crawford
Steel Foundry, Coatesville, Pa., 1936–37

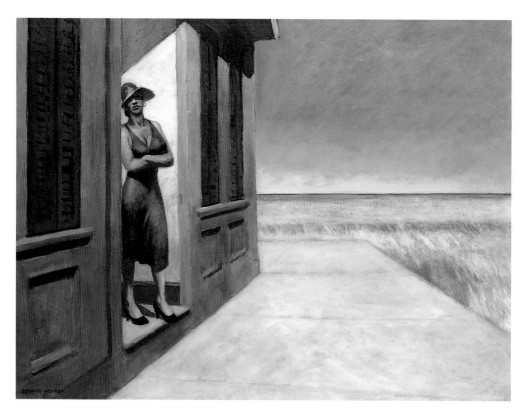

Edward Hopper
South Carolina Morning, 1955

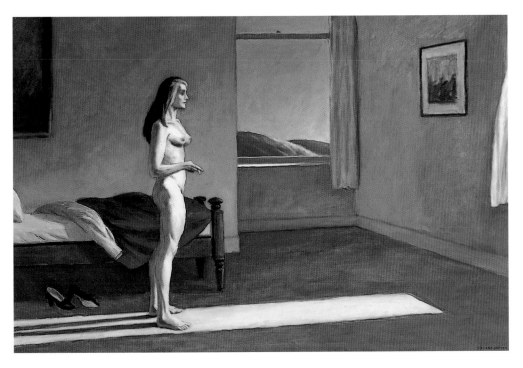

Edward Hopper

A Woman in the Sun, 1961

Reginald Marsh
Negroes on Rockaway Beach, 1934

Jeff Wall

The Storyteller, 1986

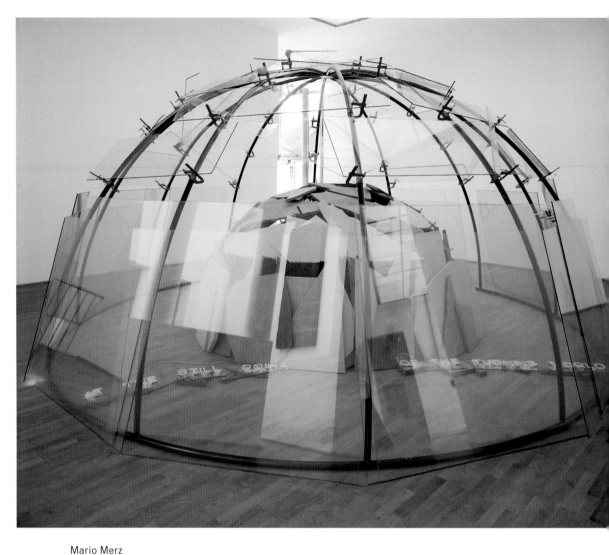

Mario Merz
**At the still point of the turning world/Spazi
immensi ninfea stellare/Die Steine sind im Jahre
1991 in Frankfurt geschnitten,** 1991

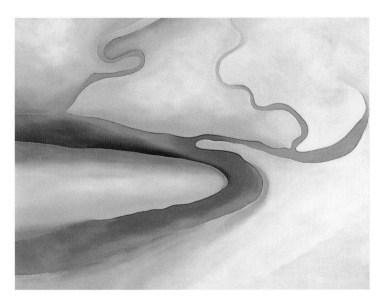

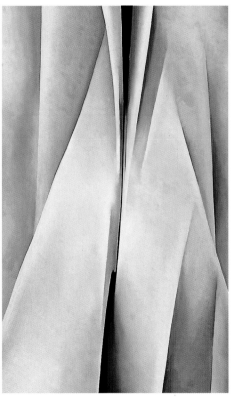

Georgia O'Keeffe
It Was Blue and Green, 1960

Georgia O'Keeffe
Abstraction, 1926

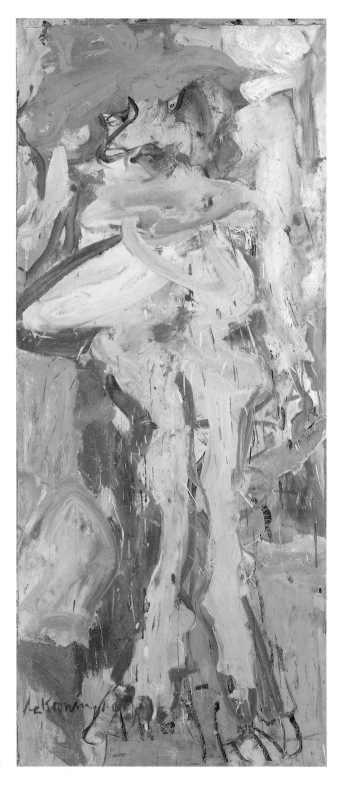

Willem de Kooning
Woman Accabonac, 1966

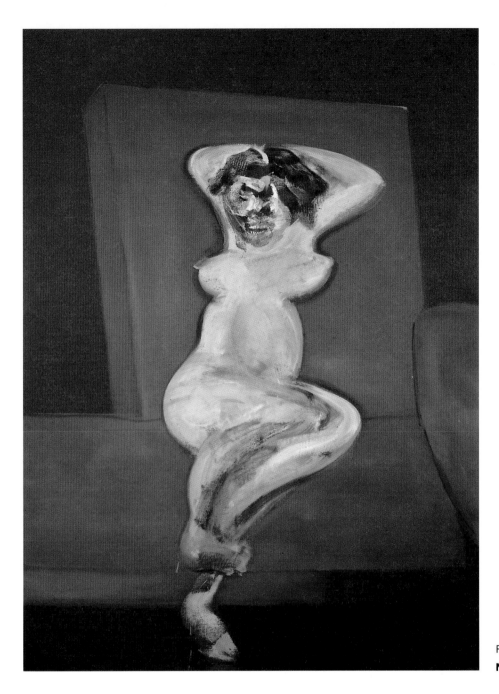

Francis Bacon
Nude, 1960

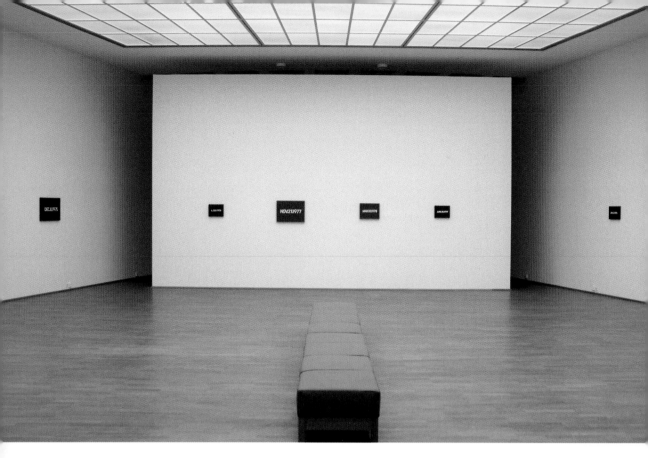

On Kawara

Date Paintings ("Today Series")

Installation view, MMK, third level

Ausstellungsraum, MMK, Ebene 3

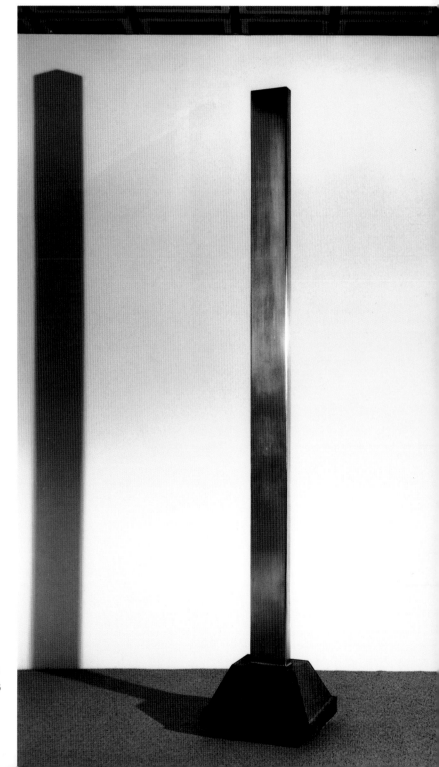

Barnett Newman
Here III, 1965–66

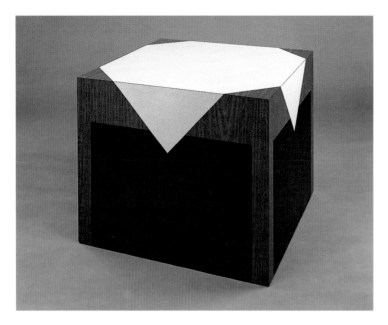

Richard Artschwager
Description of Table, 1964

Claes Oldenburg
Bedroom Ensemble, Replica I, 1969

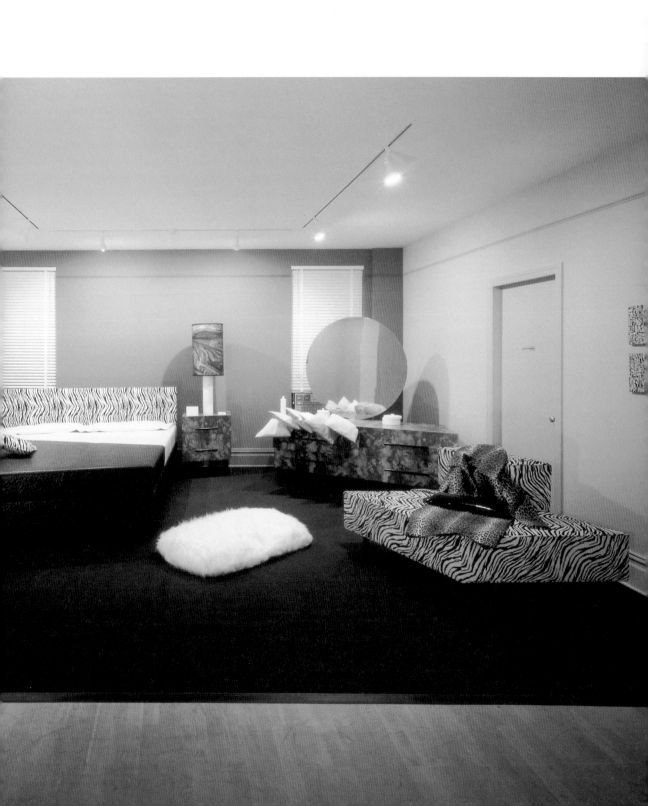

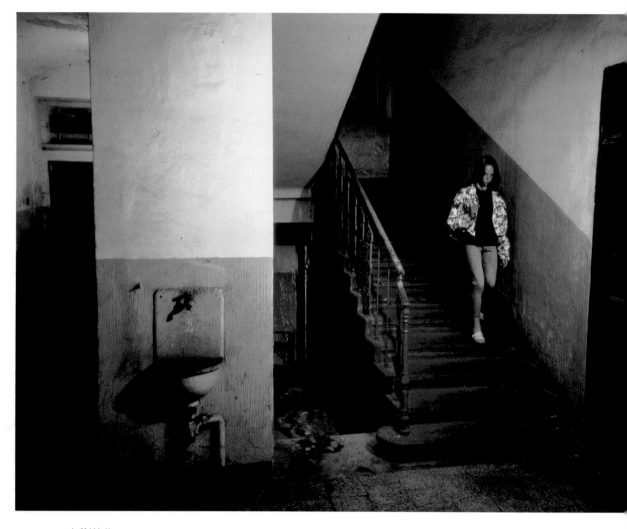

Jeff Wall
Odradek, Taboritskà 8, Prag 18. Juli 1994
(**Odradek, Taboritskà 8, Prague. July 18, 1994**), 1994

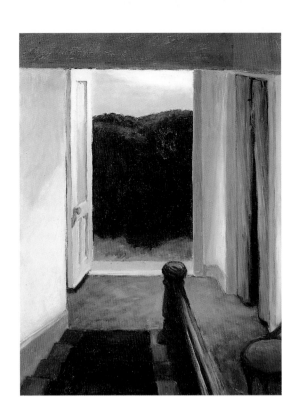

Edward Hopper
Stairway, 1949

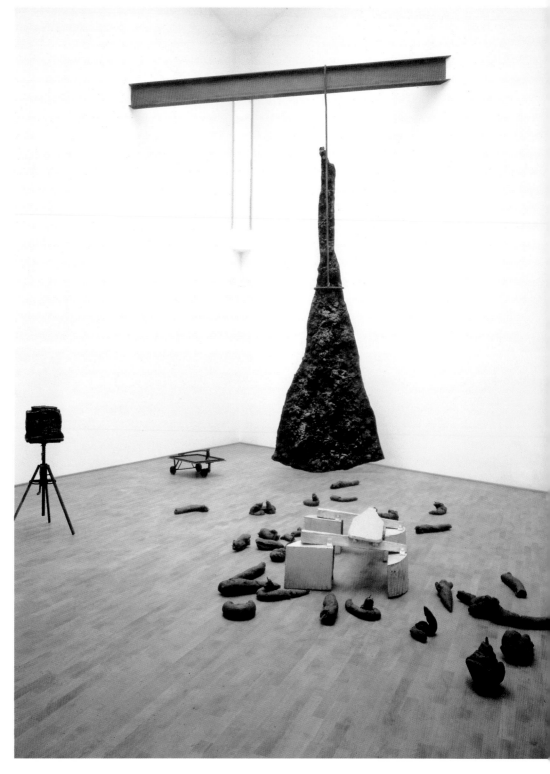

Joseph Beuys
Blitzschlag mit Lichtschein auf Hirsch
(Lightning with Stag in Its Glare), 1958–85

(AWAY FROM IT ALL)

HERE THERE & EVERYWHERE

(BENEATH IT ALL)

HERE THERE & EVERYWHERE

(ALL OVER IT ALL)

HERE THERE & EVERYWHERE

(ABOVE IT ALL)

HERE THERE & EVERYWHERE

Lawrence Weiner
Here, There & Everywhere, 1989

Alighiero e Boetti

I mille fiumi più lunghi del mondo

(**The 1000 Longest Rivers in the World**), 1976–78

Edward Ruscha

Plenty Big Hotel Room (Painting for the ...), 1985

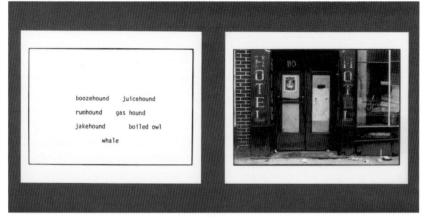

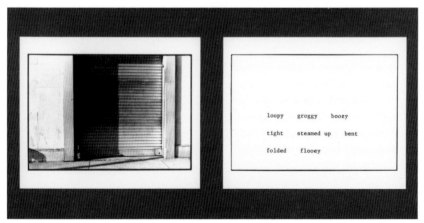

Martha Rosler
Untitled, from the series **The Bowery in Two Inadequate Descriptive Systems**, 1974–75

Heiner Blum

Spiele/Games, 1983–93

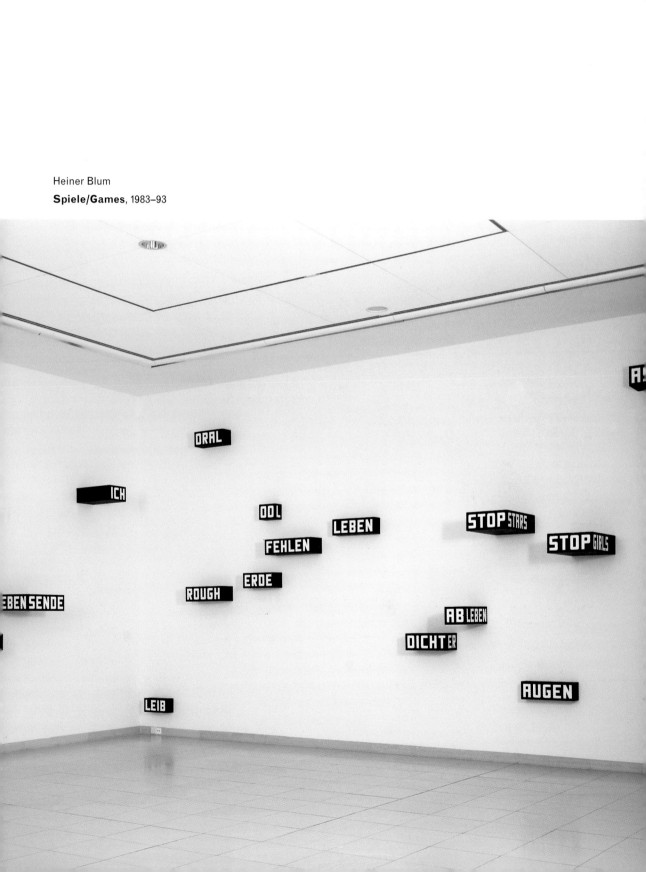

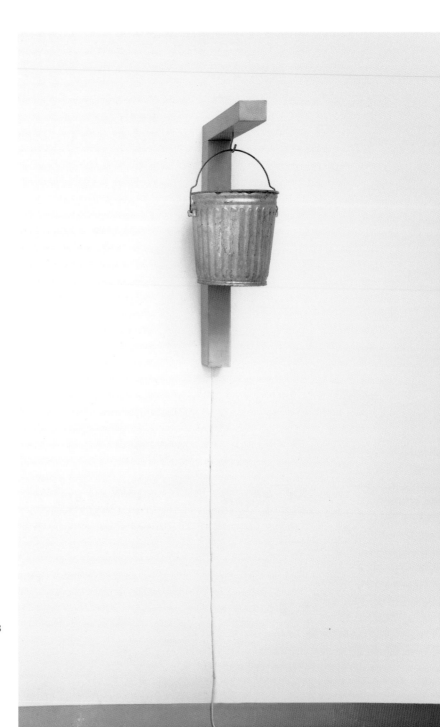

Robert Morris
Fountain, 1963

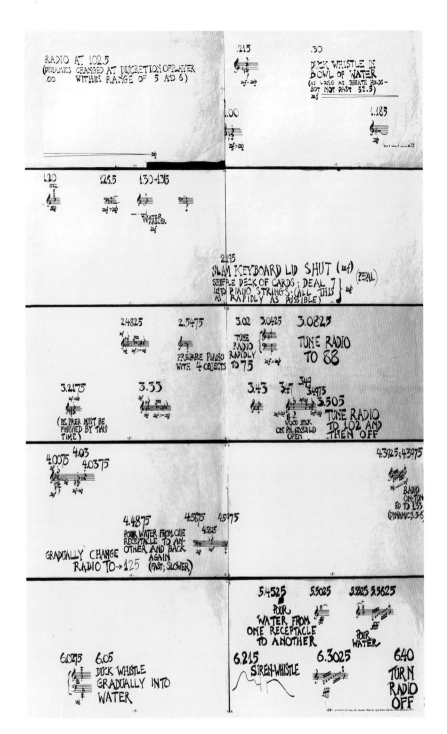

John Cage

Water Music, 1952

Alex Katz
Place, 1977

Alex Katz
The Red Smile, 1963

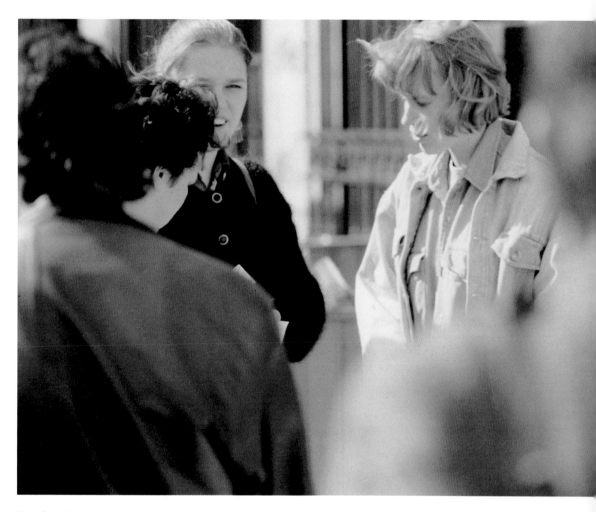

Beat Streuli
Ohne Titel
(Untitled), 1991–93

Museen im Dialog
Rolf Lauter

Museums in Dialogue
Rolf Lauter

"Views from Abroad 2" ist ein neues und in dieser Form bisher nicht realisiertes Ausstellungsmodell, das zum einen auf der intensiven Zusammenarbeit von Mitarbeitern zweier Museen aufbaut, das zum anderen durch eine Auswahl an beispielhaften Werken und Werkgruppen der modernen und zeitgenössischen Kunst sowie durch speziell auf die jeweiligen Ausstellungsorte und ihre Architektur abgestimmte Präsentationskonzepte spezifische ästhetische und inhaltliche Aspekte der Gegenwartskunst untersucht. Dabei geht es nicht — wie dies teilweise von anderen Museen versucht wurde — um die Präsentation und Vermittlung der Sammlung eines amerikanischen Museums an einem europäischen Ausstellungsort[1], wodurch etwa die Strukturen und Schwerpunkte einer historisch gewachsenen Sammlung verdeutlicht werden können, sondern vielmehr um den Versuch einer Formulierung bisher nicht gewonnener oder so noch nicht wahrgenommener Erkenntnisse über das bildnerische Denken einzelner Künstlerpersönlichkeiten der amerikanischen Kunst der Moderne und Gegenwart sowie die inneren geistigen und formal-ästhetischen Beziehungsgeflechte zwischen Künstlern verschiedener Zeiten, Länder und Kulturkreise.

"Views from Abroad 2" is based on a new exhibition model. On the one hand, it involves intensive cooperation between the staff members of two museums. On the other, it examines both specific aesthetic aspects of contemporary art as well as subject matter taken through a selection of exemplary works and through presentation concepts that have been tailored to the respective location and architecture of each institution. Unlike the approach taken by some other museums, the emphasis is not on presenting and acquainting viewers with an American art collection in a European location[1] in order to elucidate the specific structures and highlights of a collection that has been built up over the course of time. Instead, the aim here is to formulate insights — insights that were previously unknown or unperceived — into the artistic thought of outstanding artists in the American art world, both modern and contemporary, and to reveal the way the internal intellectual and creative threads linking artists of different eras, countries, and cultures are interwoven.

The curators at the Museum für Moderne Kunst (MMK) sought to ensure that both exhibitions contain exemplary individual works as well as intrinsically coherent groups

Edward Hopper
Stairway, 1949 (detail)

Die Wissenschaftler des Museums für Moderne Kunst haben sich in ihrer
Funktion als Ausstellungskuratoren zum Ziel gesetzt, exemplarische Einzelwerke
und in sich schlüssige, kohärente Werkgruppen sowohl aus der Sammlung des
Whitney Museums, als auch aus der des MMK in beiden Ausstellungen zu neuen
und in dieser Weise auch in anderen Museen nicht vorhandenen Konstellationen
zu verbinden. Unter Berücksichtigung der jeweils spezifischen Inhalte und Bedeu-
tungen eines einzelnen Kunstwerkes werden dem Betrachter durch teilweise
leicht nachvollziehbare, teilweise ungewohnte Werkgegenüberstellungen, die
sich auf verschiedenen inhaltlichen und ausdrucksbezogenen Ebenen als 'Begeg-
nungen' ereignen, eine Reihe von neuen ästhetischen Erfahrungen und inhaltlichen
Aspekten der amerikanischen Kunst deutlich gemacht. Für einen bestimmten
Zeitraum werden Teilbestände aus beiden Sammlungen zunächst in New York
und anschließend in Frankfurt zu einem 'imaginären Museum'[2] verdichtet. Die
'temporäre Struktur' des Projektes führt in vielen Fällen zu dialektischen Gegen-
überstellungen, die als thesenhafte Statements oder als ein Hinterfragen
bekannter künstlerischer Positionen erfahren werden können und die damit
den modellhaften, dialogischen Charakter des Projektes unterstreichen.

Obwohl die Ausstellung im MMK später beginnt, ist sie als inhaltlicher Ein-
stieg in das Gesamtprojekt anzusehen.[3] Das MMK integriert in diesem Zeit-
raum im Rahmen seiner bisher größten Ausstellungsaktivität seit Eröffnung
des Hauses im Jahr 1991 über 200 Werke—darunter umfangreiche 'erratische
Blöcke'—der amerikanischen Kunst der Moderne in seine Sammlung und
installiert in einer Vielzahl von Räumen erstmals zahlreiche nicht zum eigenen
Bestand gehörende Arbeiten.[4] Vor dem Hintergrund der von dem österreichi-
schen Architekten Hans Hollein entworfenen 'Erlebnisarchitektur' des Museums
für Moderne Kunst wird diese in ihrer Struktur sehr komplex angelegte Aus-
stellung zu einer inhaltlichen Herausforderung.

Werke aus dem Whitney Museum im Museum für Moderne Kunst
Aufgrund der ungewöhnlichen Situation, ausgewählte Werke aus den Beständen
des Whitney Museums temporär in die Sammlungsräume des Museums für
Moderne Kunst integrieren zu können, wurde für die Frankfurter Ausstellung
ein spezielles Konzept entwickelt. Die Auswahl bezieht sich primär auf solche
Werke und Werkgruppen, die aufgrund ihrer ästhetischen Qualität, ihrer Bedeu-
tung für das bildnerische Denken eines Künstlers, ihrer individuellen Ausdrucks-
formen, ihrer spezifischen inhaltlichen Aussage sowie aus Gründen einer
kontrastierend-dialogischen Gegenüberstellung oder auch wegen der gewünsch-
ten Ergänzung bestimmter—in der Sammlung des MMK bereits vorhandener—
Werkgruppen sinnvoll erscheint. Insofern eröffnen die in der Ausstellung zu
Räumen zusammengeführten 'Künstler- und Werkdialoge' eine Reihe von
unterschiedlichen und zum Teil neuen Wahrnehmungs- und Interpretationsan-
sätzen, die von einer formal-ästhetischen Annäherung, von motivischen
Parallelen, vergleichbaren inhaltlichen Ansätzen etwa im historischen oder

of works from the collections of the Whitney Museum and the MMK. These will be arranged in novel constellations, unlike those in any other museum. Taking into account the subject matter and meaning of each individual piece, the works will be juxtaposed so as to offer a clear view of new aesthetic and substantive approaches. The contrasts that such juxtaposition engenders will at times be easily comprehensible, at times quite unusual. Considered together, the initial exhibition at the Whitney Museum and subsequent condensed installation at the MMK form an "imaginary museum."[2] The temporary nature of the project has often produced telling groupings of work as well as dialectical juxtapositions, which can be experienced as concise statements, aesthetic challenges, or inquiries into well-known artistic positions, thus underscoring the manner in which the project is intended both as a model and a dialogue.

Although the exhibition at the MMK begins later than its sister exhibition in New York, it is in fact in Frankfurt that the subject matter of the overall project will actually be addressed.[3] During this time, the MMK will integrate more than two hundred examples of American modern art, including many "random groupings," into its galleries as part of the largest exhibition project it has launched since opening in 1991. Indeed, for the first time, the MMK will be filling some galleries with numerous works that are not part of its own collection.[4] Against the backdrop of the architecture of the MMK, designed by Austrian architect Hans Hollein and best described as "architecture to be experienced," this complex presentation of works will be a challenging event.

Works from the Whitney Museum in the Museum für Moderne Kunst

The opportunity to temporarily integrate selected works from the Whitney Museum into the MMK's galleries led to a specific exhibition concept. The works and groups of works were selected with an eye to their aesthetic quality, their significance for the creative thought of an artist, the individual forms of expression they take, and the substantive statements they make. All these criteria were taken into account when establishing juxtapositions with the MMK works that proposed either a contrasting dialogue or a supplement to existing works in the MMK collection. In this sense, these dialogues between artists and between works generate a series of different and in part new forms of perception and possible interpretations. These can involve a formal aesthetic approach, parallel motifs, comparable contents in terms of history or the sociopolitical domain, or even transhistorical juxtapositions that consider complex levels of significance.

The works are not arranged in the three MMK exhibition levels in terms of chronology, even though historical aspects have also been considered in following the "imaginary tour" of the exhibition from Level 3 to Level 1. Instead, the works from the Whitney Museum collection have been integrated throughout the levels and galleries of the MMK, according to criteria intrinsic to the works themselves and the possible dialogues that arise. Thus, many works

from the Whitney Museum occupy numerous MMK galleries that have hitherto remained unchanged, enabling the viewer to experience the Frankfurt collection in ways that clearly exceed that of normal "Szenenwechsel" ("Change of Scene") installations and to see the art works from New York in a completely new context.

American Art of the Twenties and Thirties in Siah Armajani's *Sacco and Vanzetti Reading Room*

The presentation concept for Frankfurt was based from the outset on two works: the *Sacco and Vanzetti Reading Room* created by Siah Armajani, first shown in 1988 in the Carnegie International exhibition, and part of the permanent collection on display in the MMK since it opened in 1991;[5] and the Whitney Museum's painting by Ben Shahn of 1931–32 titled *The Passion of Sacco and Vanzetti*.[6] Armajani's *Reading Room* is not only an artistically modeled spatial installation, but above all a room that can be used by the public and which prompts discourse. Here the viewer can either engage in specific individual actions (such as sitting, resting, or reading) or opt for more complex communicative forms (conversations, discussions, events). Both types of activity are provoked by the "Constructivist" shape of the architecture and furniture as well as by the literature available in several places in the room. Armajani describes the relationship between this participatory work and its context in terms of "art as a functional nexus."[7] The artist concentrates his gaze on the sore points of politics and advocates a social order based on the principle of a grass-roots democracy, in which the freedom of the individual is protected against the power of the state, and dialogue is recognized as a central component in generating a sense of community. The structure of the *Reading Room* in terms of form and content encourages visitors to engage partly in reflective, partly in communicative activities that enable them to experience the "principle of democracy" as the artist understands the term.

Placing art works created in the period during or after the Sacco and Vanzetti trial in the context of this room creates a dense atmosphere which reflects the mood and attitude in the United States in the twenties and thirties. Ben Shahn's *The Passion of Sacco and Vanzetti* dared to be critical of the trial only a few years after the death of the two labor leaders, for it strongly denounced the members of the investigation panel responsible for the miscarriage of justice as well as the judge, shown behind a window swearing to uphold justice. The picture was made directly after Shahn's second trip to Europe,[8] where he had discovered the outraged European reactions to the trial.[9]

While Armajani draws in his installation on the revolutionary formal idiom of the Constructivists, Shahn gave his picture the feel of a stylized and colored drawing charged with symbolic meaning. The dialogue between the two works, however, accentuates the importance of laws made and interpreted by people as well as the consequences of anti-democratic behavior.

gesellschaftspolitischen Bereich bis zu geschichtsübergreifenden Gegenüber-
stellungen unter Berücksichtigung komplexer Sinnschichten der einzelnen
Werke führen können.

Die Anordnung der Werke in den drei Ausstellungsebenen des Museums für
Moderne Kunst erfolgte nicht nach chronologischen Gesichtspunkten, auch
wenn bei dem folgenden 'imaginären Rundgang' durch die Ausstellung von der
Ebene 3 zur Ebene 1 historische Aspekte mitberücksichtigt wurden. Vielmehr
wurden die Bestände des Whitney Museums mit Blick auf werkimmanente
Aspekte und mögliche Dialoge mit den Beständen der Frankfurter Sammlung
auf die Ebenen und Räume des Museums verteilt. Insofern greifen viele Werke
aus dem Whitney Museum in zahlreiche bisher unangetastet gebliebene
Räume des MMK ein und ermöglichen damit eine Reihe von über den Umfang
eines 'normalen' *Szenenwechsels* hinausgehenden Erfahrungen im Umgang mit
der Frankfurter Sammlung sowie mit Blick auf die in dieser Weise noch nie
gezeigten Werke des New Yorker Museums.

Amerikanische Kunst der 20er und 30er Jahre im *Sacco und Vanzetti Leseraum* von Siah Armajani

Ausgangspunkt des Präsentationskonzeptes für Frankfurt war von Beginn an
ein Dialog zwischen dem im Jahr 1988 in der Ausstellung Carnegie Inter-
national gezeigten und seit Eröffnung des Frankfurter Museums im Jahr 1991
in die permanente Schausammlung integrierten *Sacco und Vanzetti Leseraum*
von Siah Armajani[5] und dem von Ben Shahn 1931/32 gemalten Bild *The Passion
of Sacco and Vanzetti*.[6] Armajanis *Leseraum* ist nicht allein eine künstlerisch
gestaltete Rauminstallation, sondern vor allem auch ein diskursiver, von der
Öffentlichkeit benutzbarer Raum, in dem der Betrachter entweder einfache
individuelle Handlungen (Sitzen, Ausruhen, Lesen) oder auch komplexe kommu-
nikative Handlungsformen (Unterhaltung, Diskussion, Veranstaltung) ausführen
kann. Beide Handlungsformen werden im Betrachter durch die 'konstruk-
tivistisch' gestalteten Architektur- und Möbelelemente sowie die an mehreren
Stellen des Raumes zum Lesen angebotene Literatur provoziert. Armajani
umschreibt mit seiner partizipatorischen Arbeit folglich das Verhältnis von
Kunstwerk und Kontext im Sinne einer "Kunst als Funktionsgeflecht."[7] Indem
Armajani in metaphorischer Weise die Verurteilung der beiden Arbeiterführer
Nicola Sacco und Bartolomeo Vanzetti zum Tod im Jahr 1927 interpretiert,
konzentriert er seinen Blick auf die wunden Punkte der Politik und plädiert für
eine auf den Prinzipien der Basisdemokratie aufbauende Gesellschaftsordnung,
in der die Freiheit des Individuums gegenüber der Macht und Gewalt des
Staates geschützt und das Gespräch, der Dialog als zentrales Moment einer
gemeinschaftsstiftenden Qualität erkannt wird. Die formale und inhaltliche
Struktur des *Leseraumes* animiert den Besucher teils zu reflexiven, teils zu
kommunikativen Handlungsformen, die das 'Prinzip Demokratie', wie es der
Künstler versteht, tatsächlich erleben lassen.

Im Kontext dieses Raumes sollen Werke, die in der Zeit während oder nach dem Prozeß gegen Sacco und Vanzetti geschaffen wurden, eine Atmosphäre verdichten, die die Stimmung und Geisteshaltung im Amerika der zwanziger und dreißiger Jahre widerspiegelt. Ben Shahns Bild *The Passion of Sacco and Vanzetti* wagt mehr als zehn Jahre nach dem Tod der beiden Arbeiterführer ein kritisches Statement, indem es die für den Justizirrtum verantwortlichen Mitglieder eines Prüfungsausschusses und den hinter einem Fenster im Hintergrund den Schwur auf die Gerechtigkeit leistenden Richter in eklatanter Weise anprangert. Das Bild entstand unmittelbar nach Shahns zweiter Europareise[8], bei der er die Reaktionen vieler Menschen auf den Prozeß und den Justizskandal kennengelernt hatte.[9] Während Armajani sich bei seiner Installation der revolutionären Formensprache der Konstruktivisten bediente, gestaltete Shahn sein Bild als eine stilisierte und kolorierte, stark symbolhaltige Zeichnung, die fast an politische Plakate erinnert. Durch den Dialog der beiden Werke werden die Bedeutung der vom Menschen geschaffenen und interpretierten Gesetze sowie die Konsequenzen einer antidemokratischen Haltung spannungsvoll bewußt gemacht.

Neben Shahns Bild richten in Armajanis *Leseraum* eine Werkgruppe von Edward Hopper, Bilder von George Ault, Ralston Crawford, Charles Demuth, Elsie Driggs oder Charles Sheeler den Blick des Betrachters auf Ausschnitte aus der Alltagsrealität der Amerikaner in den späten zwanziger und frühen dreißiger Jahren, auf die private Lebenswelt und die von neuen Techniken, Maschinen, Industrie und Architektur geprägte städtische Umwelt sowie die hinter diesen liegenden Stimmungen, ästhetischen Qualitäten, sozialen Ängste und politischen Gefahren. Die Kunst manifestiert sich teilweise als Spiegelbild des amerikanischen Aufbruchs in das Maschinenzeitalter, teilweise als moralische Instanz einer von Depression und sozialen Ungerechtigkeiten geprägten Realität.

Charles Sheeler konzentrierte sich auf eine klare, präzise, sachliche Darstellung von Architekturen, die tendenziell einen gewissen Abstraktionsgrad erreichen. In *River Rouge Plant* von 1932 diente ihm die Industriearchitektur der Ford Motorenwerke bei Detroit als Vorlage, um das Stimmungsbild einer technoiden Architekturlandschaft wiederzugeben, die in gewisser Weise stellvertretend für die wirtschaftliche Macht und Produktivität Amerikas steht.[10]

Das eindrucksvolle grau-in-grau gemalte Bild *Pittsburgh* (1927) von Elsie Driggs gehört stilistisch und inhaltlich in die Nähe der Arbeiten Sheelers. Driggs fokusiert unseren Blick auf einen Ausschnitt aus einem Hochofen einer Stahlfabrik in Pittsburgh. Die Komposition aus Schornsteinen, Rohren, Seilen und Stahlkonstruktionen verbindet sich mit dem graugefärbten Rauch zu einem Bild industrieller Präsenz in unserer Gesellschaft. Eine ähnliche Dominanz geht heute etwa von den Atommeilern aus, die unsere Landschaften und unser kollektives Gedächtnis prägen. Die sich zwischen Bewunderung und distanzierter Beobachtung bewegende Haltung von Driggs verweist auf den Techno-

Also on exhibition in Armajani's *Reading Room* are works by Edward Hopper, George Ault, Ralston Crawford, Charles Demuth, Elsie Driggs, and Charles Sheeler, which direct the viewer's gaze to segments of everyday life in the United States in the late twenties and early thirties, as well as to the inner emotional world and the urban environment, as influenced by new technologies, machines, industry, and architecture, and to the mood, aesthetics, social fears, and political risks underlying these developments. Art manifests itself here in part as a reflection of the US entry into the machine age and in part as a moral platform developed in response to the Great Depression and social injustices.

Charles Sheeler devised a formally simplified, "purist" means of expression, which reproduced the painted motif in a stylized, concrete manner. In *River Rouge Plant*, dating from 1932, he took the industrial architecture of the Ford automobile factory in Detroit as his model, in order to present a technoid architectural landscape which, to a certain extent, represented the United States' economic muscle and productivity.[10]

Elsie Driggs' impressive gray-in-gray picture *Pittsburgh* (1927) is related to Sheeler's oeuvre in terms of style and content. Driggs focuses our attention on a section from a blast furnace in a steel factory in Pittsburgh. The composition of chimneys, pipes, ropes, and steel structures combines with the gray hues of the smoke to forge a picture of the presence of industry in our society. Today, nuclear reactors dominate the landscape and our collective memories in a similar way. Concerning the American belief in technological progress, Driggs takes a position somewhere between admiration and disassociated observation. Her technological "still life" sears itself into our memory.

In *Steel Foundry, Coatesville, Pa.*, created in 1936–37, Ralston Crawford offers a supremely poignant description of a magically abstract industrial landscape; the clear, precise formal idiom emphasizes less the function and more the form and shape of the industrial buildings painted. Like Driggs, he selects a motif from the context of a steel factory, but steers us toward the clarity and beauty of the functional architecture. With his reductionist style, the factory is raised to the status of an architectural monument, developing before our eyes by means of a simple, poetic narrative into an intense icon.

George C. Ault's cityscapes and architectural vistas, painted in a simplified, summary idiom, such as his 1932 *Hudson Street*, stem from a similar stylistic approach. Here, the reality of the streets of a metropolis, in this case New York, is presented through a striking and to a certain extent positivistic style of painting building facades, the ever-present rooftop water tanks; the pictorial vocabulary is industrial, functionalist.

One of Edward Hopper's artistic goals was to convey life in small-town America and to paraphrase existential moods by means of metaphoric situations. In his pictures of the twenties and thirties, he primarily chose themes from daily life and imbued them with psychological details: with the solitude of

people, the emptiness of rooms or houses, the bleak mood of individuals or the longings of the lonely in anonymous, impersonal rooms and surroundings. Painted in strong colors and dramatic chiaroscuro, the people and rooms always exude a restrained, contemplative air.

Art and Social Reality: Jeff Wall and Reginald Marsh

Close to Armajani's *Sacco and Vanzetti Reading Room* hangs the large backlit Cibachrome *The Storyteller* made by Jeff Wall in 1986.[11] By means of condensed narrative and metaphorical situations, Wall's works present marginal life situations, the harshness of everyday reality, and the socio-political injustices people face. The large slide is shot from a somewhat raised angle, which gives the composition a central vanishing point. We can make out terrain at the edge of a city (Vancouver)—a destroyed, run-down place, where no one lives. The right half of the picture is defined by the concrete siding of an overpass running diagonally toward the center, while a section of woods runs from left to center. Two groups of people are sitting on dirty, sandy soil: on the left, a trio consisting of a cowering woman —speaking, the "storyteller" —and two seated men listening to her; somewhat higher up, there is a man reclining and a woman sitting. Another man crouches on the extreme right under the overpass. All the people are Native Canadians.

The easygoing, leisurely poise of the figures blatantly contradicts the decidedly non-idyllic nature that surrounds them. The Cibachrome reminds one of the pastoral landscapes of Titian or Giorgione, but transforms their natural idylls into a landscape changed and destroyed by civilization. In Wall's work, the Indians, once inseparably part of Canada's nature, are shown as "alien" beings marginalized by society, the foundation of their social and cultural existence destroyed. As models for his figures, Wall uses motifs from famous paintings by Georges Seurat and Edouard Manet, in order to highlight the discrepancy between the once intact referential unity of "person and nature" and their present disjunction.

Where Wall addresses one specific group of people in Canadian society, Reginald Marsh deploys a specific form of realism to depict the life of people on the beach at Coney Island.[12] In *Negroes on Rockaway Beach*, made in 1934, almost the entire surface is defined by the gleaming bodies of black men and women, who form a disorderly crowd on a sandy beach. The apparently cheerful behavior of the crowd is portrayed in such a way as to discredit the corporeality and conduct of the figures. Through a critical dialectic, Marsh exposes the negative opinion of blacks held by whites at the time. Here, he makes himself the devil's advocate in order to sharpen the viewer's critical awareness of injustice and oppression.

logieglauben Amerikas und gräbt sich als ein bleibendes technologisches 'Stilleben' in uns ein.

Ralston Crawford schuf mit seinem Bild *Steel Foundry, Coatesville, Pa.*, von 1936/37 die einprägsame Fassung einer magisch-abstrahierten Industriearchitektur, deren klare Formensprache weniger die Funktion, als vielmehr die Form und Gestalt des gemalten industriellen Gebäudes hervorhebt. Wie Driggs wählte er hier ein Motiv aus dem Kontext einer Stahlfabrik aus, lenkt unseren Blick dabei jedoch weniger auf den technisch-funktionalen Bereich, als vielmehr auf die Klarheit und Schönheit dieser funktionalen Architektur, die durch die Vereinfachung der Motive zu einem architektonischen Monument erhöht wird.

Aus dem gleichen stilistischen Umfeld stammen die in einer summarischen Formensprache gemalten Stadt- und Architekturansichten George Aults, wie etwa das Bild *Hudson Street* von 1932. Hier wird die Realität der Straßen einer Großstadt, in diesem Fall New Yorks, anhand von Architekturfassaden, der immer wieder auftauchenden Löschwasserbehälter auf den Häusern sowie der funktionalistischen Formensprache der Industriegebäude in einer markanten und in gewisser Weise positivistischen Malerei vor Augen geführt.

Eines der bildnerischen Ziele von Edward Hopper bestand dagegen in der Vermittlung des biederen Lebens im kleinstädtischen Amerika und in der poetischen Umschreibung existentieller Stimmungen durch metaphorische Situationen. In seinen Bildern der zwanziger und dreißiger Jahre wählte er meist Themen aus der alltäglichen Lebenswelt des Menschen aus, die besondere psychologische Momente sichtbar machen: Die Einsamkeit von Menschen, die Leere von Räumen oder Häusern, die Schwermütigkeit von Individuen oder die Sehnsüchte einsamer Menschen in meist anonymen, unpersönlichen Räumen und Umgebungen. Stets strahlen die mit kräftigen Farben und dramatischen Hell-Dunkel-Kontrasten gemalten Menschen und Räume dabei eine verhaltene, kontemplative Stimmung aus.

Kunst und soziale Realität: Jeff Wall und Reginald Marsh

In unmittelbarer Nähe von Armajanis *Sacco und Vanzetti Leseraum* hängt das großformatige, hinterleuchtete Cibachrome *The Storyteller*[11] von Jeff Wall aus dem Jahr 1986. Walls Arbeiten setzen meist Grenzsituationen und Härten des Alltags sowie sozialpolitische Ungerechtigkeiten gegenüber Menschen oder Menschengruppen mit Hilfe von erzählerisch-konzentrierten, metaphorischen Situationen in Szene. Das Großdia ist von einem etwas erhöhten Standpunkt aus in der Weise aufgenommen, daß sich eine zentralperspektivische Komposition ergibt. Man erkennt ein Gelände am Rand einer Stadt—es handelt sich um Vancouver—einen Ort verwilderter Natur, wo keine Menschen leben. Die rechte Bildhälfte wird von einem diagonal zur Bildmitte verlaufenden Betonunterbau einer Autobahn bestimmt, während sich von links zum Zentrum hin ein Waldrand erstreckt. Auf schmutzigem Erdboden sitzen zwei Personen-

gruppen: Links unten eine Dreiergruppe, bestehend aus einer im Sprechen begriffenen, kauernden Frau, der "Erzählerin" und zwei sitzenden Männern, die ihr zuhören, etwas oberhalb davon ein liegender Mann und eine sitzende Frau. Ganz rechts unter der Autobahn hockt einsam ein Mann. Alle Personen sind Indianer, Ureinwohner Kanadas.

Die lockere Freizeithaltung der Personen steht in krassem Widerspruch zu der gar nicht idyllischen Natur, die sie umgibt. Die Indianer, einst in einer untrennbaren Einheit mit der Natur Kanadas verbunden, werden hier als von der Gesellschaft ausgegrenzte, 'fremde' Wesen gezeigt, deren soziale und kulturelle Existenzgrundlage zerstört wurde. Als Vorbilder für seine Figurengruppen zitierte Wall Motive aus berühmten Gemälden von Georges Seurat und Eduard Manet, um die Diskrepanz zwischen der einst intakten Beziehungseinheit Mensch — Natur und der heute herrschenden Beziehungslosigkeit zu verstärken.

Spricht Wall in seiner Arbeit die politische Unterdrückung und Ausgrenzung einer Menschengruppe der kanadischen Gesellschaft an, so umschreibt Reginald Marsh mit einem sehr spezifischen Realismus drastisch und direkt das Leben der Menschen am Strand von Coney Island.[12] In seinem Bild *Negroes on Rockaway Beach* von 1934 wird fast die gesamte Bildfläche von glänzenden, fleischigen Leibern farbiger Männer und Frauen bestimmt, die sich in einem dichten, ungeordneten Gedränge am Sandstrand räkeln. Die Schilderung des scheinbar fröhlichen Treibens dient tatsächlich dazu, die Farbigen in ihrer Körperlichkeit und ihrem Verhalten zu diskreditieren. Marsh zeigt in einer kritisch-dialektischen Zuspitzung die damals von den Weißen getragene Meinung über die Farbigen. Er macht sich zum 'advocatus diaboli', um beim Betrachter eine kritische Haltung, ein Bewußtsein für die Ungerechtigkeiten und Unfreiheiten in Gedanken, Worten und Taten zu schärfen.

Strukturen der Welt oder Natur und Kunst im Dialog: Bilder von Georgia O'Keeffe und Arthur Dove im Raum von Mario Merz

Zur Eröffnungsausstellung des Museums im Jahr 1991 hat der italienische Arte Povera — Künstler Mario Merz für einen Raum auf der Ebene 3 sein Doppel-Iglu mit dem Titel *At the still point of the turning world/Spazi immensi ninfea stellare/Die Steine sind im Jahre 1991 in Frankfurt geschnitten* konzipiert und selbst installiert. Ausgangspunkt der Arbeit ist der Mittelpunkt des quadratischen Raumes. Um diesen ist eine kleinere, aus geschnittenen und gebrochenen Sandsteinplatten zu einem Steiniglu gebaute innere Halbkugel installiert, die von einem größeren, aus verschieden zugeschnittenen Glasplatten zu einer fragilen Hülle zusammengesetzten transparenten Iglu ummantelt wird. Innerhalb des Glasiglus verläuft — den inneren Steiniglu tangential berührend — ein in hellblauer Neonschrift ausgeführter Satz aus T.S. Eliots *Vier Quartetten* (1935), der auch gleichzeitig den ersten Teil des Werktitels bildet.

Konkretisiert sich in dem inneren Iglu durch das aus der Erde kommende Material im Bewußtsein des Betrachters einerseits eine Vorstellung von dem

Structures of the World — or Nature and Art in Dialogue: Pictures by Georgia O'Keeffe and Arthur Dove in the Mario Merz Room

For the MMK's opening exhibition in 1991, Mario Merz, an Italian member of the Arte Povera movement, conceived his double igloo with the title *At the still point of the turning world / Spazi immensi ninfea stellare / Die Steine sind im Jahre 1991 in Frankfurt geschnitten* for a room on Level 3 and installed it personally. The work takes as its starting point the center of the square room. Around it, a smaller inner hemisphere of cut and broken sandstone slabs is erected like a stone igloo; it is enveloped by a larger, fragile, transparent igloo, made of differently sized plates of glass. A sentence runs right round the inside of the glass igloo, written in bright blue neon and taken from T.S. Eliot's *Four Quartets* (1935–42)—the line also forms the first part of the title.

The igloo is a prototype dwelling Merz repeatedly uses and it is also the symbol of a spiral shape opening tip downward, which can be seen as a model of the dynamic principle underlying the laws of nature.[13] Where the inner igloo, composed of material drawn from the earth, gives the viewer a concrete idea of the planet Earth and a connection to the site in Frankfurt,[14] the outer glass igloo conjures up the cosmos, the world, simply by virtue of transparency and the visual experience of a fluent, endless space extending inward and outward. The clamps fastened on the steel construction are fixed points in the universe, the blobs of clay used in some places refer to traces of life somewhere in the universe. Despite the knowledge of the heliocentric structure of our galaxy, we still see ourselves as the center of the world, still always perceive visible reality as a concentric occurrence around us. In this sense, viewers imagine themselves in the center of the inner igloo and simultaneously in the middle of space, around which the world revolves and changes. This idea is alluded to by the neon text that flows between the igloos.

In the context of Merz' intense spatial installation, which suggests issues of the cosmos and its laws, the paintings of Georgia O'Keeffe and Arthur Dove sensitively explore the internal relationship of people to nature and the meaning of the structural laws of nature. An early group of O'Keeffe drawings includes the charcoal *Drawing No. 8* of 1915. It reveals many elements also of significance for the work of Mario Merz. In her early works, O'Keeffe developed a principle of visual concentration and approximation of natural motifs as a basis for a specific detail-rich structure. Rendered in dark hues, the drawings pull the viewer in like a magnet to the interior of an organic, tubelike form that spirals into the depths. The motif of the spiral is to be found in nature in many plants and trees, as well as in clouds and smoke formations. The spiral shape creates a movement toward the middle of the drawing into an imaginary depth that suggests the origin of life, growth, and natural evolution.[15] The innermost organic forms unleash associations with birth and femininity. The juxtaposition of the O'Keeffe drawing with the igloos of Merz signals a shared cosmic content based on structural laws that revolve around the origin of the world and its mythical source.

Like O'Keeffe, Arthur Dove was interested in the forms, colors, and motifs of nature. As early as 1910, in the works he termed *extractions*, he opted for purely abstract pictures, using a formal vocabulary of swelling curves, angular lines, rays, and dark contour lines. As we can see in *Plant Forms* (1915), Dove wanted to describe not the objective essence of a form, but the influence on it of different light conditions or moods.

Painting and Figure: Willem de Kooning and Francis Bacon

The female figure was one of the main themes in Willem de Kooning's oeuvre from the 1930s on, and the artist explored both formal and psychological issues. One of his central artistic themes is space: the motif and its surroundings always enter into an intense formal relationship—they are parts of a whole or mutually determine each other. The outlines of de Kooning's figures are open, usually fluid, bereft of anatomical significance. The search for a figure in his pictures is the search for that figure's artistic identity. *Woman Accabonac*, painted in 1966, shows a pink, flesh-colored, life-size female. All the forms—above all the breasts and extremities—are spread out over the surface and contoured with red. The tan surroundings blend with the figure to form a painted surface that highlights the painterly character of the composition more than the figure's bodily or erotic aspects. This emphasis also shifts the figure closer to the viewer as the pink, juxtaposed to the yellow, starts to vibrate and pulsate.

For de Kooning, painting is the focus of artistic interest, whereas Francis Bacon formulated an artistic idiom clearly aimed at the human existential situation. The objects and figures in his works are determined by dynamic brushstrokes, but are always outlined with clear contours.[16] Bacon concentrates on a person's emotions, fears, or moods as evinced by bodily expression. His expressive way of painting therefore focuses not on a picture but on a figure.

Nude (1960) is one of the few images of a female in Bacon's entire oeuvre. We see a female figure turned towards us, naked and seated on a large brown chair, her arms behind her head. Although, at first glance, Bacon's figure is comparable to de Kooning's female nude, a more careful examination reveals that the woman (also painted in luminous pink), with her provocative position, erotic, soft, rounded body and pointedly emphasized breast immediately engages the viewer in an emotional dialogue that is hard to escape. Her entire body exudes a strong sensuality, to which the rest of the painting surface is subordinate. The blurred, indeed distorted, physiognomy, with aggressively open mouth and bared teeth, inevitably triggers feelings of fear and transforms the erotic female aura into a direct and existential threat to the male gender.

Planeten Erde und eine Verbindung zu dem Standort Frankfurt[13], so versinn-
bildlicht der äußere Glasiglu allein schon durch seine Transparenz und durch
die visuelle Erfahrung eines nach innen und außen fließenden, unendlichen
Raumes die Vorstellung von Kosmos, von Welt. Der Iglu ist ein von Merz immer
wieder verwendeter Prototyp einer Behausung und gleichzeitig das Symbol
einer sich von der Spitze nach unten öffnenden Spiralform.[14] Die an der Eisen-
konstruktion befestigten Schraubzwingen sind Fixpunkte im Universum, die an
einigen Stellen auftauchenden Lehmklumpen verweisen — so Mario Merz —
auf Spuren des Lebens irgendwo im All. Der Mensch sieht sich aufgrund seiner
Denkstrukturen auch heute noch — trotz der Erkenntnis des heliozentrischen
Weltbildes in unserer Galaxis — selbst als Mittelpunkt der Erde, nimmt die sicht-
bare Wirklichkeit stets als ein konzentrisches Geschehen um sich herum wahr.
Insofern denkt sich der Betrachter in das Zentrum des inneren Iglus und
gleichzeitig in den Raummittelpunkt, um den herum sich die Welt dreht und
verändert. Auf diese Vorstellung und den steten Fluß der Zeit verweist auch
der Neontext zwischen den Iglus.

Im Kontext dieser intensiven Fragen der Welt und ihrer Gesetze thema-
tisierenden Rauminstallation, behandeln die Bilder von Georgia O'Keeffe und
Arthur Dove sehr sensibel Fragen der inneren Beziehungen von Mensch und
Natur oder der Bedeutung von strukturalen Gesetzmäßigkeiten der Natur für
den Menschen. Georgia O'Keeffe entwickelte eine von der Natur abgeleitete
Formensprache, die als Äquivalent ihrer Gefühlsregungen anzusehen ist. Sie
wollte keine Abstraktionen nach der Natur, sondern Symbole ihrer Zeugungs-
kraft, ihrer Gesetzmäßigkeiten und ihrer Sinnlichkeit schaffen. Mit ihren Bildern
und Zeichnungen formulierte sie eine Welt, in der natürliche — organoide oder
geometrische — Formen in einem lyrischen Gefühl Ausdruck fanden und zu
Trägern poetischer Phantasie wurden. Zu einer frühen Werkgruppe von Zeich-
nungen gehört die Kohlezeichnung mit dem Titel *Drawing No. 8* von 1915. In ihr
manifestieren sich viele Momente, die auch für das Werk von Mario Merz von
Bedeutung sind. O'Keeffe entwickelte bereits hier ein Prinzip der visuellen
Konzentration und Annäherung an pflanzliche oder andere aus der Natur stam-
mende Motive, um ihren Detailreichtum und ihre spezifische Struktur zu ergrün-
den. Die sehr dunkel gehaltene Zeichnung baut auf einer starken Sogwirkung
auf, hervorgerufen durch den Blick in das Innere einer spiralförmig in die Tiefe
verlaufenden organoiden Röhrenform. Das Spiralenmotiv läßt sich in der Natur
bei vielen Pflanzen und Bäumen aber auch bei Wolken- und Rauchformationen
immer wieder finden. Aufgrund der Spiralform entsteht eine virtuelle Bewe-
gung zur Mitte der Zeichnung hin und in eine imaginäre körperliche Tiefe, die
gleichbedeutend mit dem Ort der Entstehung von Leben, Wachstum und natür-
lichem Werden ist.[15] Die innersten organischen Formen setzen im Betrachter
Assoziationen an Geburt und Weiblichkeit frei. Verbindet man das Motiv der
Zeichnung motivisch und inhaltlich mit den Iglus von Merz, so konkretisiert sich
ein Bedeutungsgehalt, der auf kosmischen, universalen Inhalten basiert, auf

strukturalen Gesetzmäßigkeiten, die um die Entstehung der Welt und ihren mythischen Ursprung kreisen.

Arthur Dove war wie O'Keeffe an den Formen, Farben und Motiven der Natur interessiert. Bereits 1910 formulierte er in seinen *extractions* genannten Werken rein abstrakte Bilder, deren Formenvokabular aus schwellenden Kurven, kantigen Linien, strahlenartig angeordneten Formen sowie dunklen Konturlinien bestand. Nicht das objektive Sein einer Form oder eines Dings, sondern ihre — von den unterschiedlichsten Lichtverhältnissen oder einer atmosphärischen Stimmung beeinflußten — Erscheinungsweisen werden in farbigen Kompositionen, wie in dem Bild *Plant Forms* von 1915, geschildert.

Malerei und Figur: Willem de Kooning und Francis Bacon

Als ein Hauptthema zieht sich durch das Gesamtwerk von Willem de Kooning seit den späten dreißiger Jahren das Thema der weiblichen Figur, wobei ihn unterschiedliche formale, aber auch psychologische Fragen interessierten. Eines seiner bildnerischen Themen ist der Raum. Motiv und Umraum gehen stets eine intensive formale Beziehung ein, sind Teil eines Ganzen oder bedingen sich gegenseitig. Die Umrisse seiner Figuren sind offen, meist fließend, ohne anatomische Relevanz. Die Suche nach der Figur in seinen Bildern ist die Suche nach ihrer malerischen Identität. *Woman Accabonac* von 1966 zeigt eine in leuchtendem Rosa gemalte, lebensgroße Frauenfigur. Alle Körperformen — so vor allem die Brust und die Extremitäten — sind in die Fläche gebreitet und mit roter Farbe konturiert. Die gelbbraune Farbe des Umraumes verschmilzt mit der Figur zu einer Flächenmalerei, die weniger das Körperliche, Fleischliche oder Erotische, sondern vielmehr das Malerische in den Vordergrund der Komposition stellt. Sie rückt die Figur gleichzeitig aber auch in die Nähe des Betrachters, indem das Rosa gegenüber dem Gelb in eine vibrierende, pulsierende Bewegung gerät.

Steht für de Kooning die Malerei im Vordergrund des bildnerischen Interesses, so formulierte Francis Bacon mit seinen Arbeiten eine deutlich auf die existentielle Situation des Menschen ausgerichtete bildnerische Sprache. Die Gegenstände und Figuren in seinen Bildern[16] sind von einer dynamischen Pinselführung bestimmt, werden aber stets mit klaren Konturen zusammengefaßt. Bacon geht es um die bildnerische Konzentration von Gefühlen, Emotionen, Ängsten oder Stimmungen eines Menschen im Körperausdruck. Seine expressive Malweise fließt somit nicht in ein Bild, sondern in eine Figur hinein.

Das Bild *Nude* von 1960, das eine der wenigen Frauenfiguren in seinem Werk darstellt, zeigt eine dem Betrachter zugewandte, nackte und auf einem großen braunen Sessel sitzende Frauenfigur, die ihre Arme hinter dem Kopf verschränkt hat. Ist Bacons Figur auf den ersten Blick mit de Koonings Frauenakt vergleichbar, so fällt bei genauerer Betrachtung auf, daß die ebenfalls in leuchtendem Rosa gemalte Frau durch ihre provozierende Position, ihren fülligen, weich gerundeten Körper und ihre pointiert hervorgehobene Brust

Existence and Presence: Barnett Newman's Sculpture *Here III* and
On Kawara's *Date Paintings*

The Japanese artist On Kawara has lived in New York since 1965. On January 4, 1966, he produced his first Date Painting. At the time of the MMK's 1991 opening, he installed a room in which he incorporated one picture from the *TODAY* series of Date Paintings for each year that had passed since 1966. The unframed monochrome canvases bear the date of the day they were painted, each date being painted by hand in white. Each picture comes complete with a specially produced file box, into which newspaper clippings from the day in question are pasted. In addition, the artist compiles a diary containing information about his life and studio pertaining to the paintings as well as about world politics on the days in question. The theme of Kawara's room is elements of existence and human presence. A date is the lowest common denominator and apparently "objective" proof for the existence of a person.[17] It is simultaneously the shortest formula for the presence of a day, under which all subjective and collective moments of our experience of reality can be subsumed. The Kawara room requires the viewer to stand, sit, or move in a circle in the middle of the room. Around the viewer, a field of dialogue arises that sparks a variety of insights into the meaning of life, the question of existence, and the necessity of thought as opposed to action.

Kawara's room blends with Barnett Newman's narrow, angular stele of polished steel entitled *Here III* (1965) to create a contemplative and almost meditative whole. The metal rod, at first hardly perceptible, serves in this context as the center of energy and as the mirror of the reality of the surrounding room. The work functions as a proxy, as it were, for the imaginary viewer, in that it symbolically describes the dialogic interplay with the exhibition room. Given its precise form, the stele is a concrete spatial fact, to be thought of on the same epistemological plane as concrete written information in Kawara's installation. Precise spatial presence and the natural laws of the horizontal and vertical in Newman's sculpture correspond to the concrete data in Kawara's paintings. Both artists attempt to entangle the viewer in a concentrated and reflective perceptual zone, prompting self-knowledge.

The Dual Reality of Things: Works by Claes Oldenburg, Richard Artschwager, and Reiner Ruthenbeck

Many artists of the sixties focused on a creative approach involving the inclusion of everyday objects from the everyday lifeworld as well as from domestic and social life into the work of art. The perception of an art work as part of a specific gallery or its design, as an environment or as a spatial installation becomes both an aesthetic experience and a conscious cognitive process. In a different context, the work acquires a functional or pseudo-functional aspect.

Claes Oldenburg is represented in the MMK collection with his environment *Bedroom Ensemble, Replica I* (1969) and by an extensive group of objects and

drawings from the sixties. His artistic idiom is designed to create an individual experience of the world by means of the subjective power of perception. Almost all his works are based on wrestling with common objects, to which he gives a new form, instilling them with a magic life by changing their material. In 1963, Oldenburg created his *Bedroom Ensemble* for an exhibition at the Sidney Janis Gallery, of which the MMK owns a second, later version. *Bedroom Ensemble* consists of furniture, objects, garments, and works of art, which are soon revealed as "imitations" of the real things. They cause a shudder, for we find ourselves confronted by a cold, antiseptic, unerotic "notion" of a bedroom and not by a really usable living space. The objects become a mirror of society, exposing in an ironic gesture the perversions of the "discreet taste of the bourgeoisie."

This Frankfurt group will be supplemented, above all, by early painted plaster reliefs entitled *Flag* (1960)[18] and *Shirt* (1960), the painted plaster reliefs entitled *Braselette* (1961) and *The Black Girdle* (1961), which are part of the Whitney's collection, as well as by the large-size *French Fries and Ketchup* (1963), not to mention *Soft Toilet* (1966), made in vinyl with a kapok filling. Seen along with the hard version owned by the MMK, the two sculptures illustrate perfectly the meaning of the material transformation in Oldenburg's works. Objects that once had fixed functions and meanings are rendered "human" by their transposition into the domain of art; they become "individuals," which suddenly opens up new and unusual layers of significance. The world of everyday objects, which apparently obeys specific rules, has been stripped of its rules in Oldenburg's objects. The border between being and appearance, between function and aesthetics, blurs. Oldenburg undermines our fixed norms for appropriating reality and our experience of reality by continually offering a new point of view.

The gray-on-gray objects and pictures, mainly derived from furniture, that Richard Artschwager began to produce in 1962 also create a world of their own. Artschwager formulates a balancing act between the functional everyday object and the artistic object, whose pseudo-functionality only becomes apparent after a second glance.

Description of Table (1964), *Construction with Indentation* (1966), and *Organ of Cause and Effect III* (1986)—made of wood, veneered with grained plastic, usually Formica—belong neither to some functional concrete realm nor to that of aesthetic production. Here Artschwager creates self-referential structures located in some interim zone between art and life. *Description of Table*, a closed box lying on the floor which outlines the sections of a table, marked in brown, with a white imitation tablecloth, is not some real, usable table. Instead, the object presents itself as a reductive structure, functioning like an early paraphrase of Minimalism. What is involved, as the title indicates, is the *description*. This is also the context in which we should see the transformed and magical objects *Tipped-Over Furniture* (1971) by Reiner Ruthenbeck. These objects likewise take an ironic swipe at the love of order and the traditional habits of people within prevalent social norms.[19]

zum Betrachter sofort einen emotionalen Dialog aufbaut, dem er sich kaum entziehen kann. Der gesamte Körper strahlt eine starke Sinnlichkeit aus, der die übrige Malerei untergeordnet ist. Die verwischte und verzerrte Physiognomie des Gesichtes mit dem aggressiv geöffneten Mund und den gebleckten Zähnen weckt in uns zwangsläufig Gefühle der Angst und läßt die erotische weibliche Ausstrahlung zu einer unmittelbaren und existentiellen Bedrohung des männlichen Geschlechtes werden.

Existenz und Gegenwart: Barnett Newmans Plastik *Here III* und On Kawaras *Date-Paintings*

Der japanische Künstler On Kawara, der seit 1965 in New York lebt, malte am 4. Januar 1966 sein erstes *Datumsbild*. Bereits zur Eröffnung des Museums 1991 wurde von ihm ein Raum installiert, in den er stellvertretend für jedes Jahr seit 1966 ein *Datumsbild* aus der *TODAY—Serie* integrierte. Die ungerahmten, monochromen Leinwände tragen jeweils das von Hand gemalte Datum des Tages, an dem sie gemalt wurden, in Weiß. Zu jedem Bild gehört eine eigens angefertigte Schachtel, in die Zeitungsausschnitte des Tages eingeklebt sind. Außerdem stellte der Künstler verschiedene, zu den Werken und Daten gehörende Informationen aus seinem Leben und seinem Atelier sowie bezogen auf die Weltpolitik der genannten Tage in einem zu der Serie gehörenden Journal zusammen. In Kawaras Raum werden Momente der Existenz und der Gegenwart des Menschen thematisiert. Ein Datum ist der kürzeste Nenner und scheinbar 'objektive' Beweis für das Dasein.[17] Es ist gleichzeitig die kürzeste Formel für die Gegenwart eines Tages, unter die sich alle subjektiven und kollektiven Momente der Wirklichkeitserfahrung subsumieren lassen. Der Kawara-Raum ist auf den im Raummittelpunkt stehenden, sitzenden oder sich im Kreis drehenden Betrachter ausgerichtet. Um diesen entwickelt sich ein Dialogfeld, das zu einer Vielfalt an Erkenntnissen über den Sinn des Lebens, die Frage der Existenz und die Notwendigkeit des Denkens gegenüber dem Handeln führt.

Mit der schmalen, kantigen, aus poliertem Stahl gefertigten, sich aus einem Sockel senkrecht in die Höhe erhebenden Stele *Here III* aus dem Jahr 1965 von Barnett Newman lassen sich die angedeuteten Inhalte in Kawaras Raum zu einer kontemplativen und fast meditativen Einheit verschmelzen. Der feine und zu Beginn kaum wahrnehmbare Metallstab dient in diesem Kontext gleichzeitig als energetisches Zentrum und Spiegel der Wirklichkeit des Umraums. Die Arbeit übernimmt in gewisser Weise eine Stellvertreter-Position für den imaginären Betrachter. Die Stele ist aufgrund ihrer präzisen Ausführung eine konkrete räumliche Tatsache, die auf einer gleichen Ebene mit den konkreten geschriebenen Daten zu denken ist. Exakte räumliche Präsenz und die von der Natur vorgegebenen Gesetzmäßigkeiten des Horizontalen und Vertikalen in der Plastik von Newman finden ihre Entsprechung in den konkreten Daten bei Kawara. Beide Künstler versuchen den Betrachter in ein Wahrnehmungs-

feld der Konzentration und Reflexion zu verstricken, damit dieser zu einer gesteigerten Selbsterkenntnis vordringt.

Die doppelte Wirklichkeit der Dinge: Werkgruppen von Claes Oldenburg, Richard Artschwager und Reiner Ruthenbeck

Ein für viele Künstler der sechziger Jahre wichtiger bildnerischer Ansatz war es, Objekte der Alltags- und Lebenswelt des Menschen sowie den häuslichen oder gesellschaftlichen Umraum in das Kunstwerk miteinzubeziehen. Die Wahrnehmung eines Kunstwerks als Teil eines Ausstellungsraumes, seine Gestaltung als ein Environment oder als eine Rauminstallation wird gleichermaßen zu einem ästhetischen Erlebnis und erkenntnisstiftenden Bewußtseinsprozeß. Das Werk erhält in einem anderen Kontext zusätzliche Interpretationsansätze sowie funktionale oder pseudofunktionale Aspekte.

Claes Oldenburg ist in der Sammlung des Frankfurter Museums sowohl mit seinem Environment *Bedroom Ensemble, Replica I* (1969), als auch mit einer umfangreichen Werkgruppe von Objekten und Zeichnungen aus den sechziger Jahren vertreten. Seine bildnerische Sprache ist beispielhaft für die Erfahrung der Welt durch das Individuum und durch die subjektive Kraft der Wahrnehmung. Fast alle seine Arbeiten basieren auf einer Auseinandersetzung mit den Gegenständen unserer Lebenswelt, die er durch materielle und formale Transformationen zu Objekten mit einem magischen Eigenleben verfremdet. Das *Bedroom Ensemble*, bestehend aus Möbeln, Gegenständen, Kleidungsstücken und Kunstwerken, die alle sehr schnell als 'Imitate' realer Dinge entlarvt werden, läßt den Betrachter beim Anblick schaudern, fühlt er sich doch einer kalten, antiseptischen, unerotischen 'Vorstellung' eines Schlafzimmers gegenüber und nicht etwa einem wirklich benutzbaren Wohnraum. Die 'künstlichen' Möbel und Gegenstände werden zum Spiegel der Gesellschaft, decken in einer ironischen Geste die Perversion des 'diskreten Geschmacks der Bourgeoisie' auf.

Die Frankfurter Werkgruppe wird durch die frühen, pastellhaft bemalten Reliefs aus *U.S.A. Flag* (1960)[18] und *Shirt* (1960) sowie die mit Ölfarbe bemalten Gipsreliefs *Braselette* (1961) und *The Black Girdle* (1961) aus dem Whitney Museum ergänzt, außerdem durch das großformatige Objekt der *French Fries and Ketchup* (1963) und vor allem durch die in Vinyl ausgeführte und mit Kapok gefüllte Fassung der *Soft Toilet* (1966), die neben der in Frankfurt vorhandenen 'Hard Version' hervorragend die besondere Bedeutung der materiellen Transformation in seinen Arbeiten verdeutlichen kann. Einst in ihren Funktionen und in ihrer Bedeutung festgelegte Gegenstände werden durch die Transposition in den Kontext der Kunst 'vermenschlicht', werden zu individuellen 'Wesen' erhöht, die plötzlich eine andere Aura erhalten und über diese neue, ungewohnte Sinnschichten eröffnen. Die scheinbar bestimmten Gesetzmäßigkeiten folgende Welt der Gegenstände unseres Alltags ist mit den Objekten Oldenburgs ihren Gesetzen enthoben. Die Grenzen zwischen Sein und Schein, zwischen

Painterly Sculptures—Sculptural Painting: Works by John Chamberlain and Brice Marden

In the large triangular room on Level 2 of the MMK, sculptures by John Chamberlain from both museums will form a comprehensive group. They will be juxtaposed with two large-format pictures by Brice Marden from the Whitney Museum's collection, which use a special technique and have a spatial presence that prompts an unusual dialogue with Chamberlain's work.

Back in the early sixties, John Chamberlain caused quite a stir with his metal sculptures made of welded automobile scrap metal. The MMK's Chamberlains—*Wildroot* (1959), *Untitled* (1963), *Funburn* (1967), and *Wonkong Melong* (1982)—have been supplemented by sculptures from the Whitney entitled *Jackpot* (1962), *Untitled* (1963), and the relief *Untitled* (1962). With *Wonkong Melong*, a large-size sculpture, Chamberlain concentrated the expressivity of his sculptures more on the aesthetic qualities of the colored sheet steel, which is in many places painted over. In this process, he combines found car parts—a red hood as well as red, white, silver-gray, and bright-green sheets of steel spray-painted with gray lines—to create spatial formations that always balance weight and weightlessness. The steel sheets, which were not cut to size here but carefully selected and then bent or angled to create the desired compositional form, envelop an extensive volume of air, and at numerous points enable us to view the interior of the sculpture. Above all, the color is foregrounded, both in its significance as the original color of the car and in its function as an intrinsic artistic value. Works produced in the late seventies or early eighties, such as *Wonkong Melong*, are eminently painterly sculptures.

At first glance, Chamberlain's sculptures and Brice Marden's concrete, Minimalist pictures, with their adjacent monochrome color zones, are apparently polar opposites. A closer look reveals clearly, however, that Chamberlain's "spatial paintings" are similar in structure to the works of Marden. The latter address questions of light, color, space, and time in a narrative manner. Marden subtly deploys colors in accord with principles of perceptual psychology and thus opens up an expansive realm of the imagination, something Chamberlain's works achieve as well. The monochrome colors, with wax added to them, suggest a dull matteness that accentuates their material feel. Here color becomes intensified as sculptural energy. Color does not *suggest* space, it *is* space.

Painting and Photography in Dialogue: Edward Hopper—Jeff Wall

In 1995, the MMK acquired *Odradek*, a large backlit Cibachrome by Jeff Wall, made in 1994. The title derives from the Kafka story "The Cares of a Family Man" written in 1919,[20] in which the father has the painful idea that Odradek might outlive him. Kafka describes Odradek as a being, a household spirit, made up of a spool and two small wooden rods. Wall's *Odradek* is a complex paraphrase on the magic qualities of objects, which our imaginations can transform

on our notions of reality, shaped as they are by wishes, and on our dreams. *Odradek* alludes to the meaning of fetishes, to the world of play, and the power of creativity. The different historical periods united in the Cibachrome empha-size the trans-historical character of objects, which establish a second human reality, otherwise defined by the coordinates of life and death. The staircase with the girl coming down it is a place of encounter, of history, of memory, but also of transience.[21] The staircase as the symbol of "vanity" constitutes in both Kafka's story and Wall's picture a level of individual and collective memory: an infinite number of events has occurred, but they live on only in the memory of people and are forgotten with their deaths. *Odradek* is part of this collective forgetting, but also part of collective memory.

Edward Hopper's 1949 painting entitled *Stairway*, juxtaposed in dialogue with Wall's photo, depicts an intense mood without portraying any human beings, but rather by referring to the human condition. The gaze of the viewer is identi-cal to that of the resident descending the staircase and looking through the opened front door toward a dark forest outside. The idyllic, carefully arranged interior, is in blatant contrast to chilly nature, which rises up before us like an impenetrable wall. The inhabitant of the house can only cast a claustrophobic glance outside, but hardly dares step out into the other world. As depicted, the domestic environment is safe, while the outside world is an unapproachable reality subject to its own laws. Here, Hopper expresses the discrepancy between inside and outside worlds. The person who is not portrayed has become the integral element of an order of the world of objects that dictates the laws to be followed and ensnares the subject in its magic spell. Hopper's picture is Kafkaesque in approach and unfolds before our eyes as an apparently idyllic view of domestic solitude and oblivion that is, however, shot through with fear.

Material and Language: Metaphorical Properties and Concreteness in the Works of Joseph Beuys and Lawrence Weiner

In this context, Joseph Beuys' cultural-anthropological concept occupies a spe-cial position in the exhibition: with his idea of social sculpture,[22] Beuys formu-lated a transcultural concept of art and the art work.

In a room that architect Hans Hollein designed with a high ceiling specifi-cally for it, *Blitzschlag mit Lichtschein auf Hirsch* (*Lightning with Stag in Its Glare*, 1958–85) groups thirty-nine different elements to form a compelling installation. Beuys generates a narrative ensemble that combines elements of the creation and the destruction of the world. The natural forces symbolized in the vertical components of the installation, which manifest themselves as energies between heaven and earth, point to the emergence of the natural sciences and the study of the laws underlying the world. The vertical elements are symbols of the his-tory of creation and evolution which allude to the development of human culture and civilization in connection with nature. In his works, Beuys addressed the basic principles of life that are worth preserving. His sculptural idiom is based

Funktion und Ästhetik verfließen. Oldenburg untergräbt unsere festgefügten Normen der Wirklichkeitsaneignung und Wirklichkeitserfahrung durch immer neue, ungewohnte Standpunktwechsel.

Die seit 1962 entstandenen Objekte und grau-in-grau gemalten Bilder Richard Artschwagers konstituieren eine Eigenwelt. Die Objektgestaltungen, mit denen Artschwager eine Gratwanderung zwischen dem funtionalen Alltagsgegenstand und dem erst auf den zweiten Blick erkennbaren pseudofunktionalen künstlerischen Objekt formulierte, gehen meist auf Möbel zurück und paraphrasieren diese unter den verschiedensten Aspekten.

Seine Werke mit den Titeln *Description of Table* (1964), *Construction with Indentation* (1966) und *Organ of Cause and Effect III* (1986), die jeweils aus Holzkonstruktionen bestehen, welche mit gemasertem Kunststoff—meist Resopal—furniert wurden, sind weder eindeutig in den Bereich der funktionalen Gegenständlichkeit, noch in den des ästhetischen Gebildes einzuordnen. Artschwager formulierte hier vielmehr mit sich selbst identische und allein auf sich selbst verweisende Gebilde, die sich für den Betrachter in einem Zwischenbereich zwischen Kunst und Leben ansiedeln. Der auf dem Boden liegende geschlossene Kasten von *Description of Table*, der durch braun abgesetzte Partien und eine weiße Tischdeckenimitation einen Tisch umschreibt, ist nicht etwa ein realer, benutzbarer Tisch, sondern präsentiert sich als ein auf eine kubische Grundform reduziertes, minimalistisches Gebilde, das wie eine frühe Paraphrase auf die Gestaltungen der Minimal Künstler wirkt. Es handelt sich, wie im Titel angegeben, um die 'Beschreibung eines Tisches.' Artschwager versucht, unsere Wahrnehmung der Dinge zu schärfen, sie zu präzisieren und teilweise so zu beeinflussen, daß wir die gegenwärtige Realität—bedingt durch das spezifische Eigenleben und die andere 'geistige' Wirklichkeit seiner Objekte—bewußter erfahren. In diesen Kontext der Objekttransformation und Objektmagie gehören auch die *Umgekippten Möbel* (1971–93) von Reiner Ruthenbeck, die einen ironischen Seitenhieb auf die Ordnungsliebe und die traditionellen Gewohnheiten des Menschen im Rahmen gesellschaftlicher Normen paraphrasieren.[19]

Malerische Plastik—plastische Malerei: Werke von John Chamberlain und Brice Marden

In dem großen Dreiecksraum der Ebene 2 des Museums werden die Plastiken von John Chamberlain aus beiden Museen zu einer umfassenden Werkgruppe zusammengeführt. Ihnen gegenübergestellt sind die beiden aus der Sammlung des Whitney Museums kommenden großformatigen Bilder von Brice Marden, deren spezielle Technik und räumliche Präsenz einen ungewohnten Dialog zu Chamberlains Werken aufbauen.

John Chamberlain erregte bereits seit den frühen 60er Jahren mit seinen aus Autoschrotteilen bestehenden Metallplastiken Aufsehen. In die Werkgruppe des MMK, bestehend aus den Arbeiten *Wildroot* (1959), *Untitled* (1963), *Funburn*

(1967) und *Wonkong Melong* (1982) werden die aus New York kommenden Plastiken *Jackpot* (1962), *Untitled* (1963) und das Relief *Untitled* (1962) integriert.

Mit der großformatigen Plastik *Wonkong Melong* konzentrierte Chamberlain die Ausdruckswerte seiner plastischen Arbeit auf die ästhetischen Qualitäten des farbigen und an vielen Stellen übermalten Eisenblechs. Dabei setzte er vorgefundene Karosserieteile—eine rote Motorhaube sowie mit grauen Lineamenten übersprühte rote, weiße, silbergraue und hellgrüne Eisenbleche—zu räumlichen Gebilden zusammen, die immer einen Balanceakt aus Schwere und Schwerelosigkeit demonstrieren. Die Eisenbleche, die Chamberlain bei dieser Arbeit nicht speziell zurechtgeschnitten hat, sondern durch Verkantungen, Biegungen und Zuordnungen in eine gewünschte kompositorische Form brachte, umhüllen großflächig Luftvolumen, lassen den Blick aber immer wieder in das Innere der Plastiken eindringen. Darüber hinaus tritt die Farbe einerseits in ihrer Bedeutung als Eigenfarbe der Karosserieteile, andererseits in ihrer Funktion als gestalterischer Eigenwert deutlich in den Vordergrund. Arbeiten, die wie *Wonkong Melong* in den späten 70er oder frühen 80er Jahren entstanden, sind somit eminent malerische Plastiken.

Auf den ersten Blick stehen sich die Plastiken Chamberlains und die konkreten, minimalistischen Bilder Brice Mardens, die aus nebeneinandergesetzten monochromen Farbflächen aufgebaut sind, scheinbar als polare Gegensätze gegenüber. Bei genauerer Betrachtung wird aber deutlich, wie sehr Chamberlains 'Raummalereien' den Arbeiten Mardens, die ihrerseits auf Fragen des Lichts, der Farbe oder von Raum und Zeit eingehen, strukturell verwandt sind. Marden setzt Farben in subtiler Weise nach wahrnehmungspsychologischen Gesichtspunkten ein und eröffnet damit für den Betrachter vielfältige, an natürlichen Gegebenheiten orientierte Imaginationsräume, wie dies auch den Arbeiten Chamberlains eigen ist. Die unter Beimischung von Wachs aufgetragenen monochromen Farben entfalten eine stumpfe Mattigkeit, die ihre Materialität zu einer haptischen Qualität verstärkt. Farbe wird hier zu einer plastischen Energie gesteigert. Sie *suggeriert* nicht, sondern sie *ist* Raum.

Malerei und Fotografie im Dialog: Edward Hopper—Jeff Wall

Im Jahr 1995 konnte das Museum für Moderne Kunst das hinterleuchtete Großdia *Odradek, Taboritskà 8, Prag, 18. Juli 1994* (1994) von Jeff Wall erwerben. *Odradek* geht inhaltlich auf die Erzählung *Die Sorge des Hausvaters* von Franz Kafka[20] zurück, in der der Hausvater die schmerzliche Vorstellung entwickelte, daß ein kleiner dinglicher Hausgeist ihn überleben könnte. In einem in Prag gelegenen Haus mit der Adresse *Taboritskà 8* taucht aus dem dunkel gehaltenen Zentrum der Komposition, die mehr an ein Bild als an eine Fotografie erinnert, *Odradek* zunächst unmerklich auf, wird aber durch Kafkas fiktive Geschichte zu einem magischen Objekt erhöht.

Odradek ist eine Paraphrase über die metaphysischen Qualitäten von Gegenständen, die in unseren von Wünschen geprägten Wirklichkeitsvorstellungen

on an aesthetics of materials, which must be perceived directly and which lends the work a strong degree of creative imagination and reflection. In *Lightning with Stag in Its Glare*, dialogue was only possible as counterpoint, with an opposing position elucidating the essential elements and the singularity of Beuys' idiom.

Lawrence Weiner's art usually consists of texts: in other words, he always conceives his works in linguistic terms. He then writes this conception on paper as a certificate, paints it on a wall, or prints it in a catalogue. Some of the art works do not even have to be completed. He repeatedly chooses uppercase letters in order to avoid any individuality in the text. His art moves along a clearly defined border between the reality of language and the reality of the material. Both domains meet at various levels and offer many possible interpretations. The Weiner installation that is part of the Whitney's collection bridges the two different exhibitions. *Here, There & Everywhere*, made in 1989, will be displayed both in New York and in Frankfurt, each time in a different context and with a different creative solution. The exact text of the installation reads:

> AWAY FROM IT ALL
> HERE THERE & EVERYWHERE
> BENEATH IT ALL
> HERE THERE & EVERYWHERE
> ALL OVER IT ALL
> HERE THERE & EVERYWHERE
> ABOVE IT ALL
> HERE THERE & EVERYWHERE

In Frankfurt, Weiner's work will be presented on one of the high side walls in the room with the Beuys installation, with the typography proportioned to fit the wall. This dual dialogue will demonstrate how Weiner's works require a specific reality in order to exist. This reality need not be of a concrete spatial nature; it can also be ideational. A work exists as soon as it is fixed in our heads, in our thoughts.

Whereas Beuys worked above all with materials and the metaphorical and aesthetic qualities they possess, thus triggering in viewers a wide range of sensory impressions and associations—emotional and intellectual processes— Weiner works conceptually, using abstract and objective facts that can only be grasped by perception as well as methodical and analytical thought. However, Weiner and Beuys concur in their emphasis that people must strengthen their intellectual and creative abilities and use them more consciously.

Image and Language: Questions on the Meaning of Art: Works by Ed Ruscha, John Baldessari, Bruce Nauman, and Martha Rosler in Dialogue with Works by Alighiero e Boetti and Heiner Blum

Ed Ruscha, John Baldessari, Bruce Nauman, and Martha Rosler, four US artists, together with the Italian artist Alighiero e Boetti and Heiner Blum, a Frankfurt-based German artist, all have one thing in common: their works

integrate language in the form of words and texts and use these to address complex levels of meaning with reference to the domains of art and society.

Ed Ruscha's first book appeared in 1963. It was entitled *Twenty-six Gasoline Stations* and contained a series of photographs of the same name. Only twenty-five years old at the time, en route to Oklahoma City from his home in Los Angeles, Ruscha photographed twenty-six gas stations of a common American architectural type—simple business premises. As a series of black-and-white photographs, they became images of the collective memory of the United States. These photographs repeatedly show how visual impressions of West Coast Americans are defined by light, landscape, architecture, writing, and street vistas. In Ruscha's images of words, begun around the mid-sixties, he generally places names or simple buzzwords on a colored background, which, in turn, is painted with a wide variety of natural dyes. The usually sober, clear typography contrasts sharply with the frequently ambiguous words or concepts. Here language produces associations and calls for interpretation.

For the Frankfurt exhibition, some Ruscha works have been arranged together to form a significant group. With the painting *Plenty Big Hotel Room (Painting for the American Indian)* made in 1985, for example, Ruscha made a critical statement about the Indian's situation in America. In the context of the history of the persecution of Native Americans, driven from their land, the star-spangled banner as a symbol of humanity and liberty is called into question, something alluded to by the imaginary concepts behind the black bar. The blank spaces become an imaginative indictment and a critique of sociopolitical developments in the United States.[23]

In 1966, John Baldessari averred that newspaper photos, pictures from magazines, and words all lay closer to the human heart than did paintings.[24] He first produced conceptual pictures—compiled of photographs and texts—in 1967–68. In these works, which include *An Artist Is Not Merely the Slavish Announcer. . .* (1967–68),[25] words or short texts are placed below a black-and-white photograph printed across almost the entire width of the canvas. Together, the text and the image create an immediate substantive or associative context. Baldessari directs our gaze to the dry, clearly structured pictorial nature of motifs from Southern California, based as they are on simple signs; if they were photographs without additional captions, we would read them primarily with a subjective eye. But a text added in explanation or as accompaniment generates a unity of contemplation and visualization.

The MMK collection includes a series of printed "word graphics" by Bruce Nauman. In 1969 he created the *Second Poem Piece*, a floor-based work. As in his other works using words, he explores the meaning of words, concepts, and language, here elucidated by shifting and grading the concepts within one sentence. The viewer walks around the metal plate into which the words have been cast: a spatio-temporal process of perception ensues, with the viewer's thoughts circling around the contents and meanings of the word game presented on the plate.

und in unseren Träumen zu etwas ganz anderem transformiert werden können. Das Objekt verweist auf die Bedeutung von Fetischen, auf die Welt des Spiels und auf die Kraft der Kreativität. Die verschiedenen in dem Dia vereinten historischen Zeitlichkeiten betonen die Überzeitlichkeit von Gegenständen, die in der von den Koordinaten Leben und Tod geprägten Wirklichkeit des Menschen eine zweite Wirklichkeit aufbauen. Die Treppe mit dem herabschreitenden Mädchen[21] ist ein Ort der Begegnung, der Geschichte, der Erinnerung aber auch der Vergänglichkeit. Die Treppe als 'Vanitas-Symbol' konstituiert bei Kafka und Wall eine Ebene individueller und kollektiver Erinnerung: Hier haben sich unendlich viele Ereignisse abgespielt, die nur noch in der Erinnerung der Menschen weiterleben und mit ihrem Tod in Vergessenheit geraten. *Odradek* ist Teil dieses kollektiven Vergessens, aber auch Teil des kollektiven Gedächtnisses.

Edward Hopper hat mit seinem kleinformatigen Bild *Stairway* aus dem Jahr 1949, das mit Walls Arbeit zu einer Dialoggruppe verbunden wurde, ein Stimmungsbild geschaffen. Der Blick des Betrachters ist identisch mit dem Standort eines Hausbewohners, der die Treppe hinabgeht und durch die geöffnete Haustür auf einen dunklen Wald im Freien schaut. Das idyllische Interieur mit seiner geordneten Einrichtung steht in krassem Gegensatz zu der abweisenden, sich wie eine undurchdringliche Wand erhebenden Natur. Der Bewohner des Hauses vermag nur noch nach draußen zu blicken, wagt aber kaum mehr einen tatsächlichen Schritt in die äußere, 'andere,' Welt. Die häusliche Umgebung ist nach seinen Vorstellungen geordnet und gibt ihm Sicherheit, während die Außenwelt sich als eine unnahbare, von anderen Gesetzen bestimmte Realität allem Privaten entgegenstellt. Hoppers Bild ist im Ansatz kafkaesk und entwickelt vor uns ein scheinbar idyllisches aber angstbesetztes Panorama häuslicher Einsamkeit und Vergessenheit.

Material und Sprache—Metaphorik und Konkretion: Joseph Beuys und Lawrence Weiner

Eine besondere Position nimmt im Museum und in der Ausstellung das kulturanthropologische Konzept von Joseph Beuys ein, der mit seiner Idee einer sozialen Plastik[22] einen gesellschaftsübergreifenden Werk- und Kunstbegriff formulierte.

In einem von dem Architekten Hans Hollein speziell für die Arbeit *Blitzschlag mit Lichtschein auf Hirsch* (1958–85) nach oben geöffneten Raum sind 39 Werkelemente zu einer eindringlichen Rauminstallation verbunden. Hier formulierte Beuys ein erzählerisches Ensemble, das in sich Momente der Entstehung und der Zerstörung von Welt vereint. Die in den vertikalen Elementen des Raumes versinnbildlichten elementaren Naturgewalten, die sich als Energien zwischen Himmel und Erde manifestieren, sind Hinweise auf die Entstehung der Naturwissenschaften und der Erforschung der Gesetzmäßigkeiten der Welt. In den waagerechten Werkelementen sind Sinnbilder der Schöpfungs- und Evolutionsgeschichte enthalten, die auf die Entwicklung der Zivilisation und der

Kultur des Menschen in Verbindung mit der Natur verweisen. Beuys thematisierte in seiner Arbeit Grundprinzipien des Lebens, die es zu bewahren gilt. Seine bildnerische Sprache basiert auf einer Materialästhetik, die vom Betrachter eine direkte Wahrnehmung und ein hohes Maß an Phantasie und Reflexion verlangt. In bezug auf diese Arbeit konnte nur an einen Dialog gedacht werden, der im Kontrapunktischen liegt und durch eine Gegenposition das Wesentliche und die Besonderheit der Beuys'schen Sprache charakterisiert.

Lawrence Weiners Werke bestehen meistens aus Texten, das heißt er konzipiert seine Werke stets in sprachlicher Form. Ihre Ausführung kann in Form eines Zertifikates auf Papier geschrieben sein, auf eine Wand gemalt werden oder in einem Katalog gedruckt sein. Manche Werke müssen auch nicht ausgeführt werden. Immer verwendet er Schrift in Druckbuchstaben, um keine Individualität aufkommen zu lassen. Seine Arbeiten bewegen sich auf einem klar umrissenen Grat zwischen der Wirklichkeit der Sprache und der Wirklichkeit der Materie. Beide Bereiche treffen sich auf verschiedenen Ebenen und eröffnen dem Betrachter in der Reflexion zahlreiche Interpretationsansätze. Seine im Besitz des Whitney Museums befindliche Installation bildet eine Brücke zwischen beiden Ausstellungsteilen des Projektes. *Here, There, & Everywhere* (1989) wird sowohl in New York, als auch in Frankfurt gezeigt, jedesmal in einem anderen Kontext und in einer anderen gestalterischen Lösung. Der genaue Text der Arbeit lautet:

AWAY FROM IT ALL
HERE THERE & EVERYWHERE
BENEATH IT ALL
HERE THERE & EVERYWHERE
ALL OVER IT ALL
HERE THERE & EVERYWHERE
ABOVE IT ALL
HERE THERE & EVERYWHERE

In Frankfurt wird Weiners Arbeit vom Künstler auf eine hohe Seitenwand im Beuys Raum proportional und typographisch abgestimmt. Der Werktext verweist auf einen ganzheitlichen philosophischen Grundgedanken, auf unsere Vorstellung von Raum und Zeit, die sich als ein Gleichzeitiges und ein überall existierendes Sein manifestieren kann, ohne Grenzen und Einschränkungen. Weiner hinterfragt das Prinzip Sprache, indem er Texte formuliert, die allein aus sich selbst heraus einen Sinn ergeben und die gedankliche Konkretionen sind.

Arbeitete Beuys vor allem mit Materialien und ihren metaphorisch-ästhetischen Qualitäten, die im Betrachter ein großes Potential an Sinneseindrücken, Assoziationen, emotionalen und geistigen Prozessen in Gang setzen, so arbeitet Weiner konzeptuell und mit abstrakten, objektiven Tatsachen, die sich allein durch eine Wahrnehmung und methodisch-analytisches Denken erschließen lassen. Weiner trifft sich jedoch mit Beuys in der Verdeutlichung der Notwendigkeit, daß der Mensch seine geistigen und kreativen Fähigkeiten stärken und bewußter einsetzen sollte.

Alighiero e Boetti concerned himself with fundamental questions of the laws underlying the universe as manifested by the polarity of "order" and "disorder." He created a large number of works that address language, linguistic systems, and the meaning of language in a social context. In addition, he formulated a language of mathematics, geometry, literature, narrative, and metaphor. Since 1995, the MMK collection has included *I mille fiumi più lunghi del mondo*, a large-scale embroidery work naming the thousand longest rivers of the world. Nature has developed its own laws, but they have hitherto been only partially recognized and explained. People have constructed different classification systems to squeeze the disorder that occurs in nature into an ordered system which they can comprehend. The thousand longest rivers in the world are not spread across the globe and the continents according to some clearly discernible plan; we adopt the criterion of length to create an artificial and abstract order for this distribution. Together, the rivers generate an immense and imaginary flow of time and evolution, symbolizing the structural laws of the universe.

Since the sixties, Martha Rosler has been creating art forms that address sociopolitical themes. Using photography, videos, and texts, she has developed a system of language intended to make viewers aware of how they perceive art from various aesthetic vantage points. Her works always focus on an assessment of the real situation by reproducing reality. She thus also leaves room for viewers to become conscious of the intrinsic relations between the motif presented, the reproduced image, the accompanying text, and reflection. *The Bowery in Two Inadequate Descriptive Systems* is a series of forty-five black-and-white photographs, completed 1974–75, each photograph accompanied by a typewritten text panel containing an associative set of concepts. Rosler provides a photographic account of the facades of stores on the Bowery in Manhattan. The combination of text and image enables her to show how inexact any image of real social reality is, given that each picture depends on the individual vision of the particular photographer, compared with the linguistic designation of the motif of social reality contained in the picture. Like Baldessari, she endeavors to break open ossified perceptual structures by means of unusual combinations involving concepts and images and thus changing our vision and critical thought.

Heiner Blum repeatedly looks for and investigates objects, motifs, and found objects in his surroundings, relying on products and systems that are key components in our everyday life, which he then transfers into metaphorically shaped units. He chose individual German and English words for his *Spiele/ Games* group, focusing on perception, thought, and feeling through language. He gives the words an alien form by reducing them by one letter or vowel, dissecting them into concept and syllable or into two or more syllables, or by arranging the concepts in two or three short words. Thus split up, and painted in white on black on wooden boxes, the words protrude into the gallery: the longer they are, the more they protrude. Here, concepts become "linguistic bodies" with a spatial existence. Reading becomes a spatio-temporal perceptual

process linked to the numerous positions the viewer can adopt regarding each word. Each word, written on the outer sides of the box and "floating" in space, becomes a symbol for language per se, that is, an object portraying language. Heiner Blum thus creates an open, multivalent system, in which language has a completely different social function as an objectifiable variable, an ordering principle, and a fixed communication system.

The Sounds of Things: John Cage and Robert Morris

Fountain, made in 1963, is one of Morris' early works. It can be considered a direct paraphrase of what is no doubt Duchamp's most famous readymade, *Fountain*: a urinal stood on end and exhibited for the first time in New York in 1917. In 1951, the New York gallery owner Sidney Janis received a second version of it. Like Duchamp, Morris gave an object originally intended for a different function an ironic title, imbuing the object by means of word plays and concepts with new, more complex levels of meaning. *Fountain* consists of different found objects that Morris assembled and looks as if it is meant to be functional. From a vertical, gallows-like construction made of white timber, fastened to the wall slightly above eye level, a simple zinc bucket hangs: probably it was originally a fire bucket. It is not the bucket itself but rather the sound of splashing water that first attracts the viewer. Closer inspection reveals that the wall of the bucket, into which we cannot see, is grooved in parallel vertical lines. The noise can now be identified more closely. The sound invariably brings to mind the sound of a water jet in a fountain. The object itself strangely contradicts the sound it emits. By disconcerting us in this way, Morris encourages us to think about the sense or nonsensical meaning of a work's title, of a concept or a word.

As an "aural sculpture" using the sound of water, *Fountain* is related to various works by Fluxus artists and proponents of Arte Povera . The latter all drew on the thought of John Cage. To this extent, it was only logical that the score for *Water Music*, a 1952 composition by John Cage that is part of the Whitney collection, was placed opposite Morris' sculpture. *Water Music* premiered in 1952; it is a composition for a player piano and different objects, such as a radio, three whistles, a water polo ball, two water containers, a pack of cards, and a wooden stick. According to Cage, the piece was to be presented as a play in which certain actions were equal in value to the sounds. But the sound of water would predominate.

The various sounds of water noted down by Cage and the real splashing of the water in Morris' work trigger associations with various situations in life connected to water. While Cage wanted to unleash the viewer's images and memories through a wide spectrum of water-related sounds, Morris concentrated primarily on how sound is used to allude to something: here it is a sound which metaphorically reinstills the object taken from life with its functional properties in the context of a museum.[26]

Bild und Sprache. Fragen der Bedeutung von Kunst: Werke von Ed Ruscha, John Baldessari, Bruce Nauman und Martha Rosler im Dialog mit Werken von Alighiero e Boetti und Heiner Blum

Die vier amerikanischen Künstler Ed Ruscha, John Baldessari, Bruce Nauman und Martha Rosler sowie der im Jahr 1994 verstorbene Italiener Alighiero e Boetti und der in Frankfurt lebende Heiner Blum integrierten in viele ihrer Arbeiten Sprache in Form von Wort und Text und thematisierten mit ihnen komplexe Sinn- und Bedeutungsebenen in bezug auf die Bereiche Kunst und Gesellschaft.

Im Jahr 1963 erschien *Ed Ruschas* erstes Buch mit dem Titel *Twentysix Gasoline Stations*, in dem er eine gleichnamige Fotoserie von 1962 publizierte. Als gerade fünfundzwanzigjähriger Künstler fotografierte er auf dem Weg von seinem Haus in Los Angeles nach Oklahoma City sechsundzwanzig Tankstellen, die alle dem gleichen amerikanischen Architekturtyp eines einfachen Geschäfts-gebäudes entsprachen und als eine Serie von Schwarzweißfotografien zu Bildern des kollektiven Gedächtnisses Amerikas wurden. In diesen Fotografien wird immer wieder deutlich, wie sehr die optischen Eindrücke der Amerikaner der Westküste von Licht, Landschaft, Architektur, Schrift und Straße geprägt sind. In den Schriftbildern Ruschas, die etwa seit Mitte der sechziger Jahre entstanden, stehen meist Namen oder einfache Reizworte auf farbigem Bild-grund, der wiederum aus den verschiedensten natürlichen Farbstoffen gemalt ist. Die meist nüchterne, klare Typografie steht in einem bewußten Gegensatz zu den oft vieldeutigen Worten oder Begriffen. Text und Farbe rufen in seinen Bildern unterschiedlichste Assoziationen und Emotionen hervor. Sie fordern den Betrachter auf, die herkömmlichen Bedeutungen von Malerei und Sprache zu hinterfragen.

Für die Frankfurter Ausstellung konnten mehrere Arbeiten aus den sech-ziger bis neunziger Jahren zu einer Werkgruppe verbunden werden. Mit seinem Bild *Plenty Big Hotel Room (Painting for The American Indian)*, von 1985[23], schuf Ruscha beispielsweise ein kritisches Statement zur Situation der Indianer in Amerika. Die amerikanische Nationalflagge wird vor dem Hintergrund der Geschichte der aus ihrem Land vertriebenen und verfolgten Indianer zu einem kritisierten Symbol der Menschlichkeit und Freiheit, was durch die hinter den schwarzen Balken stehenden imaginären Begriffe angedeutet wird. Die Leer-stellen werden zu einer verschlüsselten Anklageschrift gegen die gesellschafts-politischen Entwicklungen in Amerika.

John Baldessari konstatierte im Jahr 1966, daß Zeitungsfotos, Abbildungen in Zeitschriften und Worte den Menschen näher lägen als Malerei.[24] Seine ersten konzeptuellen Bilder, die dann konsequenterweise aus Fotografien und Texten zusammmengesetzt wurden, entstanden 1967–68. In diesen Bildern gleicher Größe, zu denen auch die Arbeit *An Artist is Not Merely the Slavish Announcer...* (1967–68)[25] gehört, stehen jeweils Worte oder kurze Texte unterhalb einer fast die gesamte Bildbreite einnehmenden und auf die Leinwand aufgedruckten

Schwarzweißfotografie. Text und Bild stellen einen direkten inhaltlichen oder assoziativen Zusammenhang her. Baldessari lenkt unseren Blick auf die trockene, klar strukturierte und auf einfachen Zeichen basierende Bildhaftigkeit von Motiven aus dem südlichen Kalifornien, die man als Fotografien ohne Textzusatz primär mit einem subjektiven Blick betrachtet. Kommt—wie bei seinen Bildern—ein das abgebildete Motiv erklärender oder flankierender Text hinzu, entsteht eine Einheit aus bildhaftem Sehen und Kontemplation.

Bruce Nauman, von dem sich in der Sammlung des MMK u.a. eine Reihe von Wort-Grafiken befindet, schuf im Jahr 1969 die Bodenarbeit *Second Poem Piece*. Wie in seinen anderen Text-Arbeiten geht es ihm hier um eine Hinterfragung der Bedeutung von Wort, Begriff und Sprache, was in diesem Fall durch räumliche Verschiebung und Stufung der Begriffe innerhalb eines Satzes deutlich wird. Der Betrachter umläuft die in Metall gegossene Text-Platte in einem raum-zeitlichen Wahrnehmungsprozeß und umkreist in Gedanken die Inhaltlichkeit und Bedeutungen des auf die Platte geschriebenen Wortspieles.

Martha Rosler arbeitet seit den sechziger Jahren an Kunstformen, die politische und sozialpolitische Inhalte thematisieren. Mit den Medien Fotografie, Video und Text entwickelte sie ein Sprachsystem, das dem Betrachter von verschiedenen ästhetischen Positionen aus seine Wahrnehmung bewußt machen möchte. Im Zentrum ihrer Arbeit steht immer die Einschätzung einer realen Situation mit den Mitteln der Reproduktion von Wirklichkeit. Damit verbunden sollen die inneren Zusammenhänge zwischen dargestelltem Motiv, reproduziertem Bild, beigegebenem Text und gedanklicher Reflexion verdeutlicht werden. Mit ihrer Arbeit *The Bowery in Two Inadequate Descriptive Systems* (1974–75), einer Serie von 45 Schwarzweißfotografien, die jeweils von einer Texttafel, aus maschinengeschriebenen, assoziativ zusammengestellten Begriffen begleitet sind, formulierte Rosler einen fotografischen Bericht über Fassaden von Geschäften, die in der Bowery Street in New York liegen. Mit Hilfe der Kombination von Schrift und Bild war es ihr möglich zu zeigen, wie ungenau das stets von der individuellen Sehweise eines Fotografen abhängige Bild einer realen sozialen Wirklichkeit im Vergleich zu der sprachlichen Bezeichnung des im Bild festgehaltenen Motivs dieser sozialen Wirklichkeit ist. Ähnlich wie Baldessari versuchte sie, festgefahrene Wahrnehmungsstrukturen durch ungewohnte Kombinationen von Bild und Begriffen aufzubrechen und damit unser Sehen und unser kritisches Denken zu verändern.

Alighiero e Boetti, der sich mit den grundlegenden Fragen weltgesetzlicher Strukturen beschäftigte, wie sie stellvertretend in der Polarität 'Ordnung' und 'Unordnung' manifest werden, schuf eine große Zahl von Werken, die sich mit Sprache, Sprachsystemen und der Bedeutung der Sprache im Kontext der Gesellschaft auseinandersetzen. Darüber hinaus formulierte er in Werken verschiedener Gruppen die Sprache der Mathematik, der Geometrie, der Kombinatorik, der Literatur, des Erzählerischen und der Metaphorik. Das Museum für Moderne Kunst ist seit 1995 im Besitz einer großformatigen gestickten Arbeit,

Painting and Reality: A Group by Alex Katz in the MMK's Central Hall

In the MMK's central hall, which is noteworthy for its unusual lighting, physical form, and the works hitherto displayed in it,[27] a comprehensive group of works by Alex Katz will be installed as the beginning and the end of the exhibition. They present an image of humankind in the form of large-scale portraits in a very idiosyncratic and "American" way. From the Whitney Museum's collection, the pictures *Place* (1977) and *The Red Smile* (1963) have made their way to Frankfurt, and they have been supplemented by the four works from the artist's own collection: *Belinda Smiles* (1993), *Ahn Smiles*, *Jessica Smiles*, and *Kathryn Smiles* (all 1994).[28] Katz started painting in the fifties. By the end of the decade, he had developed a highly personal style based on the representative "revelation" of the human figure: the portrait, placed in front of an abstract landscape or on a monochrome pictorial ground.

Katz's pictures formulate a reality based solely on his subjective perception, for all motifs are deliberately portrayed in a representative manner. In several phases, he initially isolated the figure and then the portrait within the picture. At the same time, the scale of the pictures grew—large-format paintings were the result, as they enabled Katz to avoid presenting the individual, the specific qualities in people's faces, and instead depict a certain form of "universality" in human beings, something that could only be achieved with abstractness, employed here with great subtlety. In the early sixties, Katz increasingly focused on sculptural forms of expression based on subjective impression, the energy of a motif, and light, but also on the techniques and idiom of billboard advertising and film. In both media, and they were becoming ever more dominant in modern society, he found forms of language that continue to influence his style today. Among these are the extreme blowups of motifs, the concentration on silhouette for a face or an object, and the overlapping of motifs to strengthen the visual effect, and the dramatics of light.

All these elements are given a voice in Katz's own style in *Place* and *The Red Smile*. In *The Red Smile*, our gaze alights on the three-quarter portrait of Ada, Katz's wife, painted against a monochrome red background. The painting seems to be the product of swift but precise strokes. Physiognomic details, hair, and items of clothing are spread out across the picture's surface, so that the result is a picture of a portrait, as opposed to a portrait. Here Katz uses painting as a means of expression that transforms the individual into a representative, generalized, impersonal "model" of the human being at a specific time. All the details have been stylized. The smile becomes a stereotype that stands for the positivist outlook of society; the red-colored lips are supported by the red background. Erotic aura becomes exaggerated as stylized, representative gesture and thus points to the structures of communication in the US in the sixties, which were based on specific pre-determined types of behavior.

In *Place*, we encounter portraits of actors brought together in a group that can hardly be grasped in spatial terms and has been simply distributed across

the surface of the canvas. Katz used movie stills as the motifs, merging them into a collage of generalized faces that lack any depth and are typical of the idiom of film.

The exhibition in Frankfurt contains four large portraits from the *Smiles* series. They redefine the issue of what makes an individual and how an individual should be represented. The smiling portraits of *Belinda*, *Ahn*, *Jessica*, and *Kathryn* have been painted on a dark-gray background. The faces are smooth, lacking in depth, and painted as though they had been cut out. The different types of women are distinguished by hair style, and the color and shape of their faces and are thus identifiable as individuals. The smiles that link the portraits, depicted as stereotypical expressions, turn the faces into types. Katz shows people in the form of portraits: they leave an artistic, depictive impression on the viewer without revealing anything about the sitter's private sphere.

Translated by Jeremy Gaines

Notes

1. The series of exhibitions mounted by the Kunst- und Ausstellungshalle der Bundesrepublik Deutschland Bonn should be mentioned here. Since 1994, these exhibitions have presented the collections of larger museums under the heading "The Great Collections I–V."

2. The concept of the "musée imaginaire" was originally developed by André Malraux. In *Voices of Silence* (1952) Malraux expounded the idea of a "museum of reproductions," representing works from all eras and cultures. In addition to those seen on journeys and preserved in the memory, these images constitute an "imaginary museum in our heads."

3. The exhibition at the Whitney Museum concentrates on dialogues between artists and works based on groups of works by younger artists from the MMK collection. These dialogues generate contrapuntal contrasts to important groupings of modern and contemporary art in the Whitney Museum collection. In this way, a number of substantive contexts as well as basic concepts of the Frankfurt collection will be presented in New York and then rounded out and emphasized to include the very recent past.

4. Since the MMK opened on June 6, 1991, it has mounted only three smaller-scale special exhibitions: "Carl Andre: Extraneous Roots" (1991) in the Carmelite Monastery; as part of "Szenenwechsel V" (1994), a presentation of the early paintings of On Kawara and as part of "Szenenwechsel X," a show of the early drawings of On Kawara.

5. See Hans Ulrich Reck, *Siah Armajani: Sacco and Vanzetti Leseraum* (Frankfurt/Main: Museum für Moderne Kunst, 1990).

6. Ibid, p. 577. In the seven months before painting the picture, Shahn had produced a series of twenty-three gouaches based on newspaper photos of the case. They were his first public success as an artist (he had until then been active as an illustrator). The picture was exhibited for the first time, along with a proposal for a mural, at The Museum of Modern Art, New York, in 1932.

7. Ibid, p. 5

8. As early as 1927, in response to the trial, George Grosz had produced a drawing of a

welche die längsten Flüsse der Welt mit Kilometerangaben aufführt. Die Natur hat ihre eigenen — für den Menschen bisher nur bedingt erkenn· und erklär· baren — Gesetze entwickelt, während der Mensch andere, klassifizierende Systeme konstruiert hat, mit denen er die in der Natur vorkommenden 'Unord· nungen' in ein ihm verständliches Ordnungssystem einfügen möchte. Sind die *Tausend längsten Flüsse der Welt* nach keinem klar erkennbaren Plan über die Erde und die Kontinente verteilt, so bringt der Mensch diese Verteilung nach den Kriterien der Länge in eine künstliche und abstrakte Ordnung. Die Flüsse reihen sich so zu einem immensen und imaginären Fluß der Zeit und Evolution zusam· men und versinnbildlichen die unabdingbaren Gesetzmäßigkeiten der Welt.

Immer wieder sucht und untersucht Heiner Blum Gegenstände, Motive oder 'Fundstücke' seiner Umgebung, greift er auf Produkte oder Systeme zurück, die wesentliche Bestandteile unserer alltäglichen Gegenwart sind und überträgt die Vorgaben dann in metaphorisch gestaltete kombinatorische Beziehungs· einheiten. Für die Werkgruppe der *Spiele/Games*, bei der sich der Künstler vor allem auf das Wahrnehmen, Denken und Fühlen von Sprache konzentrierte, wählte er einzelne deutsche oder englische Begriffe und Worte aus. Diese ver· fremdete er teilweise durch Verkürzung um einen Buchstaben oder Vokal, durch Trennung der Worte in Begriffe und Silben sowie in zwei oder mehrere Silben oder auch durch Aufgliedern der Begriffe in zwei bis drei kurze Wörter. Die aufgesplitteten Wörter greifen dabei — aufgemalt in weißer Farbe auf schwarze konsolenartige Holzkästen — entsprechend der Wortlänge teils gering, teils weit in den Betrachterraum aus. Begriffe werden zu 'Sprachkörpern' verräumlicht. Das Lesen wird zu einem raum·zeitlichen Wahrnehmungsvorgang, der mit zahl· reichen Standortwechseln des Betrachters verbunden ist. Der Kasten wird über seine Funktion als Träger von Sprache zur Metapher für die in den jeweiligen Begriffen eingeschlossenen mehrfachen Lesbarkeiten. Das an seinen Außensei· ten stehende und im Raum 'schwebende' Wort wird zum Sinnbild und An· schauungsobjekt für Sprache an sich. Diese wird von Heiner Blum — entgegen ihrer gesellschaftlichen Funktion als objektivierbare Richtgröße, Ordnungsprin· zip und festgelegtes Kommunikationssystem — hier als ein offenes, vielschich· tiges System thematisiert.

Vom Klang der Dinge: John Cage und Robert Morris

Das Objekt *Fountain* (1963) gehört dem Frühwerk von Robert Morris an. *Fountain* ist eine direkte Paraphrase auf Duchamps wohl berühmtestes 'ready made' *Fountain*, ein umgekehrt gestelltes Urinoir, das er in New York im Jahr 1917 erstmals ausgestellt hatte und von dem der New Yorker Galerist Sidney Janis 1951 eine zweite Fassung erhielt. Wie Duchamp, so bezeichnete auch Morris einen ursprünglich für andere Funktionen bestimmten Gegenstand mit einem ironischen Titel, um das Objekt mit Hilfe des Wort· und Begriffsspiels für neue Bedeutungen zu öffnen. *Fountain* besteht aus verschiedenen vorgefundenen Gegenständen, die Morris zu einem scheinbar für eine Benutzung konzipierten

Ensemble zusammenfügte. An einer senkrechten, galgenartigen Konstruktion
aus weißen Holzbalken, die etwas über Augenhöhe des Betrachters an einer
Wand befestigt ist, hängt an einem Eisenhaken ein einfacher Gebrauchseimer
aus Zink, ursprünglich wohl ein Löscheimer. Aber nicht das Objekt selbst, son-
dern ein plätschernder Klang lockt den Besucher des Museums zunächst in die
Nähe, dann direkt zu der Arbeit. Durch den Klang wird man unweigerlich an
den Wasserstrahl einer Fontäne oder eines Springbrunnens erinnert. Das Objekt
selbst steht aber in sonderbarem Widerspruch zu dem von ihm ausgehenden
Klang. Die Verunsicherung unserer Wahrnehmung nutzt Morris dazu, uns über
den Sinn oder Unsinn einer Objektbezeichnung, eines Titels, eines Begriffs oder
eines Wortes bewußt werden zu lassen.

Als eine 'Klangplastik' mit Wassergeräuschen steht die Arbeit mit verschiede-
nen Werken von Künstlern der Fluxus-Bewegung oder der Arte Povera in Bezie-
hung, die ihrerseits wiederum in Verbindung mit der Musik von John Cage stehen.
Insofern war es fast zwingend, die in der Sammlung des Whitney Museums
vorhandene Partitur der Komposition *Water-Music* (1952) von John Cage dem
Werk von Morris gegenüberzustellen. Im Jahr 1952 erfolgte die Uraufführung
von *Water-Music*, ein Musikstück für präpariertes Klavier und verschiedene
zusätzliche Gegenstände, wie etwa ein Radio, 3 Pfeifen, ein Wasserball, 2 Wasser-
behälter, ein Kartenspiel, ein Holzstock. Nach Cage sollte es als Theaterstück
rezipiert werden, bei dem bestimmte Handlungen gleichberechtigt neben den
Geräuschen stehen. Im Vordergrund sollten aber Geräusche des Wassers stehen.[26]

Die diversen, bei Cage notierten Wassergeräusche und das reale Wasser-
plätschern in der Arbeit von Morris, rufen in uns Assoziationen an verschieden-
ste Lebenssituationen in Verbindung mit Wasser hervor. Wollte Cage durch eine
Bandbreite an Wassergeräuschen im Betrachter Bilder und Erinnerungen her-
vorrufen, so konzentrierte sich Morris primär auf den hinweisenden Klang des
Wassers, der dem aus der Lebenswelt entnommenen Gegenstand im Kontext
Museum seine funktionalen Eigenschaften in metaphorischer Weise zurückgab.

Malerei und Wirklichkeit: Eine Werkgruppe von Alex Katz

In der zentralen Halle des Museums wird als Anfang, aber auch als Ende der
Ausstellung eine umfangreiche Gruppe von Werken des Malers Alex Katz instal-
liert, die das Bild des Menschen in Form von großformatigen Porträts auf eine
sehr eigene, 'amerikanische' Art und Weise thematisiert.[27] Aus der Samm-
lung des Whitney Museums konnten die Bilder *The Red Smile* (1963) und *Place*
(1977) nach Frankfurt gebracht werden, aus der Sammlung des Künstlers
erhielten wir zusätzlich die Arbeiten *Belinda Smiles* (1993), *Ahn Smiles*, *Jessica
Smiles* und *Kathryn Smiles* (alle von 1994).[28] Katz, der in den fünfziger Jahren
mit der Malerei begonnen hat, entwickelte Ende der fünfziger Jahre einen Stil,
der auf der repräsentativen 'Zur-Schau-Stellung' der menschlichen Figur, des
Porträts, vor einer abstrahierten Landschaft oder einem monochromen
Bildgrund aufbaut.

bleeding Statue of Liberty entitled *Sacco & Vanzetti*, its raised hand holding an electric chair; see *George Grosz: Berlin–New York*, exh. cat. (Berlin: Neue Nationalgalerie, 1994), reprod. p. 85.

9. "Then I got thinking about the Sacco-Vanzetti case. They'd been electrocuted in 1927, and in Europe of course I'd seen all the demonstrations against the trial—a lot more than there were over here. Ever since I could remember I'd wished that I'd be lucky enough to be alive at a great time—when something big was going on, like the crucifixion. And suddenly I realized I was! Here I was living through another crucifixion. Here was something to paint!"; quote in Frances K. Pohl, *Ben Shahn* (New York: 1993), p. 12.

10. For a future exhibition, I would like, in this connection, to create a concentrated dialogue between several works by Sheeler and the photo series made by Bernd and Hilla Becher. A number of further substantive conclusions could be drawn from such a juxtaposition.

11. *The Storyteller* is 90³⁄₁₆ x 172 in. (229 x 437 cm.) See Robert Linsley and Verena Auffermann, *Jeff Wall: The Storyteller* (Frankfurt: Museum für Moderne Kunst, 1992).

12. Marsh's pictures and numerous drawings are related in many ways to the works of George Grosz; see *George Grosz*, p. 113 n. 27.

13. See especially the Fibonacci series Merz includes in many of his works, a mathematical series in which the following number is always the sum of the two prior numbers, corresponding to an infinite spiral, similar to the spatial model of the igloo.

14. The last part of the work's title alludes to this.

15. In this connection, it would be interesting to relate the early writings of Henri Bergson, which stress the dynamism of natural evolution, to the works of O'Keeffe.

16. Bacon's works were prompted by his critical appraisal of exemplary works of art by famous artists, which he then paraphrased in his own artistic idiom.

17. Compare, for example, the structure of information provided by an encyclopedia, in which personal or historical information always starts with the dates of a human life or an event.

18. I would like to thank Claes Oldenburg and Coosje van Bruggen for lending this work to the MMK for the exhibition.

19. See Mario Kramer's essay.

20. "The Cares of a Family Man," in *Franz Kafka: The Complete Stories*, trans. Willa and Edwin Muir (Mandarin), pp. 427–29.

21. This motif is to be encountered frequently in art history, for example in the works of Marcel Duchamp or Gerhard Richter.

22. See *Zeitgeist*, exh. cat. (Berlin: Martin Gropius Bau, 1992), p. 82; Wilhelm Bojescul, *Zum Kunstbegriff des Joseph Beuys* (Essen: Verl. Die Blaue Eule, 1985); Volker Harlan, Rainer Rappmann, and Peter Schata, *Soziale Plastik: Materialien zu Joseph Beuys* (Achberger Verlag, 1984).

23. Lothar Baumgarten, a German artist resident in New York, created a room in the MMK which consists of concepts and windowlike frames painted directly onto the plaster walls and derived from the specially shaped windows of the Whitney Museum. Baumgarten's approach resembled Ruscha's, in that Ruscha makes use of concepts seemingly pasted onto the pictorial surface, sometimes leaving black zones without a text in order to prompt

associations among viewers in the context of the installation's overall socially critical message.

24. Ed Ruscha's paintings from the early sixties exerted a special influence on Baldessari, in that they took concrete everyday motifs and linked them to words, concepts, or texts.

25. On this text, see Mario Kramer's essay.

26. John Cage has said: "At the time, by means of random operations and a diagram I established which tone was to sound at what time and with what volume. I not only entered data referring to the different sounds in the diagram, but also data that triggered an interesting action. I had heard somewhere that the earth consists of water, earth, fire, etc., and I thought it would be good to concentrate on water. Which is why I predominantly, if not exclusively, recorded events in the diagram that had to do with water.... Water from a beaker, poured into another, using a pipe that only functions with water, having the pipe disappear in the water and then re-emerge"; quoted in Richard Kostelanetz, *In Dialogue with John Cage: About Music, Art, and Mental Questions of Our Time* (Cologne: DuMont, 1989, p. 97).

27. The works displayed in the course of the various "Szenenwechsel" exhibitions have included Stephan Balkenhol's *57 Penguins*, Thomas Ruff's *Portrait* and *Other Portraits*, pictures by Sigmar Polke, and a group of works by Herbert Hamak.

28. My sincere thanks to Alex Katz for making these loans available.

Die Bilder von Katz formulieren einen allein von der subjektiven Wahrneh-
mung des Künstlers abhängigen Realismus, in dem alle Motive gezielt reprä-
sentativ wiedergegeben werden. In mehreren Werkphasen isolierte er zunächst
die Figur, dann das Porträt im Bild. Gleichzeitig erweiterte sich der Maßstab der
Bilder zu einer großformatigen, flächigen Malerei, welche Katz die Möglichkeit
bot, nicht das Individuelle, Spezifische aus den Gesichtern von Menschen her-
auszulesen, sondern das Allgemeine im Menschen zu formulieren. In den frühen
sechziger Jahren beschäftigte er sich verstärkt mit bildnerischen Ausdrucks-
möglichkeiten, die auf der subjektiven Empfindung, der Energie eines Motivs und
dem Licht basieren, aber auch mit den Gestaltungstechniken der Plakatwer-
bung bzw. des Films. In beiden, für die moderne Gesellschaft immer dominanter
werdenden Medien, fand er Sprachformen, die seinen Stil bis heute mitgeprägt
haben: Die extreme Vergrößerung von Motiven zu ihrer Verdeutlichung, die
scherenschnittartige Konzentration auf ein Gesicht oder Gegenstandsmotiv, die
Überschneidung von Motiven zur Verstärkung der optischen Wirksamkeit und
die Dramaturgie des Lichts.

Alle genannten Momente werden in den beiden großformatigen Bildern
The Red Smile und *Place* deutlich. In *The Red Smile* fällt der Blick auf das in
Dreivielansicht gemalte Porträt von Ada, der Ehefrau von Katz, vor einem
monochromen roten Hintergrund. Die Malerei wirkt zunächst flüchtig, bei
genauerer Betrachtung aber doch präzis. Physiognomische Details, Haare und
Kleidungsstücke werden in die Fläche gebreitet, so daß das 'Bild eines Porträts',
nicht ein 'Porträt' entsteht. Das Individuum wird zu einem verallgemeinerten,
unpersönlichen und für eine bestimmte Gegenwart stehenden 'Modell' vom
Menschen. Alle Details erscheinen stilisiert. Das Lachen gerät zu einer stereo-
typen Geste, die für ein positivistisches Denken der Gesellschaft steht. Die
Signalwirkung der rot gefärbten Lippen wird durch den roten Bildhintergrund
noch verstärkt. Erotische Ausstrahlung wird zur repräsentativen Geste gestei-
gert und zeigt damit die Verhaltensschemen der amerikanischen Gesellschaft
der sechziger Jahre.

In *Place* sind Porträts von Schauspielern zu einer räumlich kaum nachvoll-
ziehbaren und über die Bildfläche verteilten Gruppe zusammengeschlossen.
Katz entnahm seine Motive den 'Stills' verschiedener Filme und schuf aus ihnen
eine Collage verflachter, allgemeiner und für die Sprache des Films dieser Zeit
typischer Gesichter.

Aus der Serie der *Smiles* werden vier großformatige Porträts gezeigt, die
die Frage nach dem Individuum und seiner Selbstdarstellung neu definieren.
Auf dunkelgrauen. Bildhintergrund sind die lächelnden Porträts von *Belinda*,
Ahn, *Jessica* und *Kathryn* gemalt. Die Gesichter wirken glatt, flach und wie
ausgeschnitten Die unterschiedlichen Frauentypen werden allein durch Frisur,
Gesichtsschnitt und Gesichtsfarbe differenziert und als Individuen erkennbar.
Durch das alle Porträts verbindende stereotype 'Lächeln' werden die Gesichter
zu Schemen einer Vorstellung von Menschen oder gar Menschentypen verein-

heitlicht. Katz zeigt hier Bilder von Menschen in Porträtform, die beim Be-
trachter einen 'künstlichen' Eindruck hinterlassen und in keinem Fall etwas von
der Privatheit der porträtierten Personen preisgeben.

Anmerkungen

1. Hier wäre etwa die Ausstellungsreihe der Kunst- und Ausstellungshalle der Bundes-
republik Deutschland in Bonn zu erwähnen, die unter dem Titel "Die Großen Sammlungen
I-V" seit 1994 die Bestände großer Museen vorstellt.

2. Die Idee des "musée imaginaire" stammt ursprünglich von André Malraux, der in
seinem Buch *Stimmen der Stille* aus dem Jahr 1956 die Vorstellung von einem 'Museum der
Reproduktionen' entwickelte, das Menschen die Möglichkeit bietet, neben den auf Reisen
gesehenen und im Gedächtnis bewahrten Kunstwerken Werke aller möglichen Zeiten und
Kulturen in einem 'imaginären Museum im Kopf' zusammenzuführen.

3. Die im New Yorker Whitney Museum stattfindende Ausstellung formuliert eine
inhaltliche Fortsetzung des Frankfurter Ausstellungsteiles und konzentriert sich vor allem
auf solche Werkdialoge, die auf Werkgruppen von jüngeren Künstlern aus der Sammlung
des MMK basieren und wichtige zusammenhängende Blöcke der modernen und zeitgenössi-
schen Kunst aus den Beständen des Whitney Museums als Kontrapunkte dagegensetzen.
Hierdurch werden einige aus der Frankfurter Sammlung abgeleitete inhaltliche Leitlinien und
konzeptuelle Grundgedanken bis in die Zeit der jüngsten Gegenwart hinein erweitert und
akzentuiert verdeutlicht.

4. Seit Eröffnung des Museums für Moderne Kunst am 6. Juni 1991 wurden bisher nur
drei kleinere Sonderausstellungen durchgeführt: Zum 6. Juni 1991 *Carl Andre: Extraneous
Roots*, im Karmeliterkloster; Im Rahmen des *Szenenwechsel V*, 1994, die Präsentation der
frühen Bilder von *On Kawara* aus den Jahren 1952–56 und im Rahmen des *Szenenwechsel X*,
die Ausstellung des zeichnerischen Frühwerks von *Kawara* aus den Jahren 1955/56.

5. Vgl. Hans Ulrich Reck, *Siah Armajani: Sacco und Vanzetti Leseraum*, Museum für
Moderne Kunst, Frankfurt am Main 1990.

6. Shahn hatte vor der Entstehung des Bildes nach Vorlage von Zeitungsfotos innerhalb
von sieben Monaten eine Serie von 23 Gouachen gemalt, mit der er seinen ersten öffentlichen
Erfolg als Künstler hatte. (Zuvor war er als Illustrator tätig). Das Bild wurde zusammen mit
dem Entwurf für ein Wandbild erstmals in einer Ausstellung im MOMA New York 1932 gezeigt.

7. Zitat Reck, a.a.o. S. 5.

8. Bereits im Jahr 1927 hatte George Grosz eine Zeichnung mit dem Titel *Sacco &
Vanzetti* mit der blutenden und in der rechten erhobenen Hand einen elektrischen Stuhl hal-
tenden Freiheitsstatue angefertigt, mit der er einen bissigen Kommentar auf den politischen
Skandal in Amerika äußerte. Vgl. den Katalog *George Grosz: Berlin—New York*, Neue
Nationalgalerie, Berlin 1994, Abb.S. 85.

9. Er schrieb damals: "Then I got thinking about the Sacco-Vanzetti case. They'd been
electrocuted in 1927, and in Europe of course I'd seen all the demonstrations against the
trial—a lot more than there were over here. Ever since I could remember I'd wished that I'd

be lucky enough to be alive at a great time — when something big was going on, like the crucifixion. And suddenly I realized I was! Here I was living through another crucifixion. Here was something to paint!" Zitat entnommen aus Frances K. Pohl, *Ben Shahn: Writings*, New York 1993, S. 12.

10. Als ein Desiderat für eine zukünftige Ausstellung möchte ich in diesem Zusammenhang einen konzentrierten Dialog aus mehreren Werken Sheelers mit den Fotoserien von Bernd und Hilla Becher formulieren, aus dem sich eine Reihe weiterer inhaltlicher Ansätze ableiten ließe.

11. *The Storyteller* ist 229 x 437 cm groß. Vgl. Robert Linsley/Verena Auffermann, *Jeff Wall: The Storyteller*, Museum für Moderne Kunst, Frankfurt am Main 1992.

12. Marshs Bilder und zahlreiche Zeichnungen sind unter vielen Aspekten den Arbeiten von George Grosz verwandt. Vgl. Katalog *Grosz*, a.a.O., Anm. 27, S. 113.

13. In dieser Hinsicht ist auch der letzte Teil des Werktitels zu verstehen.

14. Vgl. hierzu vor allem auch die von Merz in viele seiner Arbeiten einbezogene Fibonacci-Reihe, eine mathematische Reihe, bei der sich die folgende Zahl jeweils aus der Summe der beiden vorherigen Zahlen ergibt und damit einer ins Unendliche verlaufenden Spirale entspricht, ähnlich dem räumlichen Modell des Iglus.

15. In diesem Zusammenhang wäre es interessant, die frühen Schriften Henri Bergsons, in denen die Dynamik natürlichen Werdens thematisiert wird, mit den Werken O'Keeffes in Beziehung zu setzen.

16. Das Gesamtwerk Bacons wird immer wieder durch die Auseinandersetzung mit vorbildhaften Kunstwerken berühmter Künstler aus der Kunstgeschichte angeregt, die er als Paraphrasen in seine eigene Sprache übertrug.

17. Vgl. etwa die Informationsstruktur eines Konversationslexikons, in dem persönliche oder historische Informationen stets mit den Daten eines Menschenlebens oder eines Ereignisses beginnen.

18. Für die von Claes Oldenburg und Coosje van Bruggen für die Ausstellung zur Verfügung gestellte Leihgabe sei an dieser Stelle herzlich gedankt.

19. Vgl. hierzu den Text von Mario Kramer.

20. Franz Kafka, *Die Sorge des Hausvaters* (1919), in: *Sämtliche Erzählungen*, Frankfurt am Main 1970, S. 139f.

21. Dieses Motiv ist ein in der Kunstgeschichte sehr verbreiteter Topos, so etwa bei Marcel Duchamp oder Gerhard Richter.

22. Vgl. Katalog *Zeitgeist*, Martin-Gropius-Bau, Berlin 1982, S. 82; Wilhelm Bojescul, *Zum Kunstbegriff des Joseph Beuys*, Essen 1985; Volker Harlan/Rainer Rappmann/ Peter Schata, *Soziale Plastik. Materialien zu Joseph Beuys*, Achberg 1984.

23. Die Bilder Ruschas konnten erfreulicherweise aus der Emily Fisher Landau Collection ausgeliehen werden, der wir hierfür herzlich danken.

24. Von besonderem Einfluß auf Baldessaris Werke waren die Bilder Ed Ruschas aus den frühen sechziger Jahren, in denen konkrete Alltagsmotive in Verbindung mit Worten, Begriffen oder Texten auftauchen, ebenso wie seine Fotoserien aus den Büchern *Twentysix Gasoline Stations* und *Every Building on the Sunset Strip*.

25. Vgl. hierzu den Text von Mario Kramer mit Abbildung S. 134.

26. "Damals ermittelte ich anhand von Zufallsoperationen und einem Diagramm, welcher Klang zu welcher Zeit und mit welcher Lautstärke ertönen sollte. Ich trug in das Diagramm einfach nicht nur Daten ein, die auf einen Klang verwiesen, sondern auch solche, die eine interessante Handlung in Gang setzten. Irgendwo hatte ich gehört, daß die Erde aus Wasser, Erde, Feuer usw. besteht; und ich dachte, es wäre gut, sich auf das Wasser zu konzentrieren. Deshalb verzeichnete ich im Diagramm überwiegend, wenn auch nicht ausschließlich, Gegebenheiten, die mit Wasser zu tun haben ... Wasser von einem Becher, in einen anderen gießen, eine Pfeife benutzen, die nur mit Wasser funktioniert, diese Pfeife im Wasser verschwinden und wieder auftauchen zu lassen." Zitat John Cage, entnommen aus Richard Kostelanetz, *John Cage im Gespräch: Zu Musik, Kunst und geistigen Fragen unserer Zeit*, Köln 1989, S. 97.

27. Hier wurden in verschiedenen *Szenenwechseln* unter anderem die *Pinguine* von Stephan Balkenhol, die *Porträts* und *Anderen Porträts* von Thomas Ruff, Bilder von Sigmar Polke und eine Werkgruppe von Herbert Hamak gezeigt.

28. Für die Leihgaben möchte ich Alex Katz sehr herzlich danken.

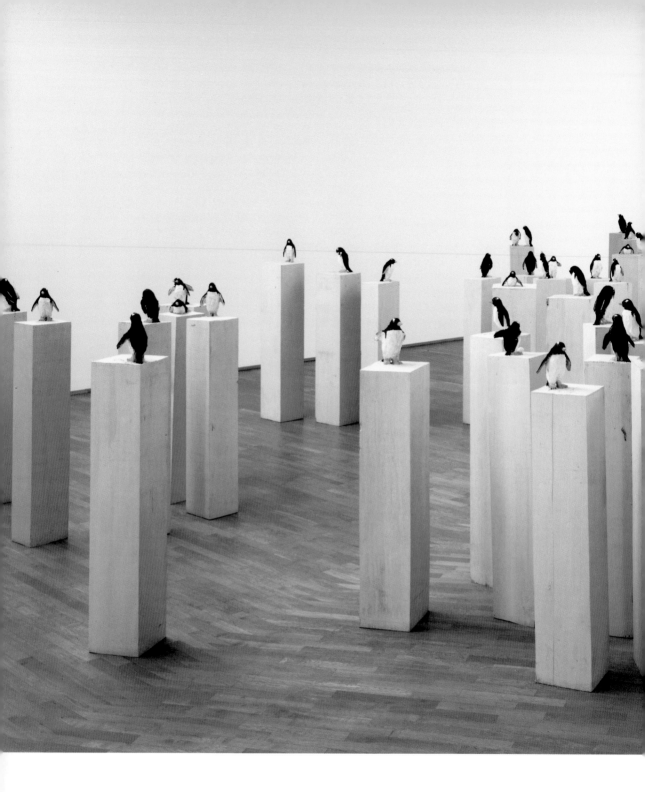

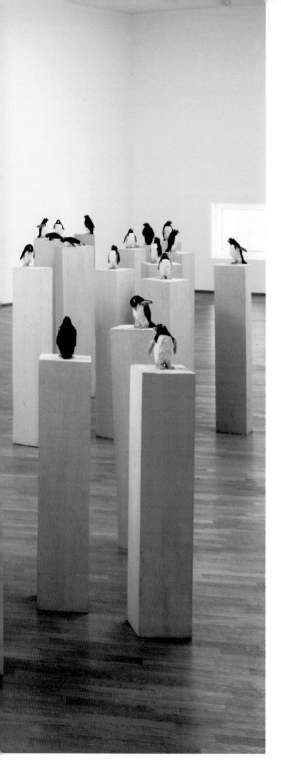

Stephan Balkenhol
57 Pinguine (57 Penguins), 1991

Reiner Ruthenbeck
Umgekippte Möbel (Tipped-Over Furniture), 1971
(Frankfurt version, 1993)

Vija Celmins
Heater, 1964

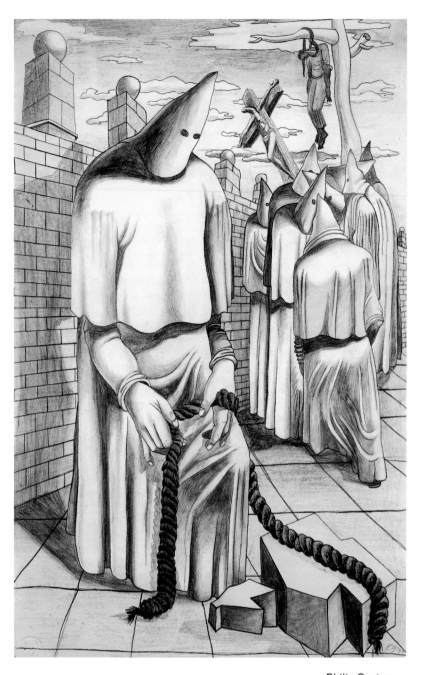

Philip Guston
Drawing for Conspirators, 1930

Rosemarie Trockel

Ohne Titel — Daddy's Striptease Room

(Untitled — Daddy's Striptease Room), 1990

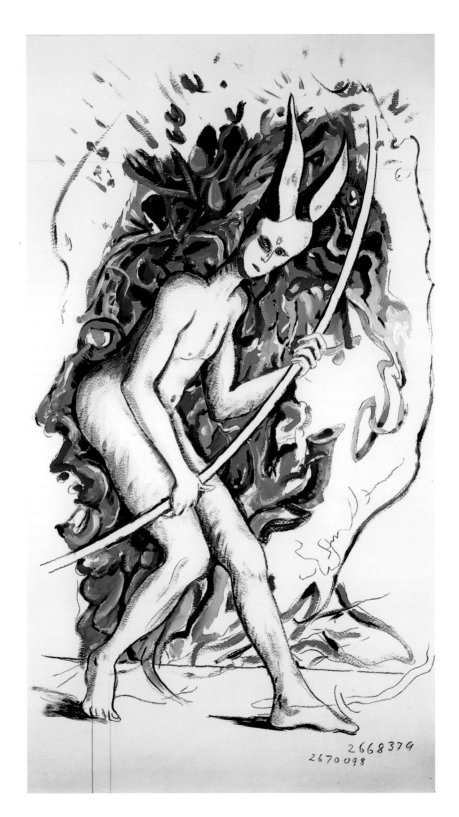

Jonathan Borofsky
Self-Portrait at
2668379 and 2670098,
1979–80

Jonathan Borofsky
5836429, 1994

Ellsworth Kelly
Briar, 1963

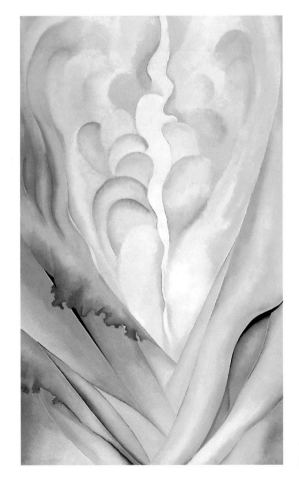

Georgia O'Keeffe
Flower Abstraction, 1924

Udo Koch
Clivia III, 1990

Stephan Melzl
Ohne Titel (Untitled), 1992

Charles Ray
Boy, 1992

Jochen Flinzer

Hertie Kinderplatte (**Hertie's Children's Embroidery Pattern**), 1989, side A and side B

Edward Hopper
House on the Cape, 1940

Martin Honert
Foto (**Photo**), 1993

Robert Gober
Untitled, 1994

Robert Gober
Ohne Titel — Behaarter Schuh
(**Untitled — Hairy Shoe**), 1992

AN ARTIST IS NOT MERELY THE SLAVISH
ANNOUNCER OF A SERIES OF FACTS.
WHICH IN THIS CASE THE CAMERA HAS
HAD TO ACCEPT AND MECHANICALLY
RECORD.

John Baldessari

An Artist Is Not Merely the Slavish Announcer..., 1967–68

Andreas Slominski

Ohne Titel (Untitled), 1993

Vija Celmins
Heater, 1964 (detail)

To Fix the Image in Memory[1]
Mario Kramer

Dem Bild einen festen Platz im Gedächtnis verleihen[1]
Mario Kramer

*I began to face my own art when
I went out to L.A. from Indiana.
For one thing, it was the first time
I had been away from my parents
and I missed them. Also, for the
first time I had a giant, empty stu-
dio with some secondhand, ordinary
things in it: chairs, tables, lamps,
a TV, my hot plate. I started pulling
back into myself and painting what
I was seeing. I painted the things
in my studio; I painted just about
everything. Then, as I got more
involved with myself and my memo-
ries as subject matter, I moved
back into my childhood, into the
war years, as subject matter.
I never considered whether that
was masculine or feminine.*
—Vija Celmins[2]

This exhibition is meant to shed
light on European and American
positions in contemporary art,
and illustrate the manner in
which they influence each other.
The selection of art works for the
exhibition is based neither on a
strict chronology nor on classifi-
cations taken from art history.

*Ich habe meiner eigenen Kunst erst wirklich ins Gesicht
geschaut, als ich von Indiana nach L.A. ging. Zum einen
lebte ich damit zum ersten Mal von meinen Eltern
getrennt, und ich vermißte sie. Zum anderen, verfügte
ich zum ersten Mal über ein riesiges, gähnend leeres
Atelier, es war mit einigen gewöhnlichen gebrauchten
Gegenständen wie Stühlen, Tischen, Lampen, einem
Fernseher und meiner Heizplatte ausgestattet. Ich fing
damit an, in mich zu gehen und das zu malen, was ich
sah. Ich malte die Gegenstände in meinem Atelier:
ich malte mehr oder weniger alles. Dann, je mehr ich
mich mit mir selber und meinen Erinnerungen als
Thema meiner Arbeit beschäftigte, desto mehr stieß
ich auf meine Kindheit, auf jene Kriegsjahre als Thema.
Ich habe mir nie Gedanken darüber gemacht, ob das
eine männliche oder eine weibliche Vorgehensweise war.*
—Vija Celmins[2]

In dieser Ausstellung werden sowohl europäische als
auch amerikanische Positionen der Gegenwartskunst
in ihrer gegenseitigen Wirkungsweise beleuchtet.
Die Werkauswahl wurde dabei weder von chronolo-
gisch-historischen noch kunsthistorischen Kategorien
bestimmt. Vielmehr können Werke von Künstlern
verschiedener Generation und Herkunft miteinander
in einen vielfältigen Dialog treten, und die unter-

After all, the works of artists of different generations and backgrounds poten-
tially interact in numerous ways. And a wide range of artistic techniques co-
exists today, each just as important as the next. The focus is consequently on
the essence of the individual works and the creative thought of the individual
artists. Moreover, how you view contemporary art often determines how you
view an older work. Time and again, individual works from the one collection
suggested a correspondence with a work in the other collection. Furthermore,
bringing together works by the same artist from both collections also prom-
ised to be fascinating, yielding new perspectives on entire groups.

The exhibition starts the moment you set foot in the Whitney Museum. In
the lobby is a highly suggestive work that forms a bond between New York and
Frankfurt. Like an enormous doorman, Jonathan Borofsky's *Hammering Man
at 2715346* (1981) stands there to greet you. Since 1991, the statue's younger,
but much larger brother has had a place next to Frankfurt's Trade Fair Tower,
designed by architect Helmut Jahn, and has become a landmark of the city of
Frankfurt. The Trade Fair Tower is one of the largest office skyscrapers in
Europe, and houses the head offices of numerous international companies.
Together with *Hammering Man at 2715346*, it constitutes a symbolic gateway to
the city of Frankfurt. The idea for *Hammering Man* dates back to 1980. The
New York version is, in fact, one of the earliest examples. From the beginning it
was conceived as an allegory, an archetypal symbol for a person engaged in
mechanical, motor-driven work. It resembles the enormous, cut-out silhouette of
a man and, deliberately, seems anonymous. What is decisive is the rhythm of
the man's hammering—a slow, concentric raising and lowering of the right arm
to the rhythm of two breaths in, two breaths out. The rhythm of our breathing
determines the rhythm of our work, and, ultimately, that of our lives. With calm
regularity, this rhythm forces its way into our consciousness, thus setting the
tone for those attending the exhibition.

The lobby, with its large glass facade, comprises a kind of public space
within the museum: here, the visitor finds a juxtaposition of two artists who
reflect on the location and the presence of art, above all through language.
Here, There & Everywhere, made in 1989 by Lawrence Weiner, corresponds to
the tripartite piece by Rémy Zaugg entitled *UND, WENN ICH EINEN UNREIFEN
APFEL ESSE, DAS GIFTIGE GRÜN NICHT MEHR VORHANDED WÄRE* (*AND IF,
WHEN I EAT AN UNRIPE APPLE, ACID BRIGHT GREEN WOULD CEASE TO EXIST*),
dating from 1978–91. Since the 1960s, both artists have concentrated on the
theme of perception and use writing as the basis for their works. The idea
that someone could eat an unripe apple and that the bright green would disap-
pear forever is a disturbing image. Rémy Zaugg, a native French speaker, has
given this idea artistic form in three different languages, each treated as a sepa-
rate image. Looking at an apple, digesting an image, tasting a poisonously
bright green. The four-fold rhythm of the captions in Lawrence Weiner's work—
Away from, *Beneath*, *All over*, and *Above It all*—likewise finds a pendant in

schiedlichsten künstlerischen Techniken stehen sich gleichwertig gegenüber. Dabei stehen das Einzelwerk in seinem Wesen und das individuelle bildnerische Denken der Künstler im Vordergrund. Gerade der Blick durch die zeitgenössische Kunst verändert oftmals die Betrachtungsweise einer historischen Arbeit. Immer wieder gaben Einzelwerke aus der einen Sammlung Anlaß, einen entsprechenden Partner aus der anderen Sammlung auszuwählen. Reizvoll erschien zudem das Zusammenführen von Werken des gleichen Künstlers aus beiden Sammlungen. So konnten neue Perspektiven auf Werkgruppen eröffnet werden, wie etwa die Arbeiten von Richard Artschwager oder Robert Gober.

Die Ausstellung findet ihren Auftakt bereits in der Eingangshalle des Whitney Museums mit einem beziehungsreichen Werk, das beide Städte, New York und Frankfurt, miteinander verbindet. Einem riesigen Türwächter vergleichbar, erwartet die Besucher im Eingangsbereich Jonathan Borofskys *Hammering Man at 2715346* von 1981. Sein jüngerer, aber wesentlich größerer Bruder steht seit 1991 neben dem Frankfurter Messeturm des Architekten Helmut Jahn. Er wurde zu einem Wahrzeichen der Stadt Frankfurt. Der Messeturm ist eines der größten Bürohochhäuser Europas, und er wurde zum Sitz von zahlreichen Firmen aus aller Welt. Zusammen mit dem *Hammering Man at 3307624* bildet er ein Einfallstor in die Stadt Frankfurt. Der *Hammering Man* geht in seiner Konzeption auf das Jahr 1980 zurück (und damit handelt es sich bei dem New Yorker Werk um eines der frühesten Beispiele) und war von Anbeginn in seinem Gleichnischarakter als archetypisches Zeichen für den motorisch arbeitenden Menschen gedacht. Seine Gestalt gleicht der riesigen herausgesägten Silhouette einer männlichen Figur und wirkt bewußt anonymisiert. Entscheidend ist der Rhythmus seiner hämmernden Bewegung — dieses langsame, konzentrische Heben und Senken des rechten Armes im Rhythmus von zweimal Ein- und zweimal Ausatmen. Der Rhythmus unseres Atmens bestimmt den Rhythmus unserer Arbeit und letzlich den unseres Lebens. Ruhig und gleichmäßig dringt der Rhythmus in unser Bewußtsein und schafft damit einen Grundton für die Besucher dieser Ausstellung.

Im Foyer, durch die großen Glaswände der Fassade hindurch, kommt es zur Gegenüberstellung von zwei Künstlern, die vor allem mit den Mitteln der Sprache ganz grundsätzlich den Ort und die Anwesenheit von Kunst reflektieren. Die Arbeit von Lawrence Weiner *Here, There & Everywhere* von 1989 findet ihre Entsprechung in der dreiteiligen Arbeit von Rémy Zaugg *UND, WENN ICH EINEN UNREIFEN APFEL ESSE, DAS GIFTIGE GRÜN NICHT MEHR VORHANDEN WÄRE.* von 1978–1991. Beide Künstler beschäftigen sich seit den sechziger Jahren mit dem Thema der Wahrnehmung und verwenden die Schrift als Bild. Die Vorstellung, daß jemand einen unreifen Apfel äße, und das giftige Grün für immer verschwände, ist ein bestürzendes Bild. Rémy Zauggs Muttersprache ist Französisch, und er hat diese Vorstellung in drei Sprachen, jede als gesondertes Bild, realisiert. Einen Apfel anschauen, ein Bild verdauen, ein giftiges Grün schmecken. Der Viererrhythmus der Zeilen von Lawrence Weiner *Here, There & Everywhere* mit den Bezeichnungen *Away from*, *Beneath*, *All over* und *Above it all* findet sein

Gegenüber ebenfalls in den kleinformatigen Gemälden Rémy Zauggs *ICI*, *HIER* und *DORT* (1989–90). Beide Künstler schaffen Wahrnehmungsmodelle, die stets von einer bestimmten Situation ausgehen. Es geht dabei um die Ortung des Kunstwerkes/Bildes und des Betrachters/Lesers und ganz generell um die Reflektion des Betrachtens.

Die Computerzeichnungen von Manfred Stumpf, ebenfalls in der Lower Gallery, sind wie Jonathan Borofskys *Hammering Man* für ein umfangreiches Projekt im öffentlichen Raum in Frankfurt 1992 entstanden.[3] Bei dem soge-nannten Esel-Zyklus (1990) handelt es sich um Entwurfszeichnungen für ein in schwarzen und weißen Mosaiksteinchen ausgeführtes, insgesamt über 200 Meter langes Wandbild einer Frankfurter U-Bahnstation. Die Zeichnungen entstanden am leuchtenden Bildschirm des Computers. Als Zeichenwerkzeug und Hilfsmittel stellt der Computer für Manfred Stumpf die konsequente Weiterführung einer präzisen Linienführung in seinen frühen Rapidograph-Zeichnungen dar. Die Arbeit am Computer ist für Manfred Stumpf zudem die zeitgenössische Form der Exerzitien des Künstlers/Mönches als Forscher.

Der Besucher wird im eigentlichen Ausstellungsbereich, im vierten Stock des Whitney Museums, von *57 Pinguinen*, einer Art Begrüßungskomitee von Stephan Balkenhol, empfangen.[4] Das Werk von 1991, eine immense skulpturale Arbeit, wurde in nur zehn Tagen und Nächten vollendet. Jeder Pinguin ist ein Einzel-wesen, das aus seinem eigenen Vierkantsockel mit großer innerer Vorstellungs-kraft und bildnerischem Instinkt herausgehauen wurde. Jedes individuelle Tier ist dennoch Teil einer Gesellschaft. Sie bilden alle zusammen eine Kolonie von Pinguinen auf einer Eismeerlandschaft. Die roh behauene Oberfläche der Skulpturen korrespondiert mit der Textur der comicartigen Filzstiftzeichnungen von Jenny Holzer mit dem Titel *Studies for Unex Sign #1* von 1983. Die Künst-lerin schafft gleichsam ein Vokabular von Signets, das durch unsere mediale Seherfahrung geübt ist.

Die spröde farbige Fassung der Holzskulpturen von Stephan Balkenhol lenkt den Blick im weiteren auf den malerischen Duktus eines Bildes von Alex Katz und läßt vor allem an dessen Werkgruppe der Cut-outs denken. Die fünf groß-flächigen Porträts (zwei Frauen und drei Männer) in dem Gemälde *Place* von 1977 begegnen den ebenso jungen Menschen in den Straßenszenen der groß-formatigen Fotoarbeiten von Beat Streuli, die in Paris, Chicago und Seattle ent-standen sind.[5] Das Verhältnis von Distanz und Nähe—auch des Individuums im öffentlichen Raum—aber ebenso des Betrachters zum Werk wird bei beiden Künstlern in ähnlicher Weise thematisiert. Sowohl Alex Katz als auch Beat Streuli beschäftigt, wie man dem immerwährenden Fluß von Bildern den Augenblick entreißt. Beide Künstler zeigen Menschen in selbstbewußtem Habitus, mit sich selbst beschäftigt, wie in einer Momentaufnahme von Nachdenklichkeit oder Innehalten, Filmstills vergleichbar. Porträts stehen im Mittelpunkt beider Werke. Unsere Aufmerksamkeit wird auf das Beiläufige, auf unsere alltäglichen Erfah-

Zaugg's small-format paintings *ICI*, *HIER* and *DORT* (*HERE*, *HERE*, and *THERE*, 1989–90). Both artists create models for modes of perception that are always based on the presumed existence of a particular situation. In works that reflect on the act of viewing, they pinpoint the coordinates of art/image and viewer/reader.

Like Jonathan Borofsky's *Hammering Man*, the computer graphics by Manfred Stumpf, in the Lower Gallery, were created as part of an extensive project designed for a public space in Frankfurt in 1992.[3] The so-called *Donkey Cycle* (1990) consists of sketches, generated by a glowing PC screen, made in preparation for a 200-meter-long mural in a Frankfurt subway station, and there executed in a black-and-white mosaic. For Manfred Stumpf, the computer is a drawing tool that represents the logical continuation of the precise lines of his earlier rapidograph drawings. Furthermore, Stumpf considers computer-generated art a contemporary form of the spiritual exercises of artist-monks.

In the main exhibition area, on the fourth floor of the Whitney Museum, the visitor is received by a sort of welcoming committee of *57 Pinguine* (*57 Penguins*), created by Stephan Balkenhol.[4] This immense sculpture was completed in just ten days and nights by the artist in 1991. Each penguin is an individual entity, carved out of its own square timber base with great inner vision and creative intuition. Yet each individual bird is nonetheless part of a community. Taken together, the sculptures form a colony of penguins against a polar landscape. Their rough surfaces correspond to the texture of the felt-tip, comic-strip drawings by Jenny Holzer entitled *Studies for Unex Sign #1*, made in 1983. Holzer has, as it were, created a language of logos that is refined by the way we see things through our experience of the media.

The dry, colorful setting of Balkenhol's wooden sculptures also directs the gaze to the painting of Alex Katz, particularly his group of cut-outs. The five large-scale portraits (two women and three men) in Katz's painting *Place* (1977) encounter the equally young people in the street scenes of the large-size photographs Beat Streuli took in Paris, Chicago, and Seattle.[5] Both artists ask how distance and proximity are related—not just between individuals in the public domain, but also between the viewer and the work. Wresting a given moment from the endless stream of images, they show self-absorbed people with a confident demeanor, as if in a snapshot taken while pausing for thought, comparable to freeze-frames. Katz and Streuli call our attention to the incidental, to everyday events, and priorities or hierarchies seem to fall by the wayside. Image, space, depth, composition, and tonal values are in perfect balance. On another, more abstract level, the works of both artists can be considered in terms of the relationship between sharp focus and blurred lines.

Drawing for Conspirators, an early work by Philip Guston, was completed in 1930 when the artist was just seventeen.[6] It prompted a juxtaposition with the large drawing by Jonathan Borofsky entitled *Self-Portrait at 2668379 and*

2670098, dating from 1979–80, as well as with a group of drawings by Rosemarie Trockel. Trockel's drawings have, moreover, been supplemented with an exemplary sculpture bearing the subtitle *Daddy's Striptease Room*, which she made in 1990, as well as two of her *Strickbilder (Knitted Pictures)* from the same period. Guston's drawing, which openly attests to the influence of the modern masters, particularly De Chirico, on the young artist exudes a surprisingly powerful aura.[7] It was made at the very beginning of his career, along with images of racism and his own experience of the physical and political power of terrorism. However, the drawing also manifests Guston's early feeling for irony and paradoxical situations. Guston turned to Abstract Expressionism around 1950, but after 1968 again took up figurative themes, which initially seemed absurd to some observers. His resonant later work, represented in this exhibition by *Close-Up*, a painting of 1969, and a 1980 drawing, almost seem to be an attack on fellow artists such as Rothko, Still, and Newman. The works certainly expose the superficial piety and much-vaunted sublimeness of the Abstract Expressionists. The themes and techniques used in Guston's earlier works reappear with caustic humor — for instance, Ku Klux Klan members as comic-strip figures, complete with dunce caps, who strip off their disguises in a horrifying way to reveal the painter himself.

A similar kind of self-portrait appears not only in Borofsky's *Hammering Man*, but also in his drawings. *Self-Portrait at 2668379 and 2670098* shows a satyr-like male figure with a rod engaged in an irrational game with the two spatially distinct numbers. Here, Borofsky has given his self-portrait long, pointed animal ears.[8] The figure is trying to find its way through an indeterminate, perhaps cosmic space, as if its perceptual abilities had been enhanced by means of antennae. This drawing is one of Borofsky's murals, and the format is derived from the natural dimensions of the person it depicts. The drawing is based on a smaller work of the same name created on a page from a notebook.[9] Borofsky has often projected images onto a wall in order to create mural drawings. In doing so, he has transformed the sketch-like side of drawing into something instilled with a unique quality of its own. He consequently gives those sheets which he later continues working up in this way two numbers, which he then, in turn, assigns to the respective drawing, a sort of artistic bookkeeping. In both his writing and his drawing, these images have always centered on the spatio-temporal continuum, and the idea of a tangible eternity. All his works bear a seven-digit number that marks their date of origin during Borofsky's obsessive counting process. Borofsky understands this code as a signature; seeing "his seven-digit numbers as a kind of drawing — as if he were drawing out a temporal 'line.'"[10] *5836429*, dating from 1994, is a series of numbers made of fragile wires molded by hand. Part of the MMK collection, it seems to be the logical extension of the artist's system of number-work identification. Yet here Borofsky seems less like a rationalist and more of a mystic attempting to visualize a metaphysical condition.

rungen gelenkt, Prioritäten und Hierarchien scheinen wegzufallen. Hinzu kommt eine gewisse Anonymität der Figuren wie der Orte. Sowohl in der Malerei als auch in der Fotografie halten sich Bild, Raum, Tiefe, Komposition und die Grau- oder Farbwerte genau die Waage. In dem Verhältnis von Schärfe und Unschärfe kann man die Werke beider Künstler auch abstrakt betrachten.

Philip Gustons[6] frühe Zeichnung *Drawing for Conspirators* von 1930, des damals Siebzehnjährigen, gab Anlaß für eine Gegenüberstellung mit der groß- formatigen Zeichnung von Jonathan Borofsky *Self-Portrait at 2668379 and 2670098* von 1979–80 und einer Werkgruppe von Zeichnungen von Rosemarie Trockel, ergänzt durch eine exemplarische Skulptur mit dem Untertitel *Daddy's Striptease Room* von 1990 und zwei Strickbilder aus dem gleichen Zeitraum.[6] Die Ausstrahlung der Zeichnung von Philip Guston, die ganz offen seine Anleihe bei modernen Meistern, insbesondere de Chirico, enthüllt, ist überraschend stark.[7] Sie steht am Anfang seiner Karriere mit Bildern von rassistischem Terror und seiner eigenen Erfahrung der physischen und politischen Kraft von Terroristen. Spürbar wird aber auch Gustons früher Sinn für Ironie und para- doxe Situationen. Nach Gustons Hinwendung zum Abstrakten Expressionismus ab 1950, erschien es zunächst absurd, daß die spirituelle Landschaft seines Frühwerkes ab 1968 zunächst in Zeichnungen wiederkehrte. Sein fulminantes Spätwerk, in dieser Ausstellung mit dem Gemälde *Close-Up* von 1969 und einer Zeichnung von 1980 vertreten, erscheint geradezu als ein Attacke gegen Künstlerkollegen wie Rothko, Still und Newman, jedenfalls gegen die oberfläch- liche Frömmigkeit und ihre vielgerühmte Sublimität. Mit beißendem Humor erscheinen die Themen und Techniken seiner früheren Werke wie die Ku-Klux- Klan-Figuren in Form von Comic-Figuren, mit der Narrenkappe sogar, die sich auf erschreckende Weise demaskieren und den Maler selbst offenbaren.

Vergleichsweise Selbstbildnerisches ist nicht nur im bereits vorgestellten Werk *Hammering Man* von Jonathan Borofsky vorzufinden, sondern vor allem in seinen Zeichnungen. Die großformatige Arbeit auf Papier *Self-Portrait at 2668379 and 2670098* zeigt eine satyrhafte männliche Figur mit Stab im irrationalen Spiel der beiden auseinanderliegenden Nummern. Borofsky hat hier sein Selbst- bildnis mit lang zugespitzten Tierohren gestaltet.[8] Die Figur sucht ihren Weg durch einen unbestimmten, vielleicht kosmischen Raum, als sei ihre Wahrneh- mung mit Hilfe von Antennen gesteigert. Die Zeichnung steht im Kontext der Wandzeichnungen Borofskys, und ihr Format leitet sich aus der natürlichen Größe der dargestellten Person ab. Die Zeichnung geht zurück auf eine gleich- namige, kleinformatige Arbeit auf Notizblockpapier.[9] Borofsky hat mehrfach mit Hilfe von Projektionen Wandzeichnungen ausgeführt und dabei das Skizzen- hafte einer zeichnerischen Notiz in eine ganz eigene Qualität überführt. Solche später weiterbearbeiteten Blätter tragen daher zwei Nummern, die auf die jeweiligen Zeichnungen, scheinbar buchhalterisch, übertragen wurden. Sowohl zeichnend als auch schreibend kreisen Borofskys Vorstellungen seit jeher um das Raum-Zeit-Kontinuum und die Vorstellung von denkbarer Unendlichkeit.

In einer universalen Linie tragen alle seine Werke eine zeitbezogene siebenstellige Nummer, die dem aktuellen Stand des "Counting" entspricht. Diese Zahl schafft eine konzeptuelle Einordnung in die Zeit, sprich das Oeuvre des Künstlers. Diese Code-Unterschrift wird von Borofsky als Signatur verstanden: "Borofsky versteht sein millionenschweres Zählen als eine Art von Zeichnung: als das Ausziehen einer zeitlichen 'Linie'."[10] So erscheint auch das Werk "5836429" von 1994, eine Zahlenfolge aus fragilem handgeformtem Draht, aus der Sammlung des MMK, als eine konsequente Fortsetzung der Identität von Zahl und Werk. Der Künstler Jonathan Borofsky erscheint uns dabei weniger als Rationalist, vielmehr als Mystiker, der einen metaphysischen Zustand anschaulich zu machen sucht.

Mystisches und Religiöses beschäftigt die Künstlerin Rosemarie Trockel in gleicher Weise wie das Spannungsverhältnis von Askese und Ekstase. Die Gleichzeitigkeit von Abwehr und Zustimmung in den sprechblasenartigen Motiven der Strickbilder schaffen ein Paradox. *Bitte tu mir nichts — Aber schnell* und *What - If / Could - Be* sprechen von Phantasien und Obsessionen, bei denen der männliche Betrachter in eine voyeuristische Position gerät. Das Stricken als "weibliches" Tun unterstreicht die absurde Widersprüchlichkeit des Textes ebenso wie die scheinbare Naivität der Sprache von Comic-Figuren. Die zentrale Skulptur in diesem Raum *Ohne Titel* (*Daddy's Striptease Room*) von 1990 zeigt den an allen vier Seiten mit Fenstereinschnitten versehenen Verpackungskarton eines Fernsehers, der im Inneren wie in einem Reliquienschrein das von der Künstlerin leicht veränderte historische Modell des Kölner Doms birgt. Für die veränderte Beschriftung verwendete Rosemarie Trockel die firmeneigene Typographie. In einer ironischen Verbindung werden tradierte rituelle Formen wie die Beichte (Kirche), voyeuristische Enthüllungen (Fernsehen) und Erziehungsmechanismen (Vater-Tochter-Beziehungen) und ihre entsprechenden Klischees von Männlichem und Weiblichem hinterfragt. Aber vor allem die Gruppe von 19 Zeichnungen von 1983–1989 bilden mit Blättern wie *Ohne Titel (Satyr)* und *Ohne Titel (Negermaske)*, um nur einige Beispiele zu nennen, das Bindeglied zu den Werkgruppen von Philip Guston und Jonathan Borofsky.

John Baldessaris frühe Werkgruppe der Fotoemulsionsbilder imitieren ähnlich wie die Siebdruck-Bilder Andy Warhols und Robert Rauschenbergs ein "Gemälde", und er bedient sich einer vergleichsweise "unkünstlerischen" Technik. Wie Ed Ruscha entwickelte Baldessari sein Werk Anfang der sechziger Jahre unter der Verwendung von Schrift (Typographie) und Bild (Fotografie) und integriert damit Sprache als wesentlichen Bestandteil der Wahrnehmung von Kunst. Eine exzellente Gruppe von "Text-Bildern" in Form von Zeichnungen und Gemälden Ed Ruschas aus dem Zeitraum von 1962–1989, vor allem aber seine Fotoserie der *Gasoline Stations*, ergänzen in einem weiteren Raum dieser Ausstellung diesen Aspekt der amerikanischen Kunst der Westküste.

John Baldessaris Werk von 1967–68 *An Artist Is Not Merely the Slavish Announcer of a Series of Facts, Which in This Case the Camera Has Had to Accept*

Rosemarie Trockel also explores things mystical and religious, along with
the tension between asceticism and ecstasy. Paradoxically, defensiveness and
acquiescence coexist in the motifs of her knitted pictures, in what resemble
cartoon speech bubbles: *Bitte tu mir nichts — aber schnell* (*Please don't hurt
me — but do it quick*) and *What-If/Could-Be* allude to fantasies and obsessions in
which the male viewer becomes a voyeur. Knitting, as a "feminine" activity,
highlights the absurd contradiction inherent in the text, as does the apparent
naiveté of the comic-strip language. The central sculpture in this room, *Untitled
(Daddy's Striptease Room)*, dating from 1990, shows a television packing carton,
with windows cut on all four sides. Inside, as in a reliquary, Trockel has posi-
tioned a slightly modified historical model of the Cologne Cathedral. She uses
the TV company's own fonts for the changed caption. By means of the ironic
link she thus forges, Trockel questions the meaning of traditional ritual forms
such as the confession (church), of voyeuristic exposure (television), child-
rearing (father-daughter relationships), and the corresponding gender clichés.
However, it is especially the group of nineteen drawings Trockel produced from
1983 to 1989, such as *Untitled (Satyr)* and *Untitled (Negermaske/African Mask)*,
that creates a bridge to the works by Philip Guston and Jonathan Borofsky.

Like the silkscreens of Andy Warhol and Robert Rauschenberg, John Baldes-
sari's early pictures imitate "painting" through the use of a non-art technique —
photographic emulsion. And like Ed Ruscha, Baldessari began his work in the
early sixties with scripts (typography) and images (photography), thus incorpo-
rating language as an essential component of the way we perceive art. In
another room, an excellent group of "text pictures" by Ruscha — drawings and
paintings from 1962 to 1989, and in particular his series of photographs entitled
Gasoline Stations — round out this aspect of West Coast American art.

John Baldessari's piece from 1967–68, *An Artist Is Not Merely the Slavish
Announcer of a Series of Facts, Which in This Case the Camera Has Had to Accept
and Mechanically Record*, questions the artist's true function, as does *Untitled
(Child's Bicycle*, 1993) by Andreas Slominski. The linguistic and conceptual
plane of Baldessari's picture and his ironic commentary on the act of creating
and observing art are paralleled in Slominski's work in blue denim, entitled *Bild
aller Augäpfel aller Menschen auf dieser Erde* (*Picture of All the Eyeballs of All the
People on This Earth*, 1988). Ever since 1984, Slominski's work has focused on
what could be described as field research — an aesthetic investigation of every-
day perceptions of the most incidental nature. In its reduction of what we
understand a picture to be, the denim piece can safely be termed an
"absolute" image. For there is no difference here between form, material, color,
and concept. Here, the idea has become the picture, which is nonetheless not a
conceptual picture. All over the world, denim has come to represent twentieth-
century clothing, as a material, and as a predominant concept, particularly in
the form of jeans. While the dimensions and proportions of Slominski's picture
are aligned to industrial standards, this art work also functions as an abstract

image for myth. As a "perfect" picture it sublimates desires, longings, and images. And in the context of this exhibition it stands out as the "masculine" antipode to Rosemarie Trockel's knitted pictures.

Slominski's *Tornetz ohne Tor* (*Net Without Goal*, 1987), in which the title suddenly gives completely new meaning to a limp green net, seems to be an ironic response to the American floor-based sculptures of Carl Andre. However, it can also become a trap for the unwary visitor, and is comparable to Marcel Duchamp's *Trébuchet* (*Trap*), produced in 1917.

For the majority of visitors, *Child's Bicycle* is no doubt the most provocative work. And they will probably ask themselves whether the overladen bicycle does indeed bear all the belongings of a homeless child. The nature of this "child's" bicycle seems to contradict the function it has today. However, it is not a found object as such. Rather, Slominski photographed the original model, the bicycle of an adult homeless person, and then reconstructed it in the present version, which is true down to the very last detail. Nonetheless, it is a child's bicycle, loaded and equipped as if for survival. Switching from the adult world to the world of children, the artist has created from the bicycle an almost abstract image. The work has become an inexorable existential question—for the artist himself and for the viewer. For where is the difference here between image, copy, and what has been copied, between the signifier and the signified? In Slominski's work, an extremely fine balance prevails between the concrete and the abstract.

The theme of childhood and adolescence emerges time and again in this exhibition and is presented to the viewer most clearly in *Boy*, a 1992 sculpture by Charles Ray. The boy, with his hair carefully parted and neatly dressed in light blue shorts and white knee socks, could be out for a Sunday afternoon stroll with his parents. But this idyll turns out to be a cliché, even a nightmare. The boy has mutated into a giant baby (enlarged to the size of the artist) and is frozen in a mannequinlike pose. One peers into similar abysses in Robert Gober's *Hairy Shoe* of 1992. A variety of fears grows in the form of (male) body hair extruding from a (female) child's shoe. Molded in yellowish white wax, it is a well-worn shoe with a scuffed heel, clearly portraying the temporal element of growing up and becoming an adult. But by what sorts of role models has the child been indoctrinated? We all know the admonitions: Boys don't cry! Boys don't play with dolls! Girls don't climb trees! and so on. *Hairy Shoe* is supplemented in the exhibition by images of two everyday objects that have been raised to the level of the uncanny: the rough drawing of a sink (*Untitled*, 1985), which calls to mind a child's handwriting; and a slab of butter, enlarged to enormous proportions, placed on a paper wrapper (*Untitled*, 1994). The piece of bread spread so lovingly with butter, ready for a school lunchbox, sticks in your throat.

Works by Robert Gober from the collections of both museums also enter into a dialogue with those of a German artist of the same generation. In the wake of

and Mechanically Record stellt die Frage nach der Existenz des Künstlers ebenso wie das Kinderfahrrad (*Ohne Titel*, 1993) von Andreas Slominski. Die sprachliche, konzeptuelle Ebene des Bildes von Baldessari und die damit verbundene ironische Hinterfragung des Kunstmachens und des Kunstbetrachtens findet aber auch eine Korrespondenz in Slominskis Werk aus blauem Jeansstoff mit dem Titel *Bild aller Augäpfel aller Menschen auf dieser Erde* von 1988. Das, womit sich Andreas Slominski seit 1984 beschäftigt, könnte man ganz allgemein als Feldforschung beschreiben — ein ästhetisches Erkunden von Alltagswahrnehmung beiläufigster Art. Das Jeansbild kann in seiner Reduktion dessen, was wir uns unter einem Bild vorstellen, als ein "absolutes" bezeichnet werden. Form, Material, Farbe und Begriff sind eins. Es handelt sich um eine bildgewordene Idee und ist dennoch kein konzeptuelles Bild. Jeansstoff als Material, aber eben auch als übergeordneter Begriff, vor allem in Gestalt der Jeanshose, ist weltweit zu dem Kleidungsstück des 20. Jahrhunderts geworden. Von James Dean über Marlon Brando zum Kulturwert schlechthin. Slominskis Bild, Größe und Proportion richten sich nach dem Industriemaß, ist auch ein abstraktes Bild vom Mythos. Als "perfektes" Bild sublimiert es Wünsche, Begierden und Vorstellungen. Und es erscheint im Kontext dieser Ausstellung als "männliches" Gegenstück zu den Strickbildern von Rosemarie Trockel.

Wie ein ironischer Reflex auf die amerikanische Bodenskulptur eines Carl Andre erscheint auch das Werk *Tornetz ohne Tor* von 1987, bei dem ein abgespanntes grünes Tornetz durch den Titel eine schlagartige Wendung erfährt. Für den unachtsamen Museumsbesucher kann es aber auch zur Fußangel werden, dem *Trébuchet* ("Stolperfalle") aus dem Jahr 1917 von Marcel Duchamp vergleichbar.

Das "Kinderfahrrad" birgt wahrscheinlich für die meisten Museumsbesucher die weitreichendste Provokation. Und man wird sich fragen, ob das übervoll bepackte Rad das ganze Hab und Gut eines obdachlosen Kindes trägt. Die Art des "Kinder"-Rades scheint seiner heutigen Funktion zu widersprechen. Es ist jedoch kein Fundstück. Andreas Slominski hat vielmehr das originale Vorbild, das Fahrrad eines erwachsenen Landstreichers, fotografiert und bis ins kleinste Detail konstruiert. Es ist jedoch ein Kinderfahrrad, bepackt und bestückt wie für das Überleben in einer Notsituation ohne Zuhause. Es wurde durch die Wendung von der Erwachsenen- zur Kinderwelt in ein nahezu abstraktes Bild übertragen. Das Werk wurde zu einer unerbittlichen, existentiellen Frage für den Künstler selbst. Es ist ein Werk über die Existenz, auch die des Betrachters. Aber wo ist der Unterschied zwischen Bild, Abbild und Abgebildetem, zwischen Bedeutung und Bedeutendem? Im Werk von Andreas Slominski herrscht eine sehr feine Balance zwischen Gegenständlichkeit und Abstraktion.

Das in dieser Ausstellung immer wiederkehrende Thema des Kindes und der damit verbundenen Adoleszenz begegnet dem Besucher am deutlichsten in der Skulptur von Charles Ray mit dem Titel *Boy* von 1992. Der brav gescheitelte und adrett gekleidete Junge in hellblauen kurzen Hosen und weißen

Kniestrümpfen könnte sich mit den Eltern auf einem Sonntagsspaziergang befinden. Das Idyll erweist sich als Klischee und entpuppt sich als Alptraum. Der Junge ist zu einem Riesenbaby mutiert (vergrößert auf die Körpergröße des Künstlers) und zur Geste einer Schaufensterpuppe erstarrt. In ähnliche Abgründe blickt man in dem Werk von Robert Gober mit dem Untertitel *Hairy Shoe* aus dem gleichen Jahr. Sehr unterschiedliche Ängste wachsen in Form von (männlichen) Haaren aus der Schuhsohle eines (weiblichen) Kinderschuhs. Im schimmernden Abguß aus gelblich weißem Wachs ist noch zu spüren, daß es sich einst um einen vielgetragenen Schuh mit abgelaufenem Absatz handelte. Das zeitliche Element des Heranwachsens und des Erwachsenwerdens wird darin deutlich. Was für Rollenbilder werden dem Kind aber eingeimpft? Was ist männlich? Was ist weiblich an Verhaltensmustern in unserer Gesellschaft? Wir alle kennen die Ermahnungen: Ein Junge weint nicht! Ein Junge spielt nicht mit Puppen! Ein Mädchen klettert nicht auf Bäume! und ähnliches. Die Werkgruppe von Robert Gober wird ergänzt durch zwei geradezu ins Unheimliche gesteigerte Objekte unseres Alltags. Zum einen die spröde Zeichnung eines Waschbeckens (*Ohne Titel*, 1985), die durchaus an eine Kinderhandschrift erinnert, und zum anderen ein ins Riesige vergrößertes Stück Butter auf Einwickelpapier (*Ohne Titel*, 1994). Das mit soviel Liebe tagtäglich gestrichene Butterbrot für die Schulpause bleibt einem im Halse stecken.

Die Arbeiten von Robert Gober aus den Sammlungen beider Museen treten im weiteren in einen Dialog mit den Werken eines deutschen Künstlers gleicher Generation. Jochen Flinzer untersucht—in der Folge der amerikanischen Pop Art, vor allem von Andy Warhol—das Verhältnis von Kulturellem und Trivialem in seinen zweiseitigen, gestickten Bildern. Die "Handarbeit" als Thema des Gesamtwerks wird bei dem Stück *Hertie Kinderplatte* von 1989 besonders deutlich. Die Stickmustervorlage aus dem Kaufhaus wurde samt Farbpalette und Winkelformen zur Markierung des Bildrandes ausgestickt. Ein idyllisches Tierstilleben mit zwei Vögelchen auf einem Kirschzweig. Das "realistische" Naturstück erfährt seine Umkehrung auf der Rückseite. Das reizende Motiv der Vögelchen verwischt hier zu einem fast "bösen" abstrakten Lineament. Das auf der Vorderseite genormte, vorgegebene Stickmuster erhält ein geradezu anarchisches "Gegenbild" auf der Rückseite. Diese für gewöhnlich als unbedeutend betrachtete und damit abgewertete Struktur wird als zweites Bild dem ersten gleichgestellt. Jochen Flinzers Werke haben zumeist zwei Bildseiten. Bei den Arbeiten der "Tätowierungen" von 1992 wird, betrachtet man sie werkimmanent, konsequenterweise das auf die Haut tätowierte Vorbild in Stickerei übertragen. Das Sticken mit der Nähnadel wiederholt das Perforieren der Haut mit der Stechnadel beim Tätowieren. Machtvoll durchstößt dann auch im Motiv, mit entsprechend sexueller Implikation, der Dolch die Rose. Seine Spitze zeigt dabei auf die Widmung, die Personifizierung "Pamela". Auch dies ein Bild von Sehnsüchten und ihren Gegenbildern. Jochen Flinzer, der von 1984–1986 in Tokio lebte, kennt das japanische Ritual des Tätowierens, und so nimmt auch sein

US Pop art, and in particular that of Andy Warhol, Jochen Flinzer examines the relationship between the cultural and the trivial in his two-sided embroidered pictures. *Hertie Kinderplatte* (*Hertie Children's Embroidery Pattern*, 1989) makes it clear that the series focuses on work done by hand. The pattern from the Hertie department store has been completely embroidered, including the color scheme and the corners that mark the edge of the picture, which represents an idyllic animal still life with two small birds on a cherry branch. This work of "realistic" nature is inverted on the back of the embroidery. Here, the charming motif of the little birds is blurred to a nearly "evil" abstract web of lines. The standard, predetermined embroidery pattern on the front thus has an almost anarchistic counterpart on the reverse.

Jochen Flinzer's works usually have two sides. If one observes the "tattoo works" from 1992 in terms of his overall oeuvre, then the model tattooed onto the skin is transposed quite logically onto an embroidered pattern. The act of puncturing the fabric with the embroidery needle reflects the skin being pierced by the tattoo needle. The dagger, with all the corresponding sexual implications, thus powerfully stabs through the rose, its point aimed toward the dedication, the personification "Pamela." This, too, is an image of desires and their counterparts. Flinzer, who lived in Tokyo between 1984 and 1986, is familiar with the Japanese ritual of tattooing, and refers to it quite distinctly in his most recent work in this exhibition. Comparable to a litany, *53 Wochen Glück* (*53 Weeks of Happiness*, 1994–95) consists of fifty-three names of lovers on a fourteen-foot-long kimono sash that is presented like a banner. All the obsessions, desires, and perhaps disappointments associated with each individual name are re-experienced and re-suffered as they are embroidered into the material. On the back of the turquoise-green band of silk, all the names are joined by the sheer infinite length of the embroidery thread, which simultaneously elides the memory of the names. This side of the banner is more like the graphic image of a seismographic recording; perhaps it is best termed a cardiogram of the emotions.

Finally, three large-format color photographs by Stefan Exler round out this very open space, presenting a contemporary take on the classic theme of the interior. One work depicts a "studio picture," while the other two represent two students' or young people's rooms that have been carefully reconstructed down to the last detail. All three works involve what are essentially self-portraits. The eye roves more or less aimlessly from one situation to the next, and viewers instantly begin to read their own past into the picture. In this context, the unusual bird's-eye view does not in fact offer the real overview which it initially promised.

In a subsequent series of rooms, two extensive and concentrated groups of works by Georgia O'Keeffe and the young Frankfurt-based Stephan Melzl illuminate each other.[11] The installation offers a kind of affinity of neighborhoods, in which the visitor wanders from one room to the other, discovering numerous

thematic and formal correspondences. The two rooms foreground the motif of metamorphosis. O'Keeffe's and Melzl's art is pervaded by natural forms that have been removed from their original context, and both artists place their subjects in a sensuous, partially abstract, partially visionary world of images. An almost surreal sensibility turns the corporeal, and indeed the sexual, into an inner landscape. The Whitney's outstanding drawings and paintings by Georgia O'Keeffe here illustrate how an exemplary creative approach has become entwined in a multifaceted dialogue with examples of both American and European painting, for instance, the group of works by Cecilia Edefalk or the individual painting by Vija Celmins, to name but two. Georgia O'Keeffe's paintings are located directly in the center of the exhibition, as well as at the spiritual heart of the exhibition itself.

As if in a closed diorama, we are confronted with the sculptural ensemble created by Reiner Ruthenbeck and entitled *Umgekippte Möbel* (*Tipped-Over Furniture*, 1971), with its clear reference to how we construe space. Along with Gerhard Richter, Sigmar Polke, and Blinky Palermo, Ruthenbeck is one of the most influential German artists of his generation. In the early sixties, he studied under Joseph Beuys in Düsseldorf, and in 1969 took part in Harald Szeeman's legendary exhibition, "When Attitudes Become Form" in Bern. To those who are familiar with his early works from the sixties—which place objects in a minimal balance by sharply reducing the materials used—*Tipped-Over Furniture* comes across as a radical sculptural solution. The conception goes back to 1971. Ruthenbeck quite literally pulled the carpet out from under the "feet" of a middle-class livingroom. The furniture lies strewn about the room, and nothing seems familiar any longer. Everything has taken on a challenging tension, and we need to straighten things out and re-instill order. Such a simple, straightforward action jolts our equilibrium. Stripped of their function as everyday objects, the individual pieces of furniture are perceived as "beings," analogized to the proportions of the human body and the basic language of our physical movements, such as standing, sitting, and lying down.

The artistic vocabulary of the early works of Richard Artschwager is likewise developed through a critical look at furniture.[12] Artschwager is a sculptor and painter, and many of his works reflect interiors with middle-class furnishings. His interests are always focused on a subversive alliance between intimacy and publicity. Starting in 1962, Artschwager began using Celotex hardboard as the ground for his paintings. The coarse-grained, rough surface gives the paintings the appearance of tangible objects. The surface of the picture becomes a field of perception, an effect Artschwager often underscores by using a reflective aluminum frame. Artschwager avoids using a personal idiom or a particular style. Almost every painting is based on a photograph with banal, insignificant motifs. As if under a magnifying glass, every last detail of the photographic model is transposed onto the textured ground. All objects forfeit their individual

jüngstes Werk in dieser Ausstellung ganz deutlich darauf Bezug. *53 Wochen Glück* von 1994/95 versammelt, einer Litanei vergleichbar, 53 Namen von Liebhabern auf einer über 4 Meter langen Kimonoschärpe, die wie eine Fahne präsentiert wird. Alle, mit jedem einzelnen Namen verbundenen Obsessionen, Begierden und vielleicht auch Enttäuschungen werden im Nachsticken noch einmal erlebt und erlitten. Auf der Rückseite des türkisgrünen Seidenbandes werden all die Namen zwar durch das schier unendlich lange Stickgarn mit einander verbunden, aber die Erinnerung an die Namen wird zum Verschwinden gebracht. Es entsteht auf dieser Seite vielmehr ein graphisches Bild einer seis-mographischen Aufzeichnung, die man auch als Kardiogramm der Emotionen beschreiben könnte.

Schließlich ergänzen drei großformatige, farbige Fotoarbeiten von Stefan Exler diesen sehr offenen Raum mit seiner zeitgenössischen Sicht auf das klassische Thema des Interieurs. Sowohl im einen Werk, das ein "Atelier-Bild" beschreibt, als auch in den beiden anderen Arbeiten, in denen zwei bis ins kleinste Detail konstruierte Studenten- oder Jugendzimmer dargestellt sind, erkennen wir eine Art Selbstbildnis. Das Auge schweift mehr oder weniger ungerichtet von einem Gegenstand zum anderen, und man beginnt unmittel-bar seine eigene Geschichte in das Bild hineinzulesen. Die ungewohnte Vogel-perspektive gewährt dabei nur eine scheinbare Übersicht.

In einer weiteren Raumfolge werden zwei sehr umfängliche und dichte Werkgruppen der amerikanischen Künstlerin Georgia O'Keeffe und des jungen, in Frankfurt lebenden Künstlers Stephan Melzl sich gegenseitig beleuchten.[11] Nicht in einer oberflächlichen Konfrontation, vielmehr in einer Nachbarschaft, in der der Besucher von einem zum anderen Raum wandert, werden sich zahl-reiche thematische und formale Entsprechungen entdecken lassen. Das Motiv der Metamorphose steht dabei im Vordergrund. In beiden Werken durchdrin-gen sich Formen der Natur, die aus ihren originären Kontexten herausgelöst sind, und beide Künstler überführen ihre Sujets in eine zum Teil abstrakte, zum Teil visionäre Bildwelt von hoher sinnlich malerischer Qualität. Eine fast surreale Sensibilität läßt bei beiden Künstlern Körperliches, ja Geschlechtliches zum Bild einer inneren Landschaft werden. Die herausragende Gruppe von Zeichnungen und Gemälden Georgia O'Keeffes aus der Sammlung des Whitney Museums aus dem Zeitraum von 1915 bis 1960 veranschaulicht ein exemplar-isches bildnerisches Denken, das einen vielfachen Dialog sowohl mit amerikani-schen als auch europäischen Beispielen der Malerei in dieser Ausstellung führt, wie etwa die Werkgruppe von Cecilia Edefalk oder das Einzelwerk von Vija Celmins, um nur einige Beispiele zu nennen. Die Gemälde Georgia O'Keeffes bilden auch innerhalb der Ausstellungsarchitektur, an ganz zentralem Ort, das Herzstück dieser Ausstellung.

Wie in einem in sich abgeschlossenen Bühnenprospekt begegnet uns das raumbezogene skulpturale Ensemble der *Umgekippten Möbel* von Reiner

Ruthenbeck. Der Künstler zählt neben Gerhard Richter, Sigmar Polke und Blinky Palermo zu den einflußreichsten deutschen Künstlern seiner Generation. Anfang der sechziger Jahre studierte Reiner Ruthenbeck bei Joseph Beuys an der Düsseldorfer Kunstakademie, und seit seiner Teilnahme an Harald Szeemanns legendären Ausstellung "When Attitudes Become Form" in Bern 1969 ist er international präsent. Kennt man sein Frühwerk der sechziger Jahre, ein Formenrepertoir, das in äußerster Reduktion der Mittel seine Objekte in eine minimale Balance versetzt, so erscheint dieses Werk als eine radikale skulpturale Lösung. Die Konzeption der Arbeit *Umgekippte Möbel* geht auf das Jahr 1971 zurück. Mit einer fast aktionistisch zu nennenden Geste hat der Künstler einem bürgerlichen Wohnzimmer im wahrsten Sinne der Wortes den Teppich unter den "Füßen" weggezogen. Die Möbel liegen wie gewürfelt im Raum, und nichts ist uns mehr vertraut. Alles ist in eine herausfordernde Spannung geraten, und wir haben das Bedürfnis, die Dinge wieder in ein geordnetes Lot zu bringen. Eine so leichte, unscheinbare Handlung bringt unser eigenes Gleichgewicht zum Wanken. Losgelöst von ihrer Funktion als Gebrauchsgegenstände nehmen wir die einzelnen Möbelstücke als "Wesen" wahr. Die Möbel repräsentieren aber auch auf exemplarische Weise menschliche Körperproportionen, und wie in einer Choreographie wird uns das Grundvokabular unserer Körperbewegungen wie Stehen, Sitzen und Liegen vorgeführt. Ein spielerisches, aber zugleich anarchisches Element ist diesem Werk zu eigen.

Auch Richard Artschwagers künstlerisches Vokabular seines Frühwerkes entwickelt sich in der Auseinandersetzung mit Möbeln.[12] Artschwager ist Bildhauer und Maler, und in vielen seiner Werke spiegeln sich vor allem Interieurs mit bürgerlicher Möblierung. Ihn interessiert dabei immer wieder ein subversives Bündnis zwischen Intimität und Öffentlichkeit. Seit 1962 verwendet Artschwager die Hartfaserplatte Celotex als Bildträger für seine Gemälde. Die grobkörnige rauhe Oberfläche verleiht der Malerei dabei eine ausgesprochen objekthafte Qualität. Das Gemälde wird für das betrachtende Auge "tastbar". Die Bildoberfläche wird zum Wahrnehmungsfeld, was oftmals durch einen spiegelnden Aluminiumrahmen unterstrichen wird. Die Gemälde basieren fast immer auf einer Fotografie mit Motiven von banaler Belanglosigkeit. Die fotografische Vorlage wird bis ins kleinste Detail wie unter einem Vergrößerungsglas in eine Art Gewebestruktur des Gemäldes übertragen. Alle Gegenstände verlieren durch eine Unschärfe im Umriß und in der Oberfläche ihren individuellen Charakter. Das Interieur *The Bush* von 1971 bildet in dieser Ausstellung ein verblüffendes Pendant zu den Möbeln von Reiner Ruthenbeck aus dem gleichen Jahr. In dem Gemälde *One of Them* von 1967 zeigen sich auf ironische Weise Artschwagers wissenschaftliche Neigungen, hat er doch ein abgeschlossenes Biochemiestudium an der Cornell University vorzuweisen, wobei sein besonderes Interesse der Zellbiologie galt. Wie durch ein Mikroskop fixiert und lokalisiert der Künstler/Forscher das Eine unter Vielen und übergibt diese Aufgabe an den Betrachter.

character as a result of the blurred contours and surfaces. Within this exhibition, Artschwager's 1971 interior *The Bush* forms a perplexing counterpart to Ruthenbeck's furniture arrangement of the same year. The painting entitled *One of Them* (1967) ironically reveals Artschwager's affinities for science — after all, he received a degree in biochemistry from Cornell University, with a particular focus on cellular biology. As if looking through a microscope, the artist-cum-researcher pinpoints and localizes the one among the many, and then hands this task over to the viewer.

The work of Vija Celmins is also to be seen in the context of that of Artschwager and Ruthenbeck. From the very beginning of this exhibition project, Celmins' 1964 *Heater*, in the Whitney's collection, became pivotal in the selection of other works. The metaphoric nature of the objects in Celmins' early paintings is threateningly intense. The isolated, unsightly portable household appliances have a frightening, hypnotic effect. An electric heater glows when functioning properly, but this heater glows dangerously: it seems to have an independent physical life. Celmins paints with meticulous precision and usually prefers a true-to-life scale. Born in Latvia, she describes her early work as a period of longing for a lost childhood, expressed through her reconstructions of toys and objects. In this context, it is easy to draw references to the works by Robert Gober in the exhibition. From the painterly viewpoint, Celmins' art can be compared, in particular, to the pieces by Swedish artist Cecilia Edefalk.

The twelve self-portraits by Cecilia Edefalk, subdivided into smaller groups, were painted between 1992 and 1994.[13] The titles are in various languages, such as *Echo, First Elephant, Kammerspiel (Mirror), Two Copies* or *Réplique*, and thus already direct our attention to acoustic as well as painterly phenomena. The starting point for the works was the three-quarter-view photograph of a young woman, although it served as the model for only the first picture. This picture then became the model for the second picture, which in turn became the model for the third, and so on. The color scheme has been largely reduced to shades of gray, heightening our attention. There are only minimal differences between the respective pictures, but they are decisive. The facial expression shows that the sitter is listening attentively, and one suddenly becomes aware of the silence that emanates from the pictures. The series represents an essay on painting, and refers to perception and memories of perception. The motif of the portrait painted upside down (and it was not simply turned upside down after being painted), as well as the "portrait inside out" and the "empty" picture without a portrait, reveal the picture behind the picture and the fundamentally related manner in which painting critically assesses painting. The way the cycle of paintings has been hung is specifically tailored to the room, and its soft rhythm dictates the motion of the viewer.

A self-portrait is also at the center of the group of works by Martin Honert. However, any search for comparable examples in art history will be in vain, for it is a self-portrait of the artist as a child from the point of view of an adult.

Bearing the astonishing title *Foto* (*Photo*, 1993), this work, which the artist has also called a "spatial image," reflects upon a portion of collective memory. Within the scope of this exhibition, the small boy at the table is the actual antipode to Charles Ray's *Boy*, which was created at almost the same time. The model for Honert's multicolored sculpture was in fact an overexposed color photograph from his parents' family photo album. This is why the sculpture is so strongly shadowed. The boy's clothes, and in particular the pattern of the tablecloth, allude to the early 1960s. Martin Honert invents that by including the present point of view.[14] The boy's glance is directed inward, expressing that moment of awareness when we perhaps sense that we are not symbiotically bound to our parents, but are in fact individuals. Only with this dawning realiza-tion do we gain a notion of loneliness and of the unfamiliar. Recognizing one's self and thus our distinction from those around us represents an essential element of our collective memory.

Two additional works round out the Honert ensemble, although they were created earlier and completely independently of each other. *Haus* (*House*, 1988)—too large to hold an electric train set and too small for a doll's house— speaks of the drab everyday existence of a somber house. On the other hand, *Zigarrenkistenbild* (*Cigar Box Picture*), also made in 1988, is an oversized picture in which we can imagine ourselves in distant parts. It is a deceptive paradisal landscape that has been constructed artificially from beginning to end.

The Honert works also direct our attention to a selection of excellent draw-ings by Edward Hopper. All are major preliminary studies for famous paintings such as *Nighthawks* (1942), *Morning in a City* (1944), or *Morning Sun* (1952). These drawings portray the isolation of individual people, whose loneliness or inability to communicate is often underscored by a dreary interior. Like the face of the small boy at the table, the bright light determines the focus of these pictures.

Thanks to a generous loan from a New York private collector, yet another of Martin Honert's major works has found its way into this exhibition. *Kinder-kreuzzug* (*Children's Crusade*, 1985–87) was actually Honert's senior project at the Düsseldorf Kunstakademie. The story is based on the military crusades the Church organized against the infidel during the Middle Ages. According to legend, thousands of zealous children in France and the Lower Rhine region joined a crusade and most of them perished. The model for this work could have come from a schoolbook; in the child's imagination, the figures step out of the picture, as if in a dream.

The most obvious things you find in the studio of Udo Koch—for example, a potted plant or even his own hand—function as points of departure for his work. To put it simply, they are "there." Studying the silhouette of his spread fingers, Koch pays special attention to the interstices, the empty spaces between things. This results in the highly complex interaction of forms present

Im Kontext dieser Arbeiten von Artschwager und Ruthenbeck steht auch das Einzelwerk von Vija Celmins. Das frühe Hauptwerk *Heater* von 1964 aus der Sammlung des Whitney Museums wurde von Anbeginn dieses Ausstellungs projektes zu einem Dreh- und Angelpunkt für die weitere Auswahl von Werken aus beiden Sammlungen. Die Metaphorik der Objekte in Vija Celmins frühen Bildern hat eine bedrohliche Intensität. Die isolierten Gegenstände, zumeist unansehnliche tragbare Haushaltsgeräte, haben eine beängstigende, hypnoti sche Wirkung. Ein Elektroheizer glüht, wenn er funktionstüchtig ist, aber dieses Exemplar glüht gefährlich, es hat ein körperliches Eigenleben. Vija Celmins malt die Dinge akribisch genau und zumeist in ihrer natürlichen Größe. Aber sie geht weit über ein Stilleben hinaus. Die in Lettland gebürtige amerikani sche Malerin, deren ersten Lebensjahre vor allem vom Krieg in Europa geprägt waren, beschreibt ihr Frühwerk als eine Zeit der Sehnsucht nach einer ver lorenen Kindheit. In Objekten wie *Pencil* (1967) oder *Comb* (1969–70) hat Vija Celmins Spielzeuge und Gegenstände rekonstruiert. In diesem Zusammenhang lassen sich leicht Bezüge zu den Arbeiten von Robert Gober in dieser Ausstel lung herstellen. Vom malerischen Standpunkt läßt sich vor allem die Werk gruppe der schwedischen Künstlerin Cecilia Edefalk vergleichen.

Die zwölf Selbstbildnisse Cecilia Edefalks, in einzelne Werkgruppen geglie dert, sind zwischen 1992 und 1994 entstanden.[13] Bereits die verschieden sprachigen Titel wie *Echo*, *First Elephant*, *Kammerspiel (Mirror)*, *Two Copies* oder *Réplique* verweisen den Betrachter/Hörer auf Phänomene des Malerischen wie des Akustischen.

Ausgangspunkt bildet eine Fotografie einer jungen Frau in Dreiviertelan sicht. Sie diente allerdings nur dem ersten Bild als Vorlage. Dieses erste Bild wurde dann zur Vorlage für das zweite Bild und dieses wiederum die Vorlage des dritten usw. Die Farbpalette ist weitgehend reduziert auf Grautöne, was unsere Aufmerksamkeit schärft. Die Unterschiede zwischen den jeweiligen Bildern sind minimal und doch entscheidend. Der ganze Ausdruck des Gesichtes zeugt davon, daß sie lauscht, und man nimmt plötzlich die Stille wahr, die von den Bildern ausgeht. Die Wiederholung, ein Versuch über Malerei, bezieht sich auf die Wahrnehmung und auf die Erinnerung von Wahrnehmung. Sowohl das Bildmotiv mit dem überkopfgemalten Porträt (es wurde nicht einfach verkehrt herum aufgehängt) als auch das "seitenverkehrte" und das "leere" Bildnis ohne Porträt zeigen das Bild hinter dem Bild und die damit ganz grundsätzlich ver bundene Befragung der Malerei mittels der Malerei. In einem leichten Rhythmus versetzt die spezifisch raumbezogene Installation des Gemäldezyklus den Betrachter in Bewegung.

Im Zentrum der Werkgruppe von Martin Honert steht ebenfalls ein Selbst bildnis. Man wird in der Kunstgeschichte allerdings vergeblich nach Vergleichs beispielen suchen, denn es handelt sich um ein Selbstbildnis des Künstlers als Kind aus der Sicht des Erwachsenen. Mit dem überraschenden Titel *Foto*, das Werk stammt von 1993, reflektiert der Künstler, der das Objekt auch als

"räumliches Bild" bezeichnet hat, ein Stück kollektiver Erinnerung. Der kleine Junge am Tisch wird in dieser Ausstellung zum eigentlichen Gegenstück des *Boy* von Charles Ray, der fast zeitgleich entstand. Die Vorlage für die farbig gefaßte Skulptur war in der Tat ein etwas überbelichtetes Farbfoto aus dem elterlichen Familienalbum. Daher rührt auch die starke Licht- und Schattenwirkung der Szenerie. Die Kleidung des Jungen, aber in besonderer Weise das Muster des Tischtuches, verweisen in die frühen sechziger Jahre. Martin Honert konstruiert Erinnerung, indem er den Standpunkt der Gegenwart einschließt.[14] Der nach innen gerichtete Blick des Jungen spricht von einem Moment des Gewahr-werdens, in dem man vielleicht nur ahnt, daß man nicht symbiotisch mit Vater und Mutter verbunden ist, sondern daß man ein Individuum darstellt. Erst die zunehmende Gewißheit gibt uns ein Bewußtsein der Fremdheit und Einsamkeit. Das Erkennen des eigenen Ichs und die damit verbundene Trennung von der Gesellschaft beschreibt ein wesentliches Element unseres kollektiven Gedächt-nisses. Zwei weitere Werke ergänzen das Ensemble. Sie sind allerdings früher und völlig unabhängig voneinander entstanden. Das *Haus* von 1988, zu groß für ein Fallerhäuschen für die elektrische Eisenbahn und zu klein für ein Puppen-haus wird in dieser Konstellation zum grauen Alltag eines nüchternen Hauses. Das *Zigarrenkistenbild*, ebenfalls von 1988, wird dagegen zu einem über-dimensionierten Bild zum Hineinträumen. Ein trügerisches Bild einer durch und durch inszenierten paradiesischen Landschaft.

Die Werkgruppe von Martin Honert lenkt den Blick der Ausstellungsbesucher im weiteren auf eine Auswahl exzellenter Zeichnungen von Edward Hopper. Es handelt sich durchweg um die wichtigsten Vorstudien zu bekannten Gemälden wie *Nighthawks* (1942), *Morning in a City* (1944) oder *Morning Sun* (1952). Auch in ihnen wird immer wieder die Isolation von einzelnen Menschen geschildert, deren Einsamkeit oder Kommunikationslosigkeit durch die oftmals tristen Interieurs unterstrichen wird. Das gleißende Licht in diesen Bildern führt in ähnlicher Weise Regie wie im Gesicht des Jungen am Tisch.

Durch eine großzügige Leihgabe aus New Yorker Privatbesitz gelangte schließlich noch eines der Hauptwerke Martin Honerts in diese Ausstellung. Der *Kinderkreuzzug* von 1985–87 war eigentlich Honerts Abschlußarbeit an der Düsseldorfer Akademie. Die Geschichte geht zurück auf die von der Kirche geförderten kriegerischen Kreuzzüge gegen "Ungläubige" und Ketzer im Mittel-alter. Der Kreuzzugeifer soll der Legende nach sogar Kinder in Frankreich und am Niederrhein zu Tausenden ergriffen und ins Verderben geführt haben. Die Vorlage zu diesem Werk könnte aus einem Schulbuch stammen, und in der Vorstellungskraft des Kindes treten die Figuren, wie in einem Traum, aus dem Bild heraus.

Die naheliegendsten Dinge im Atelier von Udo Koch, wie etwa eine Topfpflanze (Clivia) oder sogar seine eigene Hand, können Ausgangspunkte für einen künst-lerischen Formprozeß sein. Sie sind schlicht gesagt "vorhanden". Ausgehend

and absent. In the process, the contours are repeatedly rotated around an imaginary, yet precisely constructed axis. The resulting stenciled sketches then yield sculptures that appear to be three-dimensional negatives of the objects themselves. Here the in-between spaces receive concrete substance. The objects, usually molded out of plaster, have a full life of their own, so that you suddenly find yourself "viewing between the lines." Tension thus arises between the visible and the invisible, and a very fragile balance is struck between concreteness and abstraction. The use of plaster, a highly brittle material, gives the sculptures the character of models. There really is no such thing as emptiness, for the absence of something is an invention, a definition, an idea that must constantly be reexamined and questioned. In particular, the complex drawings for *Clivia III* (1990) and *Blutfarbene Lilie* (*Blood-Red Lily*, 1994), which can be read like a physiology of the plant world, inspired the juxtaposition to Georgia O'Keeffe's plant drawing and *Briar*, a 1963 work by Ellsworth Kelly.

In choosing the works from the collections of the two museums, special attention was paid to drawings, and a large number from both collections will be arranged in a room of their own. The Whitney Museum collection will present master drawings in groups: de Kooning, Guston, Kline, and Motherwell; Indiana, Johns, Rauschenberg, and Warhol; Vija Celmins and Richard Tuttle. Two groups from the MMK collection, by Silvia Bächli and Mathias Völcker, respectively, will round out the display in this room.

Translated by Jeremy Gaines and Rebecca Wallach

Notes

1. The title of a group of works by Vija Celmins, made from 1977 to 1982: eleven pairs of acrylic-painted cast bronzes and original stones.

2. Vija Celmins interviewed by Chuck Close, 1991, in *Between Artists: Twelve Contemporary American Artists Interview Twelve Contemporary American Artists* (Los Angeles: A.R.T. Press, 1996), p. 21.

3. The American public first became acquainted with Manfred Stumpf's work through "BiNATIONALE 1988," an exhibition of works in dialogue at the Museum of Fine Arts, Boston. Stumpf's *Container Project* went on display both in Boston and in front of the Contemporary Arts Museum in Houston.

4. A retrospective of Stephan Balkenhol's work opened at the Hirshhorn Museum and Sculpture Garden in Washington, D.C., in the fall of 1995.

5. Beat Streuli, who received a P.S.1 studio scholarship in 1992, spent nearly three years in New York, from 1991 to 1994. His works were exhibited at Janice Guy's New York gallery in February–March 1996.

6. The 1981 Philip Guston retrospective at the Whitney Museum was one of the main discoveries I made on my second trip to the United States; the exhibition left a lasting impression on me.

7. In 1930, through Reuben Kadish, Guston became familiar with the extraordinary collection of modern European painting and sculpture owned by Walter and Louise Arensberg. It was also here that he first encountered the work of De Chirico.

8. On this point, Christian Geelhaar writes, quoting Borofsky, that it was always a question of "he himself as a dog or goat. It is about hearing, about the sensitivity of animal ears, like radar"; see *Jonathan Borofsky: Zeichnungen, 1960–1983*, exh. cat. (Basel: Kunstmuseum Basel, 1983), p. 160 n. 51.

9. "Drawing at 2668379 and 2670098," c. 1979–80, Kupferstichkabinett Basel, inv. 1983.64.

10. D. Koepplin, in *Jonathan Borofsky: Zeichnungen, 1960–1983*, p. 5.

11. Stephan Melzl spent 1994 at the New York studio of the Hessische Kulturstiftung.

12. In 1953, Artschwager opened a cabinetmaker's shop in New York, which also served as his studio until 1970.

13. They were originally presented as a Swedish contribution to the 22nd São Paulo Biennial in 1994.

14. Honert was represented in the German pavilion of the 1995 Venice Biennial with a comparable work titled *Ein szenisches Modell des fliegenden Klassenzimmers* (*A Model Scene of the Flying Classroom*), based on a story by Erich Kästner.

von der Silhouette zum Beispiel der gespreizten Finger seiner Hand, schenkt Udo Koch vor allem den Zwischenräumen, den Leerstellen seine Aufmerksamkeit. Daraus entsteht ein höchst komplexes Zusammenspiel von präsenten als auch absenten Formen. Die Konturlinien werden dabei vielfach um eine imaginäre, aber sehr genau konstruierte Achse gedreht. Aus den hieraus gewonnenen Schablonenzeichnungen werden Skulpturen abgeleitet, die als plastische Negativformen erscheinen. Die Zwischenräume werden verdinglicht. Die zumeist aus Gips geformten Objekte sind völlig autonom. Der Betrachter liest plötzlich zwischen den Zeilen. Sichtbares und Unsichtbares bilden ein Spannungsverhältnis, und es entsteht eine sehr fragile Balance zwischen Gegenständlichkeit und Abstraktion. Durch die Verwendung des leicht brüchigen Materials Gips kommt den Skulpturen ein exemplarischer Modellcharakter zu. Die Leere gibt es nicht wirklich, denn die Abwesenheit von etwas ist eine Erfindung, eine Definition, eine Idee, die immer wieder neu geprüft und befragt werden muß. Vor allem die höchst komplexen Zeichnungen zur *Clivia III* (1990) und zur *Blutfarbenen Lilie* (1994), die sich wie eine Pflanzen-Physiologie lesen lassen, gaben den Impuls für eine Gegenüberstellung der Pflanzenzeichnungen von Georgia O'Keeffe und Ellsworth Kellys *Briar* von 1963.

Der Gattung Zeichnung galt ein besonderes Augenmerk bei der Auswahl der Werke beider Museen. Daher soll in einem eigenen Raum im Rahmen dieser Ausstellung ein größeres Ensemble mit Zeichnungen aus beiden Sammlungen entstehen. Aus der Sammlung des Whitney Museums sind es vor allem Gruppen von Meisterzeichnungen von De Kooning, Guston, Kline und Motherwell, von Indiana, Johns, Rauschenberg und Warhol, von Vija Celmins und Richard Tuttle. Aus der Sammlung des Museums für Moderne Kunst ergänzen zwei Werkgruppen von Silvia Bächli und Mathias Völcker diesen Raum.

Anmerkungen

1. "Dem Bild einen festen Platz im Gedächtnis verleihen" ist der Titel einer Werkgruppe von Vija Celmins von 1977–82, bestehend aus elf Paaren von mit Acryl gefaßten Bronzen und originalen Steinen.

2. Vija Celmins in einem Interview mit Chuck Close im September 1991. *Between Artists. Twelve contemporary American artists interview twelve contemporary American artists* (A.R.T. Press, Los Angeles, 1996), S. 21.

3. Manfred Stumpf wurde dem amerikanischen Publikum vor allem durch die dialogische Gruppenausstellung BiNATIONALE im Museum of Fine Arts in Boston 1988 bekannt. Sein damaliges Container Projekt für den öffentlichen Raum war sowohl in Boston als auch vor dem Contemporary Arts Museum in Houston, Texas zu sehen.

4. Eine Retrospektive des Werkes von Stephan Balkenhol wurde im Herbst 1995 im Hirshhorn Museum and Sculpture Garden in Washington eröffnet.

5. Beat Streuli, der 1992–93 das P.S.1-Atelier-Stipendium inne hatte, lebte von 1991 bis

1994 mit wenigen Unterbrechungen in New York. Im Februar/März diesen Jahres war sein Werk im Ausstellungsraum von Janice Guy in New York zu sehen.

6. Die Retrospektive des Werkes von Philip Guston im Whitney Museum in New York im Jahr 1981 gehört für mich persönlich zu den großartigsten Entdeckungen und Eindrücken meiner zweiten Amerikareise.

7. Guston lernte durch Reuben Kadish 1930 die außerordentliche Sammlung moderner europäischer Malerei und Skulpturen von Walter und Louise Arensberg kennen. Hier begegnete er erstmals dem Werk von de Chirico.

8. Diesbezüglich schreibt Christian Geelhaar, und zitiert dabei Borofsky, es handle sich jeweils um "ihn selber als Hund oder Ziege. Es ist über das Hören, über die Sensitivität des Gehörs der Tiere, das wie Radar ist." Jonathan Borofsky: Zeichnungen 1960–1983, Ausstellungskatalog Basel: Kunstmuseum, 1983, S. 153, siehe Anm. 51.

9. Zeichnung bei 2668379 und 2670098, ca. 1979–80, Kupferstichkabinett Basel, KK. Inv. 1983.64.

10. D. Koepplin im Ausstellungskatalog: Jonathan Borofsky: Zeichnungen 1960–1983, S. 5.

11. Stephan Melzl lebte 1994 für ein Jahr im New Yorker Atelier der Hessischen Kulturstiftung.

12. Artschwager eröffnete 1953 in New York eine Möbeltischlerei, die ihm bis 1970 auch als Atelierraum diente.

13. Die Werkgruppe war zunächst als schwedischer Beitrag anläßlich der XXII. Biennale von São Paulo 1994 ausgestellt.

14. Mit einem vergleichbaren Werk von Martin Honert mit dem Titel *Ein szenisches Modell des Fliegenden Klassenzimmers* nach einer Erzählung Erich Kästners war der Künstler 1995 auf der Biennale in Venedig im Deutschen Pavillon vertreten.

Works in the Exhibition

Dimensions are in inches, followed by centimeters; height precedes width precedes depth.

Works from the Permanent Collection of the Whitney Museum of American Art:

Richard Artschwager (b. 1923)
The Bush, 1971
Synthetic polymer on composition board, 48½ x 70½ (123.2 x 179.1)
Purchase, with funds from Virginia F. and William R. Salomon 72.13

Door, Mirror, Table, Basket, Rug, Window D, 1975
Ink on paper, 26¾ x 30 (67.9 x 76.2)
Purchase, with funds from the Burroughs Wellcome Purchase Fund 84.1

John Baldessari (b. 1931)
An Artist Is Not Merely the Slavish Announcer..., (1967–68)
Synthetic polymer and photoemulsion on canvas, 59⅛ x 45⅛ (150.2 x 114.6)
Purchase, with funds from the Painting and Sculpture Committee and gift of an anonymous donor 92.21

Jonathan Borofsky (b. 1942)
Self-Portrait at 2668379 and 2670098, 1979–80
Acrylic and charcoal on paper, sheet: 84¾ x 48 (215.3 x 121.9)
Purchase, with funds from Joel and Anne Ehrenkranz 82.3

Hammering Man at 2715346, 1981
Painted wood and masonite with metal stripping and motor
a): 139½ x 66¾ (354.3 x 169.5)
b): 12½ x 56¼ x ⅛ (31.8 x 142.9 x .3)
Gift of Robert and Jane Meyerhoff 90.30a-b

Vija Celmins (b. 1939)
Heater, 1964
Oil on canvas, 47⁷⁄₁₆ x 48 (120.5 x 121.9)
Purchase, with funds from the Contemporary Painting and Sculpture Committee 95.19

Ocean: 7 Steps #1, 1972–73
Graphite on acrylic-sprayed ground, 12⅝ x 99⅛ (32.1 x 251.8)
Purchase, with funds from Mr. and Mrs. Joshua A. Gollin 73.71

Untitled #6, 1994
Charcoal on paper, 18¹⁄₁₆ x 24¹⁄₁₆ (45.9 x 61.1)
Purchase, with funds from the Drawing Committee 96.30

Willem de Kooning (b. 1904)
Landscape, Abstract, c. 1949
Oil on paper mounted on board, 19 x 25½ (48.3 x 64.8)
Gift of Mr. and Mrs. Alan H. Temple 68.96

Arthur G. Dove (1880–1946)
Plant Forms, c. 1912
Pastel on canvas, 17¼ x 23⅞ (43.8 x 60.6) sight
Purchase, with funds from Mr. and Mrs. Roy R. Neuberger 51.20

Ferry Boat Wreck, 1931
Oil on canvas, 18 x 30 (45.7 x 76.2)
Purchase, with funds from Mr. and Mrs. Roy R. Neuberger 56.21

Land and Seascape, 1942
Oil on canvas, 25 x 34¾ (63.5 x 88.3)
Gift of Mr. and Mrs. N.E. Waldman 68.79

Robert Gober (b. 1954)
Untitled, 1985
Graphite on paper, 11 x 14 (27.9 x 35.6)
Purchase, with funds from the Drawing Committee and The Norman and Rosita Winston Foundation, Inc. 92.43

Untitled, 1994
Beeswax, wood, glassine, and felt-tip pen
a) Butter: 9½ x 36½ x 9¾ (24.1 x 92.7 x 24.8)
b) Wrapper: 47¾ x 40 (121.3 x 101.6)
Purchase, with funds from the Contemporary Painting and Sculpture Committee 94.134a-d

Philip Guston (1913–1980)
Drawing for Conspirators, 1930
Graphite, ink, colored pencil, and crayon on paper
22½ x 14½ (57.2 x 36.8) irregular
Purchase, with funds from The Hearst Corporation and The Norman and Rosita Winston Foundation, Inc. 82.20

Ink Drawing, 1952, 1952
Ink on paper, 18⅝ x 23⅝ (47.3 x 60)
Purchase, with funds from the Friends of the Whitney Museum of American Art 61.23

Close-Up, 1969
Synthetic polymer on canvas, 42 x 48 (106.7 x 121.9)
Musa Guston Bequest 92.106

Untitled, 1980
Ink on board, 20 x 30 (50.8 x 76.2)
Purchase, with funds from Martin and Agneta Gruss and Mr. and Mrs. William A. Marsteller 81.6

Jenny Holzer (b. 1950)
Studies for Unex Sign #1, 1983
Felt-tip pen and graphite on paper mounted on paper, 22 drawings, 22 x 17⅝ x ¾ (55.9 x 44.8 x 1.9) overall
Gift of the artist 85.54.1-22

Edward Hopper (1882–1967)
Study for **Evening Wind**, 1921
Conté and charcoal on paper, 10 x 13¹⁵⁄₁₆ (25.4 x 35.4)
Josephine N. Hopper Bequest 70.343

Study for **Cape Cod Evening**, 1939
Conté on paper, 8½ x 11 (21.6 x 27.9)
Josephine N. Hopper Bequest 70.183a

House on the Cape, 1940
Conté and charcoal on paper, 15¹⁄₁₆ x 22⅛ (38.3 x 56.2)
Josephine N. Hopper Bequest 70.299

Study for **Office at Night**, 1940
Conté and charcoal with touches of white on paper, 15⅛ x 18⅜ (38.4 x 46.7)
Josephine N. Hopper Bequest 70.341

Study for **Nighthawks**, 1942
Conté on paper, 8 x 8 (20.3 x 20.3)
Josephine N. Hopper Bequest 70.253

Study for **Morning in a City**, 1944
Conté and graphite on paper, 8½ x 11 (21.6 x 27.9)
Josephine N. Hopper Bequest 70.207

Study for **Pennsylvania Coal Town**, 1947
Conté and graphite on paper, 11⅛ x 15 (28.3 x 38.1)
Josephine N. Hopper Bequest 70.229

Study for **Conference at Night**, 1949
Conté and graphite on paper, 8½ x 11 (21.6 x 27.9)
Josephine N. Hopper Bequest 70.171

Study for **Hotel by Railroad**, 1952
Conté on paper, 12 x 19 (30.5 x 48.3)
Josephine N. Hopper Bequest 70.427

Study for **Morning Sun**, 1952
Conté on paper, 12 x 19 (30.5 x 48.3)
Josephine N. Hopper Bequest 70.244

Study for **City Sunlight**, 1954
Conté on paper, 15¼ x 11 (38.7 x 27.9)
Josephine N. Hopper Bequest 70.257

Study for **City Sunlight**, 1954
Conté and graphite on paper, 15¼ x 22¹⁵⁄₁₆
(38.7 x 58.3)
Josephine N. Hopper Bequest 70.329

Robert Indiana (b. 1928)
The Great American Dream: New York,
1966
Colored crayon and frottage on paper,
39⁷⁄₈ x 26¹⁄₈ (101.3 x 66.4) sight
Gift of Norman Dubrow 77.98

Jasper Johns (b. 1930)
Sketch for Three Flags, 1958
Charcoal on paper, 4³⁄₁₆ x 9⁷⁄₁₆ (10.6 x 24)
Gift of the artist 90.9

Alex Katz (b. 1927)
Place, 1977
Oil on canvas, 108 x 144 (274.3 x 365.8)
Purchase, with funds from Frances and
Sydney Lewis 78.23

Ellsworth Kelly (b. 1923)
Briar, 1963
Graphite on paper, 22³⁄₈ x 28³⁄₈ (56.8 x 72.1)
Purchase, with funds from the Neysa
McMein Purchase Award 65.42

Franz Kline (1910–1962)
Composition, 1955
Oil and gouache on paper, 10³⁄₈ x 13
(26.4 x 33)
Gift of Frances and Sydney Lewis 77.35

Untitled, 1960
Ink on paper, 8½ x 10½ (21.6 x 26.7)
Purchase, with funds from Mr. and Mrs.
Benjamin Weiss 78.53

Brice Marden (b. 1938)
Summer Table, 1972
Oil and wax on canvas, three panels,
60 x 105 (152.4 x 266.7) overall
Each panel: 60 x 35 (152.4 x 88.9)
Purchase, with funds from the National
Endowment for the Arts 73.30

Robert Motherwell (1915–1991)
N.R.F. Collage, Number 1, 1959
Oil and collage on paper, 28³⁄₈ x 22³⁄₈
(72.1 x 56.8)
Purchase, with funds from the Friends of
the Whitney Museum of American Art
61.24

N.R.F. Collage, Number 2, 1960
Oil and collage on paper, 28¹⁄₈ x 21½
(71.4 x 54.6)
Purchase, with funds from the Friends of
the Whitney Museum of American Art
61.34

Bruce Nauman (b. 1941)
**Green Corridor Looking Out on Sky &
Ocean at La Jolla**, 1971
Graphite and pastel on paper, 23 x 29
(58.4 x 73.7) sight
Gift of Norman Dubrow 77.102

Georgia O'Keeffe (1887–1986)
Drawing No. 8, 1915
Charcoal on paper mounted on cardboard,
24¼ x 18⁷⁄₈ (61.6 x 47.9)
Purchase, with funds from the Mr. and
Mrs. Arthur G. Altschul Purchase Fund
85.52

Music—Pink and Blue II, 1919
Oil on canvas, 35 x 29¹⁄₈ (88.9 x 74)
Gift of Emily Fisher Landau in honor of
Tom Armstrong 91.90

Flower Abstraction, 1924
Oil on canvas, 48 x 30 (121.9 x 76.2)
50th Anniversary Gift of Sandra Payson
85.47

Abstraction, 1926
Oil on canvas, 30¼ x 18¹⁄₁₆ (76.8 x 45.9)
Purchase 58.43

Single Lily with Red, 1928
Oil on composition board, 12 x 6¼
(30.5 x 15.9)
Purchase 33.29

Black and White, 1930
Oil on canvas, 36 x 24 (91.4 x 61)
50th Anniversary Gift of Mr. and
Mrs. R. Crosby Kemper 81.9

The White Calico Flower, 1931
Oil on canvas, 30 x 36 (76.2 x 91.4)
Purchase 32.26

Black Place Green, 1949
Oil on canvas, 38 x 48 (96.5 x 121.9)
Promised 50th Anniversary Gift of Mr. and
Mrs. Richard D. Lombard P.17.79

Drawing IV, 1959
Charcoal on paper, 18⁵⁄₈ x 24¹¹⁄₁₆
(47.3 x 62.7)
Gift of Chauncey L. Waddell in honor of
John I.H. Baur 74.67

It Was Blue and Green, 1960
Oil on canvas mounted on composition
board, 30¹⁄₁₆ x 40¹⁄₈ (76.4 x 101.9)
Lawrence H. Bloedel Bequest 77.1.37

Claes Oldenburg (b. 1929)
**Proposal for a Cathedral in the Form of
a Colossal Faucet, Lake Union,
Seattle**, 1972
Watercolor, graphite, and colored pencil,
29 x 22⁷⁄₈ (73.7 x 58.1)
Purchase, with funds from Knoll
International, Inc. 80.35

Robert Rauschenberg (b. 1925)
Untitled, 1958
Graphite and watercolor on paper,
24¼ x 36¹⁄₈ (61.6 x 91.8)
Gift of Mr. and Mrs. B.H. Friedman 72.2

Untitled (Drawing for Cover of Art in
America**, vol. 50, No. 1, 1962)**, 1961
News-media transfers, graphite,
watercolor, and crayon on paper, 15¹¹⁄₁₆ x 20
(39.8 x 50.8)
Gift of Howard and Jean Lipman 84.64

Untitled, 1968
Graphite, gouache, and magazine transfer,
22¼ x 29⁷⁄₈ (56.5 x 75.9)
Purchase, with funds from the National
Endowment for the Arts 72.134

Charles Ray (b. 1953)
Boy, 1992
Painted fiberglass, steel, and fabric,
71½ x 27 x 34 (181.6 x 68.6 x 86.4) overall
Purchase, with funds from Jeffrey Deitch,
Bernardo Nadal-Ginard, and Penny and
Mike Winton 92.131a-i

Edward Ruscha (b. 1937)
Trademark Study 5, 1962
Ink and watercolor on paper, 10¹¹⁄₁₆ x 14⁵⁄₁₆
(27.1 x 36.4)
Gift of Emily Fisher Landau 87.62

Securing the Last Letter ("Boss"), 1964
Oil on canvas, 59 x 55 (149.9 x 139.7)
Collection of Emily Fisher Landau

Motor, 1970
Gunpowder and pastel on paper, 23 x 29
(58.4 x 73.7)
Purchase, with funds from The Lauder
Foundation—Drawing Fund 77.78

**Plenty Big Hotel Room (Painting for
the...)**, 1985
Oil on canvas, 84 x 60 (213.4 x 152.4)
Collection of Emily Fisher Landau

Drugs, Hardware, Barber, Video, 1987
Acrylic on canvas, 72 x 72 (182.9 x 182.9)
Collection of Emily Fisher Landau

Gasoline Stations, 1989
Portfolio of 10 gelatin silver prints,
19½ x 23 (49.5 x 58.4) each
Collection of Emily Fisher Landau

Richard Tuttle (b. 1941)
Equals, Harmony, Hill, 1965
Ink on cardboard, three sheets, 5 x 5
(12.7 x 12.7) each
Gift of Jack Tilton Gallery 90.1a-c

Untitled, 1965
Watercolor and graphite on paper, 13¾ x 11
(34.9 x 27.9)
Gift of Eric Green 78.61

Untitled, 1967
Watercolor on paper, 13¾ x 10½ (34.9 x 26.7)
Gift of Eric Green 78.62

Dane Grey, 1973
Ink and graphite on paper, 14 x 11
(35.6 x 27.9)
Purchase, with funds from the Albert A.
List Family 74.19

Orange Plot, 1974
Ink and felt-tipped pen on paper, 14 x 11
(35.6 x 27.9)
Purchase, with funds from the Albert A.
List Family 74.20

Sirakus, 1974
Ink on paper, 14 x 11 (35.6 x 27.9)
Purchase, with funds from the Albert A.
List Family 74.21

Cy Twombly (b. 1928)
Untitled, 1964
Graphite, colored pencil, and crayon on
paper, 27½ x 39⅜ (69.9 x 100)
Purchase, with funds from the Drawing
Committee 84.21

Andy Warhol (1925–1987)
Untitled (Lips), 1956
Ink on paper, 16⅝ x 13⅞ (42.2 x 35.2)
Promised gift of Arlyn and Edward L.
Gardner P.2b.88

Bow Ties, 1960
Watercolor and ink, 21 x 28½ (53.3 x 72.4)
Purchase 65.37

Ginger Rogers, 1962
Graphite on paper, 23¾ x 18 (60.3 x 45.7)
Purchase, with funds from The Lauder
Foundation—Drawing Fund 79.29

Lawrence Weiner (b. 1942)
Here, There & Everywhere, 1989
Wall installation, dimensions variable
Purchase, with funds from the
Contemporary Painting and Sculpture
Committee 94.136

**Stones Found and Broken Sometime in
the Future**, 1994
Wall installation, dimensions variable
On loan from the artist

Works from the collection of the Museum für Moderne Kunst, Frankfurt am Main:

Richard Artschwager (b. 1923)
One of Them, 1967
Acrylic on Celotex, 37¹⁵⁄₁₆ x 49¹⁄₁₆
(96.4 x 124.5)
On permanent loan from Liegenschaftsamt
der Stadt Frankfurt am Main 1995/195L

Silvia Bächli (b. 1956)
Ohne Titel (Untitled), 1990
Ink on paper, 5¹³⁄₁₆ x 5¹⁵⁄₁₆ (14.8 x 15)
On permanent loan to the Museum für
Moderne Kunst 1992/259

Ohne Titel (Untitled), 1990
Gouache on paper, 13¹³⁄₁₆ x 9⅞ (35 x 25)
On permanent loan to the Museum für
Moderne Kunst 1992/261

Ohne Titel (Untitled), 1991
Ink on paper, 8¹⁵⁄₁₆ x 5¹⁵⁄₁₆ (22.7 x 15)
On permanent loan to the Museum für
Moderne Kunst 1992/264

Ohne Titel (Untitled), 1991
Gouache on paper, 8⁹⁄₁₆ x 10¹⁵⁄₁₆ (21.8 x 27.7)
On permanent loan to the Museum für
Moderne Kunst 1992/270

Ohne Titel (Untitled), 1991
Gouache on paper, 9¹³⁄₁₆ x 13¹³⁄₁₆ (25 x 35)
Gift of the artist 1992/272

Ohne Titel (Untitled), 1991
Gouache on paper, 13¹³⁄₁₆ x 9¹³⁄₁₆ (35 x 25)
On permanent loan to the Museum für
Moderne Kunst 1992/274

Ohne Titel (Untitled), 1992
Charcoal on paper, 8¼ x 5¹³⁄₁₆ (20.9 x 14.8)
On permanent loan to the Museum für
Moderne Kunst 1992/277

Ohne Titel (Untitled), 1992
Charcoal on paper, 8⁵⁄₁₆ x 5¹³⁄₁₆ (21 x 14.8)
On permanent loan to the Museum für
Moderne Kunst 1992/279

Ohne Titel (Untitled), 1992
Charcoal on paper, 5¹³⁄₁₆ x 8⁵⁄₁₆ (14.8 x 21)
On permanent loan to the Museum für
Moderne Kunst 1992/280

Ohne Titel (Untitled), 1992
Charcoal on paper, 6⁵⁄₁₆ x 9¹³⁄₁₆ (16.1 x 24.9)
On permanent loan to the Museum für
Moderne Kunst 1992/281

Ohne Titel (Untitled), 1992
Charcoal on paper, 6⁵⁄₁₆ x 9¹³⁄₁₆ (16 x 24.9)
On permanent loan to the Museum für
Moderne Kunst 1992/282

Ohne Titel (Untitled), 1992
Ink on paper, 8⁵⁄₁₆ x 5¹³⁄₁₆ (21 x 14.8)
On permanent loan to the Museum für
Moderne Kunst 1992/284

Ohne Titel (Untitled), 1992
Gouache on paper, 9¹³⁄₁₆ x 6⅜ (25 x 16.2)
On permanent loan to the Museum für
Moderne Kunst 1992/285

Ohne Titel (Untitled), 1992
Gouache on paper, 9¹³⁄₁₆ x 6⅜ (25 x 16.2)
On permanent loan to the Museum für
Moderne Kunst 1992/288

Ohne Titel (Untitled), 1992
Gouache on paper, 12 x 9 (30.5 x 22.9)
On permanent loan to the Museum für
Moderne Kunst 1992/289

Ohne Titel (Untitled), 1992
Gouache on paper, 13¹³⁄₁₆ x 9¹³⁄₁₆ (35 x 25)
On permanent loan to the Museum für
Moderne Kunst 1992/291

Ohne Titel (Untitled), 1992
Gouache on paper, 9¹³⁄₁₆ x 13¹³⁄₁₆ (25 x 35)
On permanent loan to the Museum für
Moderne Kunst 1992/292

Ohne Titel (Untitled), 1992
Gouache on paper, 9¹³⁄₁₆ x 13¹³⁄₁₆ (25 x 35)
On permanent loan to the Museum für
Moderne Kunst 1992/293

Ohne Titel (Untitled), 1992
Gouache on paper, 13¹³⁄₁₆ x 9¹³⁄₁₆ (35 x 25)
On permanent loan to the Museum für
Moderne Kunst 1992/298

Ohne Titel (Untitled), 1992
Gouache on paper, 9¹³⁄₁₆ x 13¹³⁄₁₆ (25 x 35)
On permanent loan to the Museum für
Moderne Kunst 1992/300

Stephan Balkenhol (b. 1957)
57 Pinguine (57 Penguins), 1991
Painted Wawawood, 57 parts,
59¹⁄₁₆ x 13¹³⁄₁₆ x 13¹³⁄₁₆ (150 x 35 x 35) each
1992/70–126

Jonathan Borofsky (b. 1942)
5836429, 1994
Steel wire, 9½ x 5 x 2¹³⁄₁₆ (24.1 x 12.7 x 6.9)
On permanent loan to the Museum für
Moderne Kunst 1994/110

Walter Dahn (b. 1954)
Kopf (Head), n.d.
Watercolor and gouache on paper,
5⅝ x 4¹⁄₁₆ (14.3 x 10.4)
Gift of the artist 1994/1

**Mann mit grünem Horn (Man with
Green Horn)**, n.d.
Watercolor on ruled paper, 4⁵⁄₁₆ x 5¹⁵⁄₁₆
(10.8 x 15)
On permanent loan to the Museum für
Moderne Kunst 1992/5

Wolken (Clouds), n.d.
Watercolor on paper, 10⁷⁄₁₆ x 4¹⁄₁₆ (26.5 x
10.4)
On permanent loan to the Museum für
Moderne Kunst 1992/7

Mond (Moon), c. 1975
Gouache on paper, 4¹¹⁄₁₆ x 2¹⁵⁄₁₆ (11.9 x 7.6)
Gift of the artist 1994/2

Dieterfuchskopf, 1987
Synthetic colored resin and paper on
cardboard, 11⅝ x 8⁵⁄₁₆ (29.5 x 21.1)
Gift of Helge Achenbach, Düsseldorf
(1993/172)

Ohne Titel (Untitled), 1987
Synthetic colored resin and white paper
on cardboard, 5³⁄₁₆ x 8⅝ (14.8 x 21)
Gift of Helge Achenbach, Düsseldorf
(1993/167)

Black Cloud, 1988
Gouache on envelope, 6³⁄₁₆ x 4⁷⁄₁₆
(15.6 x 11.3)
On permanent loan to the Museum für
Moderne Kunst 1992/9

Geist (Ghost), 1988
Synthetic colored resin on envelope laid on
cardboard, 9¹⁄₁₆ x 6⅝ (23 x 16)
Gift of Helge Achenbach, Düsseldorf
(1993/174)

Kilroy, 1988
Synthetic colored resin, tacker, and paper
on cardboard, 11¹¹⁄₁₆ x 8³⁄₁₆ (29.7 x 20.9)
Gift of Helge Achenbach, Düsseldorf
(1993/173)

Kopf/Herz (Head/Heart), 1988
Gouache on paper, 4⁵⁄₁₆ x 5¹³⁄₁₆ (10.8 x 14.7)
On permanent loan to the Museum für
Moderne Kunst 1992/18

Sabine Knust, 1988
Watercolor and letter paper on cardboard,
11⅝ x 8⁵⁄₁₆ (29.5 x 21)
Gift of Helge Achenbach, Düsseldorf
1993/165

Voodoo-Kopf (Voodoo-Head), 1988
Gouache on paper, 8³⁄₁₆ x 5¹¹⁄₁₆ (20.8 x 14.6)
On permanent loan to the Museum für
Moderne Kunst 1992/13

**Junge vor Pyramide (Boy in Front of
Pyramid)**, 1988–89
Gouache on paper, 11⁹⁄₁₆ x 7¹⁵⁄₁₆ (29.4 x 20.3)
On permanent loan to the Museum für
Moderne Kunst 1992/24

Frühling (Spring), 1989
Gouache on collage made of two envelopes
on writing paper, 11⁹⁄₁₆ x 8⁹⁄₁₆ (29.4 x 21.8)
On permanent loan to the Museum für
Moderne Kunst 1992/30

**Kristallblock auf offener See (warum
sinkt er nicht??) (Crystal on the Open
Sea (Why Does It Not Sink??))**, 1989
Gouache on paper, 11⁹⁄₁₆ x 8³⁄₁₆ (29.3 x 20.8)
On permanent loan to the Museum für
Moderne Kunst 1992/31

**Landschaftserinnerung (Memory of a
Landscape)**, 1989
Gouache on squared paper, 8⁵⁄₁₆ x 11⅝
(21 x 29.5)
On permanent loan to the Museum für
Moderne Kunst 1992/33

**("Cyrano macht eine Entdeckung…")
("Cyrano makes a discovery…")**, 1990
Gouache on paper, 9¹⁄₁₆ x 12 (23 x 30.5)
On permanent loan to the Museum für
Moderne Kunst 1992/36

Cyrano—stinksauer (Cyrano—Mad),
1991
Gouache on envelope, 8¹³⁄₁₆ x 6⁵⁄₁₆ (22.4 x 16)
On permanent loan to the Museum für
Moderne Kunst 1992/37

**Kaffee und Asche II (Coffee and
Ashes II)**, 1991
Gouache on paper, two parts, 6⅝ x 4
(16.8 x 10.2) each
On permanent loan to the Museum für
Moderne Kunst 1992/39.1-2

Gummimaske (Rubber Mask), 1992
Watercolor on paper, 5⁹⁄₁₆ x 3¹⁵⁄₁₆ (14.0 x 10.1)
Gift of the artist 1994/5

Loch (Hole), 1992
Gouache on paper, 3³⁄₁₆ x 2⅝ (8.1 x 6.6)
Gift of the artist 1994/4

**Ohne Titel–No More Sex?
(Untitled–No More Sex?)**, 1992
Watercolor on print, 7⁷⁄₁₆ x 4¹³⁄₁₆ (19.0 x 12.3)
Gift of the artist 1994/7

2 Eier/2 Eiformen (2 Eggs/2 Egg Shapes)
Watercolor and gouache on paper,
5⁹⁄₁₆ x 3¹⁵⁄₁₆ (14.2 x 10.1)
Gift of the artist 1994/15

Gold/aus Scheisse (Gold/Out of Shit),
1993
Watercolor and gouache on paper,
5⁹⁄₁₆ x 3¹⁵⁄₁₆ (14.2 x 10)
Gift of the artist 1994/20

Cecilia Edefalk (b. 1954)
Echo, 1992–94
Oil on canvas, three parts, 23¹¹⁄₁₆ x 16⁹⁄₁₆ x ¹⁵⁄₁₆
(60 x 42.1 x 2.4); 39⁷⁄₁₆ x 26³⁄₁₆ x ¹⁵⁄₁₆
(100.3 x 66.4 x 2.5); 23¹¹⁄₁₆ x 15⅞ x ¹⁵⁄₁₆
(60.1 x 40.2 x 2.2)
On permanent loan to the Museum für
Moderne Kunst 1994/118.1-3

Kammerspiel (Mirror), 1993–94
Oil on canvas, three parts, 23¹³⁄₁₆ x 16¹¹⁄₁₆ x ¹⁵⁄₁₆
(60.4 x 42.4 x 2.5); 23¹³⁄₁₆ x 15⅞ x ¹⁵⁄₁₆
(60.2 x 40.3 x 2.3); 23¹³⁄₁₆ x 15⅞ x ¹⁵⁄₁₆
(60.4 x 40.4 x 2.3)
On permanent loan to the Museum für
Moderne Kunst 1994/116.1-3

First Elephant, 1994
Oil on canvas, three parts, 39⁵⁄₁₆ x 26³⁄₁₆ x 1⁷⁄₁₆
(99.8 x 66.5 x 3.8); 39⅜ x 26³⁄₁₆ x 1⁷⁄₁₆
(99.9 x 66.4 x 3.8); 39⅜ x 26³⁄₁₆ x 1⁷⁄₁₆
(99.9 x 66.4 x 3.8)
On permanent loan to the Museum für
Moderne Kunst 1994/117.1-3

Replique (Replica), 1994
Oil on canvas, 31⅝ x 21¹⁄₁₆ x 1⁷⁄₁₆
(80.3 x 53.4 x 3.8)
On permanent loan to the Museum für
Moderne Kunst 1994/119

Two Copies, 1994
Oil on canvas, two parts, 31⁹/₁₆ x 20⁷/₈ x ¹⁵/₁₆
(80 x 53 x 2.5) overall
On permanent loan to the Museum für
Moderne Kunst 1994/115.1-2

Stefan Exler (b. 1965)
Ohne Titel (Untitled), 1994–95
Chromogenic print in plexiglass,
47⁵/₁₆ x 59¹/₁₆ (120 x 150)
On permanent loan to the Museum für
Moderne Kunst 1995/280

Ohne Titel (Untitled), 1994–95
Chromogenic print in plexiglass,
47⁵/₁₆ x 59¹/₁₆ (120 x 150)
On permanent loan to the Museum für
Moderne Kunst 1995/281

Ohne Titel (Untitled), 1994–95
Chromogenic print in plexiglass,
47⁵/₁₆ x 59¹/₁₆ (120 x 150)
On permanent loan to the Museum für
Moderne Kunst 1995/282

Jochen Flinzer (b. 1959)
**Hertie Kinderplatte (Hertie's
Children's Embroidery Pattern)**, 1989
Embroidery thread on embroidery pattern,
12³/₁₆ x 14¹⁵/₁₆ (31 x 38)
1991/417

Fuck/Ass/Suck/Cock/KY, 1991
Embroidery thread on paper, five parts,
11¹¹/₁₆ x 8³/₁₆ (29.7 x 21.0), each
On permanent loan to the Museum für
Moderne Kunst 1991/420.1-5

**Debbie Lenz, Artistic Dermagraphics,
Youngstown, OH**, 1992
Embroidery thread on cloth, 23⅝ x 19¹¹/₁₆
(60 x 50)
1992/43

**53 Wochen Glück (53 Weeks of
Happiness)**, 1994–95
Embroidery thread on silk, 169⁵/₁₆ x 12¹³/₁₆
(430 x 32.5)
1995/95

Robert Gober (b. 1954)
**Ohne Titel—Behaarter Schuh
(Untitled—Hairy Shoe)**, 1992
Wax and hair, 7½ x 2⅝ x 3 (20 x 7.3 x 7.8)
Gift of the artist 1994/3

Untitled, 1992
Toned gelatin silver print, 29⅝ x 25¼
(75.2 x 64.1)
Loan from the artist

Martin Honert (b. 1953)
Kinderkreuzzug (Children's Crusade),
1985–87
Figures: Painted polyester, approximately
64¹⁵/₁₆ (165)
Relief: Painted polyester, 78¹¹/₁₆ x 62¹⁵/₁₆
(200 x 160)
Painting: Oil on canvas, 104⅜ x 169⁵/₁₆
(265 x 430)
Collection of Raymond Learsy and
Gabriella De Ferrari

Haus (House), 1988
Brass, zinc, polyester, and plexiglass,
73¼ x 20⅞ x 19⁵/₁₆ (186 x 53 x 49), with
pedestal
On permanent loan to the Museum für
Moderne Kunst 1991/366

Zigarrenkistenbild (Cigar Box Picture),
1988
Oil on plywood, 57⅞ x 78¹³/₁₆ (147 x 200)
On permanent loan to the Museum für
Moderne Kunst 1991/365

Foto (Photo), 1993
Epoxy and painted wood, two parts, figure
approximately 39⅜ (100); table, 31⅛ x
28¹³/₁₆ x 48⁷/₁₆ (79 x 73 x 123)
On permanent loan to the Museum für
Moderne Kunst 1993/148

Udo Koch (b. 1958)
Hand I Aufriss (Hand I Outline), 1988
Graphite on tracing paper, 18⁹/₁₆ x 39⅜
(47 x 100)
On permanent loan to the Museum für
Moderne Kunst 1992/431

Hand II, 1988–89
Plaster and wood, 6¹¹/₁₆ x 11⅞ x 9⅞
(17 x 30 x 24)
On permanent loan to the Museum für
Moderne Kunst 1990/77

Hand, 1989
Graphite and ink on paper, 21¹¹/₁₆ x 35⁷/₁₆
(55 x 90)
On permanent loan to the Museum für
Moderne Kunst 1992/439

Hand, 1989
Graphite on tracing paper, 11⅝ x 16⁵/₁₆
(29.5 x 41.5)
On permanent loan to the Museum für
Moderne Kunst 1992/453

Hand III, 1989
Graphite and rapidograph on tracing paper,
11⅝ x 13¹³/₁₆ (29.5 x 35)
On permanent loan to the Museum für
Moderne Kunst 1992/440

Hand IV, 1989
Stencil drawing (outline), ball-point pen,
and pencil on tracing paper, 8³/₁₆ x 37¹⁵/₁₆
(20.8 x 96.5)
On permanent loan to the Museum für
Moderne Kunst 1992/438

**Kontur der linken Hand (Contour of
Left Hand)**, 1989
Graphite and ink on paper, 5⁹/₁₆ x 36³/₁₆
(47 x 92)
On permanent loan to the Museum für
Moderne Kunst 1992/437

Clivia III, 1990
Graphite, watercolor, pen, and photocopy
on paper, 61¹/₁₆ x 50⁷/₁₆ (155 x 128)
On permanent loan to the Museum für
Moderne Kunst 1992/450

Hände (Hands), 1990
Graphite on paper, 24 x 33¹/₁₆ (61 x 84)
On permanent loan to the Museum für
Moderne Kunst 1992/451

Hand, 1991
Graphite on tracing paper, 11¹¹/₁₆ x 16⁹/₁₆
(29.7 x 42)
On permanent loan to the Museum für
Moderne Kunst 1992/457

Blutfarbene Lilie (Blood-Colored Lily),
1994
Graphite on paper, 70⅞ x 98⁷/₁₆ (180 x 250)
Gift of the artist 1994/67

Clivia IV, 1994
Plaster, polystyrene, and wood, approxi-
mately 27⁹/₁₆ x 50¹³/₁₆ x 61⁷/₁₆ (70 x 129 x 156)
On permanent loan from the Karl Ströher-
Stiftung, Frankfurt am Main 1994/66L

Stephan Melzl (b. 1959)
Ohne Titel (Untitled), 1991
Oil on paper on plywood, 11¹¹/₁₆ x 16⁹/₁₆
(29.7 x 42)
On permanent loan to the Museum für
Moderne Kunst 1991/371

Ohne Titel (Untitled), 1991
Oil on paper on plywood, 11¹¹/₁₆ x 16¹⁵/₁₆
(29.8 x 43.1)
On permanent loan to the Museum für
Moderne Kunst 1992/131

Ohne Titel (Untitled), 1991
Oil on paper on plywood, 11¹¹/₁₆ x 16¹⁵/₁₆
(29.7 x 43)
On permanent loan to the Museum für
Moderne Kunst
1992/132

Ohne Titel (Untitled), 1991–92
Oil on paper on plywood, 16¹⁵⁄₁₆ x 11¹¹⁄₁₆
(43 x 29.7)
On permanent loan to the Museum für
Moderne Kunst 1992/482

Ohne Titel (Untitled), 1992
Oil on paper on plywood, 16¹⁵⁄₁₆ x 11¹¹⁄₁₆
(43 x 29.7)
On permanent loan to the Museum für
Moderne Kunst 1992/133

Ohne Titel (Untitled), 1992
Oil on paper on plywood, 11¹¹⁄₁₆ x 16¹⁵⁄₁₆
(29.7 x 43)
On permanent loan to the Museum für
Moderne Kunst 1992/484

Ohne Titel (Untitled), 1992
Oil on paper on plywood, 11¹¹⁄₁₆ x 16¹⁵⁄₁₆
(29.7 x 43)
On permanent loan to the Museum für
Moderne Kunst 1992/485

Ohne Titel (Untitled), 1992
Oil on paper on plywood, 33⅞ x 24³⁄₁₆
(86 x 61.5)
On permanent loan to the Museum für
Moderne Kunst 1992/486

Ohne Titel (Untitled), 1993
Oil on paper on plywood, 16⁹⁄₁₆ x 11¹¹⁄₁₆
(42 x 29.7)
On permanent loan to the Museum für
Moderne Kunst 1994/28L

Ohne Titel (Untitled), 1993–94
Oil on paper on plywood, 18⅛ x 16⁹⁄₁₆
(46 x 42)
On permanent loan to the Museum für
Moderne Kunst 1994/43L

Ohne Titel (Untitled), 1993–94
Oil on paper on plywood, 19¹¹⁄₁₆ x 14⁹⁄₁₆
(50 x 37)
On permanent loan to the Museum für
Moderne Kunst 1994/44L

Ohne Titel (Untitled), 1994
Oil on paper on plywood, 11⅞ x 16⁹⁄₁₆
(30 x 42)
On permanent loan to the Museum für
Moderne Kunst 1994/29L

Ohne Titel (Untitled), 1994
Oil on paper on plywood, 16⁹⁄₁₆ x 11⅞
(42 x 30)
1995/96

Ohne Titel (Untitled), 1995
Oil on paper on plywood, 16⁹⁄₁₆ x 11⅞
(42 x 30)
1995/97

Ohne Titel (Untitled), 1995
Oil on paper on plywood, 16⁹⁄₁₆ x 11⅞
(42 x 30)
On loan from the Hessische Kulturstiftung,
Wiesbaden 1995/98L

Ohne Titel (Untitled), 1995
Oil on paper on plywood, 19½ x 11⅝
(49.5 x 29.5)
Gift of the artist 1995/99L

Albert Oehlen (b. 1954)
Traurigkeit (Sadness), 1991
Graphite on paper, 40¹⁄₁₆ x 30 (101.7 x 76.2)
On permanent loan to the Museum für
Moderne Kunst 1991/363

Eventuell (Possibly), 1993
Graphite on paper, 40¹⁄₁₆ x 30⅛ (101.7 x 76.5)
On permanent loan to the Museum für
Moderne Kunst 1993/142

Reiner Ruthenbeck (b. 1937)
**Umgekippte Möbel (Tipped-Over
Furniture)**, 1971 (Frankfurt version, 1993)
Two tables, five chairs, and a chaise
longue, dimensions variable
On permanent loan to the Museum für
Moderne Kunst 1993/149

Andreas Slominski (b. 1959)
Tornetz ohne Tor (Net without Goal),
1987
Polyethylene net, approximately 118⅛ (300)
long
1991/427

**Bild aller Augapfel aller Menschen auf
dieser Erde (Picture of All the Eyeballs
of All the People on Earth)**, 1988
Denim, 78¹¹⁄₁₆ x 55³⁄₁₆ (200 x 140)
On permanent loan from the Karl Ströher-
Stiftung, Frankfurt 1991/323

Ohne Titel (Untitled), 1988
Cloth, approximately 7⅞ x 7⅞ x 7¹¹⁄₁₆
(20 x 20 x 19.5)
On permanent loan from the Karl Ströher-
Stiftung, Frankfurt 1991/324

Ohne Titel (Untitled), 1988
Cloth, approximately 2¹⁵⁄₁₆ x 6⅞ x 6⅞
(7.5 x 17.5 x 17.5)
On permanent loan from the Karl Ströher-
Stiftung, Frankfurt 1991/325

Ohne Titel (Untitled), 1988
Cloth, approximately 3¹³⁄₁₆ x 7⅞ x 7⁷⁄₁₆
(9.5 x 20 x 19)
On permanent loan from the Karl Ströher-
Stiftung, Frankfurt 1991/326

Ohne Titel (Untitled), 1993
Silver gelatin print, 20¹⁄₁₆ x 14⁹⁄₁₆ (51 x 37)
1995/290

Ohne Titel (Untitled), 1993
Children's bicycle with filled plastic bags,
32⅝ x 52⅜ x 27¹⁵⁄₁₆ (83 x 133 x 70)
On permanent loan to the Museum für
Moderne Kunst 1993/150

Beat Streuli (b. 1957)
Ohne Titel (Untitled), 1991–93
Black-and-white photograph under a plexi-
glass cover, 53¹⁵⁄₁₆ x 79⅛ (137 x 201)
On permanent loan to the Museum für
Moderne Kunst 1995/269

Ohne Titel (Untitled), 1991–93
Black-and-white photograph under a plexi-
glass cover, 53¹⁵⁄₁₆ x 79⅛ (137 x 201)
On permanent loan to the Museum für
Moderne Kunst 1995/270

Ohne Titel (Untitled), 1992
Black-and-white photograph under a plexi-
glass cover, 53¹⁵⁄₁₆ x 79⅛ (137 x 201)
On permanent loan to the Museum für
Moderne Kunst 1995/271

**Ohne Titel (US 1993/94)
(Untitled (US 1993/94))**, 1995
C-print, 53¹⁵⁄₁₆ x 79⅛ (137 x 201)
Gift of the artist 1995/278

Ohne Titel (Untitled), 1995
C-print, 53¹⁵⁄₁₆ x 79⅛ (137 x 201)
Gift of the artist 1995/279

Manfred Stumpf (b. 1957)
Ohne Titel (Untitled), 1990
39 computer drawings on paper,
8¹⁵⁄₁₆ x 11¹¹⁄₁₇ (21 x 29.7) each
On permanent loan to the Museum für
Moderne Kunst 1990/171–182 and 1992/226-
252

**Das Heilige Abendmahl (The Holy
Supper)**, 1995
Computer drawing, 62¹⁵⁄₁₆ x 204¹¹⁄₁₆
(160 x 520)
1995/268

Rosemarie Trockel (b. 1952)
Ohne Titel—Glocke (Untitled—Bell),
1983
Ink on paper, 8⁵⁄₁₆ x 6¹⁄₁₆ (20.9 x 15.3)
Gift of the artist 1990/239

**Ohne Titel—Gittermuster (Untitled—
Grating)**, 1984
Watercolor on paper, 11⅝ x 8⁵⁄₁₆ (29.5 x 21)
Gift of the artist 1991/4

Ohne Titel—Negermaske (Untitled—Black Mask), 1984
Collage, 9¹/₁₆ x 8⁵/₁₆ (23 x 21)
Gift of the artist 1991/5

Ohne Titel—Gegenwart (Untitled—Present), 1985
Collage, 7⁷/₁₆ x 4¹¹/₁₆ (19 x 12)
Gift of the artist 1991/6

Ohne Titel—Tragische Dekoration (Untitled—Tragic Decoration), 1985
Ink and watercolor on paper, 9¹⁵/₁₆ x 7¹³/₁₆ (25.3 x 19.7)
Gift of the artist 1990/240

Ohne Titel—Kopf mit Dornenkrone (Untitled—Head with Crown of Thorns), 1986
Verso: paint on paper, recto: red watercolor, 13¹/₁₆ x 13¹³/₁₆ (33.1 x 35.1)
Gift of the artist 1990/241

Ohne Titel—Ratte (Untitled—Rat), 1986
Ink on varnished, ruled paper, 9⅞ x 8³/₁₆ (25.1 x 20.8)
Gift of the artist 1990/242

Ohne Titel—Satyr (Untitled—Satyr), 1986
Verso: drawing on paper; recto: ink on lubricated paper, 11⅞ x 8⁷/₁₆ (30.2 x 21.5)
Gift of the artist 1990/243

Ohne Titel—Wo ist Niemand? (Untitled—Where Is Nobody?), 1986
Mixed media, 11⅝ x 8⁵/₁₆ (29.5 x 21)
Gift of the artist 1991/7

Ohne Titel—Hans Grimm: Warum—Woher—Aber wohin? (Untitled—Hans Grimm: Why—Where From—But Where To?), 1986
Collage, 8⁵/₁₆ x 5½ (21 x 14)
Gift of the artist 1991/8

Ohne Titel—Können Bäume weinen? (Untitled—Do Trees Cry?), 1987
Collage, 8⁹/₁₆ x 5¾ (21.7 x 14.6)
Gift of the artist 1991/9

Ohne Titel—Kopf mit Atompilz (Untitled—Head with Mushroom Cloud), 1987
Drawing and collage, newspaper print, pencil and ink mounted with cellophane tape on paper with wood pulp, 11³/₁₆ x 8⁵/₁₆ (28.5 x 21)
Gift of the artist 1990/244

Ohne Titel—Cogito, ergo sum (Untitled—Cogito, ergo sum), 1988
Photocopy and collage, 11¹/₁₆ x 8¹/₁₆ (28 x 20.5)
Gift of the artist 1991/13

Ohne Titel— Schweinsblase mit Meßlatte (Untitled—Pig's Bladder with Surveyor's Pole), 1988
Ink and graphite on paper, 11¹¹/₁₆ x 8⁵/₁₆ (29.7 x 21)
Gift of the artist 1991/10

Ohne Titel—Porträt und Pferdekopf (Untitled—Portrait and Horse's Head), 1988
Graphite on paper, 7¹³/₁₆ x 5¹³/₁₆ (19.8 x 14.8)
Gift of the artist 1991/11

Ohne Titel—Dinosaurierkopf (Untitled—Dinosaur's Head), 1988
Collage, 11³/₁₆ x 8⁵/₁₆ (28.5 x 21)
Gift of the artist 1991/12

Ohne Titel—Sex für Millionen (Untitled—Sex for Millions), 1988
Collage, 8⁵/₁₆ x 7⅞ (21 x 20)
Gift of the artist 1991/14

Ohne Titel—Bitte tu mir nichts—Aber schnell (Untitled—Please don't do anything to me—but do it fast), 1989
Computer-knitted wool, supported with cotton, mounted into a frame, 72¹³/₁₆ x 59¹/₁₆ (185 x 150)
On permanent loan from the Karl Ströher-Stiftung, Frankfurt 1989/24

Ohne Titel—Wie verrückt ist Salvador Dali? (Untitled—How Mad Is Salvador Dali?), 1989
Collage, 12³/₁₆ x 8¹¹/₁₆ (31 x 22)
Gift of the artist 1991/15

Ohne Titel—Unterschriften von Napoleon (Untitled—Signatures by Napoleon), 1989
Photocopy, watercolor, and felt tip on paper, 11¹³/₁₆ x 8⁵/₁₆ (30 x 21)
Gift of the artist 1991/16

Ohne Titel—Daddy's Striptease Room (Untitled—Daddy's Striptease Room), 1990
Wood and paint on cardboard box, 24⁷/₁₆ x 23¹³/₁₆ x 33⁵/₁₆ (62 x 60.5 x 84.5)
On permanent loan to the Museum für Moderne Kunst 1990/252

Ohne Titel—What If—Could Be (Untitled—What If—Could Be), 1990
Computer-knitted wool, supported with cotton, mounted into a frame, 59⅜ x 61⁷/₁₆ (150.8 x 156)
On loan from the Adolf und Luisa Haeuser-Stiftung, Frankfurt 1990/251

Mathias Völcker (b. 1955)
Ohne Titel (Untitled), 1982
Watercolor, graphite, and gouache on paper, 9⁹/₁₆ x 12⁵/₁₆ (24.2 x 31.3)
On permanent loan to the Museum für Moderne Kunst 1991/51

Ohne Titel (Untitled), 1983
Watercolor, graphite, and charcoal on paper, 8³/₁₆ x 11⅝ (20.9 x 23.7)
On permanent loan to the Museum für Moderne Kunst 1991/55

Ohne Titel (Untitled), 1983
Graphite, gouache, and collage on computer paper, 10⁵/₁₆ x 14⅝ (26.1 x 37.2)
On permanent loan to the Museum für Moderne Kunst 1991/56

Ohne Titel (Untitled), 1983
Watercolor on paper, 10⁵/₁₆ x 14⅝ (39.7 x 30)
On permanent loan to the Museum für Moderne Kunst 1991/57

Ohne Titel (Untitled), 1983
Graphite on paper, 3¹⁵/₁₆ x 6⁵/₁₆ (10.1 x 16.1)
On permanent loan to the Museum für Moderne Kunst 1991/58

Ohne Titel (Untitled), 1985
Watercolor and graphite on paper, 4⅜ x 3⁹/₁₆ (11.1 x 8.9) irregular
On permanent loan to the Museum für Moderne Kunst 1991/61

Ohne Titel (Untitled), 1985
Watercolor and graphite on paper, 5⅞ x 4¹⁵/₁₆ (14.9 x 12.6)
On permanent loan to the Museum für Moderne Kunst 1991/62

Ohne Titel (Untitled), 1986
Watercolor on paper, 9¹/₁₆ x 12⅛ (24.1 x 30.8)
On permanent loan to the Museum für Moderne Kunst 1991/66

Ohne Titel (Untitled), 1987
Watercolor, graphite, and silver leaf on paper, 3¹³/₁₆ x 3⅞ (9.7 x 9.8)
On permanent loan to the Museum für Moderne Kunst 1991/72

Ohne Titel (**Untitled**), 1988
Watercolor and graphite on paper,
9⁷⁄₁₆ x 12³⁄₁₆ (23.9 x 30.9)
On permanent loan to the Museum für
Moderne Kunst 1991/80

Ohne Titel (**Untitled**), 1989
Graphite on paper, 11⁷⁄₁₆ x 14³⁄₁₆ (29 x 36.1)
On permanent loan to the Museum für
Moderne Kunst 1991/83

Ohne Titel (**Untitled**), 1990
Watercolor and graphite on paper,
11⁷⁄₁₆ x 14³⁄₁₆ (29 x 36)
On permanent loan to the Museum für
Moderne Kunst 1991/87

Ohne Titel (**Untitled**), 1991
Watercolor, graphite, and typewriter,
3¹¹⁄₁₆ x 5¹⁵⁄₁₆ (9.3 x 15)
On permanent loan to the Museum für
Moderne Kunst 1991/89

Ohne Titel (**Untitled**), 1991
Watercolor and graphite on paper,
7¹¹⁄₁₆ x 9⁷⁄₁₆ (19.5 x 23.9)
On permanent loan to the Museum für
Moderne Kunst 1994/45L

Ohne Titel (**Untitled**), 1991
Graphite, gouache, and collage on paper,
1⁹⁄₁₆ x 7¹⁄₁₆ (4 x 18)
On permanent loan to the Museum für
Moderne Kunst 1994/46L

Ohne Titel (**Untitled**), 1992
Graphite on paper, 10¹¹⁄₁₆ x 9¹³⁄₁₆ (27.1 x 24.9)
On permanent loan to the Museum für
Moderne Kunst 1994/48L

Ohne Titel (**Untitled**), 1992
Graphite on paper, 6³⁄₁₆ x 8⁵⁄₁₆ (15.8 x 21.2)
On permanent loan to the Museum für
Moderne Kunst 1994/49L

Ohne Titel (**Untitled**), 1992
Graphite on paper, 9⁷⁄₁₆ x 14³⁄₁₆ (24 x 36)
On permanent loan to the Museum für
Moderne Kunst 1994/51L

Ohne Titel (**Untitled**), 1993
Watercolor, graphite, and collage on paper,
5¹⁄₁₆ x 4¹⁄₁₆ (12.9 x 10.3)
On permanent loan to the Museum für
Moderne Kunst 1994/52L

Ohne Titel (**Untitled**), 1995
Watercolor on paper, 4³⁄₁₆ x 3¹¹⁄₁₆ (10.75 x 9.5)
Gift of the artist 1995/7

Rémy Zaugg (b. 1943)
**AND IF, WHEN I EAT AN UNRIPE
APPLE, ACID GREEN CEASED TO
EXIST**, 1978–91
Stove enamel on aluminum,
78³⁄₈ x 70⁷⁄₈ x 1¹¹⁄₁₆ (199 x 180 x 4.4)
1991/203

**ET SI, LORSQUE JE MANGE UNE
POMME PAS MURE, LE VERT ACIDE
N'EXISTAIT PLUS. (AND IF, WHEN I
EAT AN UNRIPE APPLE, ACID
GREEN CEASED TO EXIST.**), 1978–91
Stove enamel on aluminum,
98¹³⁄₁₆ x 89³⁄₈ x 1¹¹⁄₁₆ (251 x 227.5 x 4.4)
1991/201

**UND, WENN ICH EINEN UNREIFEN
APFEL ESSE, DAS GIFTIGE GRÜN
NICHT MEHR VORHANDEN WÄRE.
(AND IF, WHEN I EAT AN UNRIPE
APPLE, ACID GREEN CEASED TO
EXIST.**), 1978–91
Stove enamel on aluminum,
94⁷⁄₈ x 86⁷⁄₁₆ x 1¹¹⁄₁₆ (241 x 219.5 x 4.4)
1991/202

DORT (**THERE**), 1989–90
Acrylic on canvas, 11¹⁵⁄₁₆ x 40⁵⁄₈ x ¹³⁄₁₆
(30.3 x 103.2 x 2.1)
1991/207

HIER (**HERE**), 1989–90
Acrylic on canvas, 11¹⁵⁄₁₆ x 35¹⁄₁₆ x ¹³⁄₁₆
(30.3 x 89.1 x 2.1)
1991/206

ICI (**HERE**), 1989–90
Acrylic on canvas, 11¹⁵⁄₁₆ x 21¹¹⁄₁₆ x ¹³⁄₁₆
(30.3 x 55 x 2.1)
1991/205

Werke in der Ausstellung

Alle Maßangaben in cm.
Höhe mal Breite mal Tiefe.

Werke der Permanent Collection des Whitney Museums of American Art

Carl Andre (geb. 1935)
Letter to Doug Lawder, 1967
Filzstift auf Karopapier, 26 x 32.4
Ankauf mit Mitteln von Benjamin
Sonnenberg 78.42

Richard Artschwager (geb. 1923)
Description of Table, 1964
Kunstharz auf Holz, 66.4 x 81 x 81
Geschenk der Howard and Jean Lipman
Foundation, Inc. 66.48

Construction with Indentation, 1966
Sperrholz und Melaninlaminat,
152.1 x 121.8 x 24.3
Geschenk von Philip Johnson 72.32

Location, 1969
Kunstharz, Glas, Plexiglas, Gummi,
Pferdehaar und Holz
Maße variabel
a) Kunstharzkiste: 38.1 x 27.3 x 12.7
b) Glas blp: 34.3 x 11.4 x 1.9
c) Spiegel blp: 34.3 x 11.4 x 1.9
d) Pferdehaar blp: 20.3 x 12.7 x 5.1
e) Schwarzes Glas blp: 17.8 x 11.4 x 1.9
f) Holz blp: 17.8 x 8.9 x 1.9
Ankauf mit Mitteln der Dorothea L.
Leonhardt Foundation, Inc. 94.52a-f

The Bush, 1971
Synthetischer Polymer auf Kunstpappe,
123.2 x 179.1
Ankauf mit Mitteln von Virginia F. and
William R. Salomon 72.13

Door, Mirror, Table, Basket, Rug, Window D, 1975
Tinte auf Papier, 67.9 x 76.2
Ankauf mit Mitteln des Burroughs
Wellcome Purchase Fund 84.1

Organ of Cause and Effect III, 1986
Kunstharz und Latexfarbe auf Holz, 6 Teile,
insgesamt: 327.7 x 156.8 x 45.7
a): 235.3 x 151.1 x 20.3
b): 22.7 x 156.8 x 45.7
c): 15.9 x 156.5 x 37.1
d): 12.1 x 19.1 x 17.5
e): 12.4 x 18.6 x 17.1
f): 12.4 x 18.6 x 17.5
Ankauf mit Mitteln des Painting and
Sculpture Committee 87.6a-f

George C. Ault (1891–1948)
Hudson Street, 1932
Öl auf Leinwand, 61 x 50.8
Ankauf 33.40

John Baldessari (geb. 1931)
An Artist Is Not Merely the Slavish Announcer..., 1967–68
Synthetischer Polymer und Fotoemulsion
auf Leinwand, 150.2 x 114.6
Ankauf mit Mitteln des Painting and
Sculpture Committee und dem Geschenk
eines anonymen Spenders 92.21

Ashputtle, 1982
11 Schwarzweißfotografien, eine
Farbfotografie und Texttafel
Insgesamt: 213.4 x 182.9
Jedes Bild: 50.8 x 61
Ankauf mit Mitteln des Painting and
Sculpture Committee 83.8a-m

Jonathan Borofsky (geb. 1942)
Self-Portrait at 2668379 and 2670098,
1979–1980
Acryl und Kohle auf Papier
215.3 x 121.9
Ankauf mit Mitteln von Joel und Anne
Ehrenkranz 82.3

John Cage (1912–1992)
Water Music, 1952
Tusche auf Papier, jedes der 10 Blätter:
27.9 x 43.2, Zertifikat: 24.1 x 15.2
Ankauf mit den Mitteln eines anonymen
Spenders 82.38a-j

Vija Celmins (geb. 1939)
Ocean: 7 Steps #1, 1972–73
Bleistift auf mit Acryl besprühtem
Untergrund, 32.1 x 251.8
Ankauf mit Mitteln von Mr. und Mrs.
Joshua A. Gollin 73.71

Untitled #6, 1994
Kohle auf Papier, 45.9 x 61.1
Ankauf mit Mitteln des Drawing
Committee 96.30

John Chamberlain (geb. 1927)
Jackpot, 1962
Bemalter Stahl und Goldpapier,
152.4 x 132.1 x 116.8
Geschenk von Andy Warhol 75.52

Untitled, 1962
Stoff, Papier, Leinwand, Gouache und
Heftklammern auf Kunstpappe,
52.1 x 52.1 x 14.6)
Ankauf mit Mitteln des Drawing
Committee 92.99

Untitled 1963, 1963
Bemalter und verchromter Stahl,
79.4 x 95.3 x 69.9
Ankauf mit Mitteln der Howard and Jean
Lipman Foundation, Inc. und einem
Geschenk 66.18

Ralston Crawford (1906–1978)
Steel Foundry, Coatesville, Pa., 1936–37
Öl auf Leinwand, 81.3 x 101.6
Ankauf 37.10

Willem de Kooning (geb. 1904)
Door to the River, 1960
Öl auf Leinwand, 203.2 x 177.8
Ankauf mit Mitteln der Friends of the
Whitney Museum of American Art 60.63

Woman Accabonac, 1966
Öl auf Papier auf Leinwand aufgezogen,
200.7 x 88.9
Ankauf mit Mitteln des Künstlers und Mrs.
Bernard F. Gimbel 67.75

Woman in Landscape III, 1968
Öl auf Papier auf Leinwand aufgezogen,
161.3 x 108
Ankauf mit Mitteln von Mrs. Bernard F.
Gimbel und der Bernard F. und Alva B.
Gimbel Foundation 68.99

Untitled (Woman), ca. 1974
Kohle auf Pergamentpapier auf Pappe
aufgezogen, 168.9 x 106.7
Ankauf mit Mitteln des Grace Belt
Endowed Purchase Fund, des Wilfred P.
and Rose J. Cohen Purchase Fund, der
Dana Foundation, Incorporated, des List
Purchase Fund, der Norman und Rosita
Winston Foundation, Inc. und des Drawing
Committee 85.23

Untitled VII, 1983
Öl auf Leinwand, 203.2 x 177.8
Teilweises und versprochenes Geschenk
von Robert W. Wilson P.4.84

Charles Demuth (1883–1935)
Buildings, Lancaster, 1930
Öl auf Kunstpappe, 61 x 50.8
Geschenk eines anonymen Spenders 58.63

Arthur G. Dove (1880–1946)
Plant Forms, ca. 1912
Pastell auf Leinwand, 43.8 x 60.6
Ankauf mit Mitteln von Mr. und Mrs. Roy R.
Neuberger 51.20

Ferry Boat Wreck, 1931
Öl auf Leinwand, 45.7 x 76.2
Ankauf mit Mitteln von Mr. und Mrs. Roy R.
Neuberger 56.21

Land and Seascape, 1942
Öl auf Leinwand, 63.5 x 88.3
Geschenk von Mr. und Mrs. N. E. Waldman
68.79

Elsie Driggs (1898–1992)
Pittsburgh, 1927
Öl auf Leinwand, 87 x 101.6
Geschenk von Gertrude Vanderbilt
Whitney 31.177

Eric Fischl (geb. 1948)
A Visit To / A Visit From / The Island,
1983
Öl auf Leinwand, 2 Tafeln, insgesamt:
213.4 x 426.7
Jede der Tafeln: 84 x 84 (213.4 x 213.4)
Ankauf mit Mitteln der Louis and Bessie
Adler Foundation, Inc., Seymour M. Klein,
Präsident 83.17a-b

Robert Gober (geb. 1954)
Untitled, 1985
Bleistift auf Papier, 27.9 x 35.6
Ankauf mit Mitteln des Drawing
Committee und der Norman und Rosita
Winston Foundation, Inc. 92.43

Untitled, 1994
Bienenwachs, Holz, Papier und Filzstift
a) Butter: 24.1 x 92.7 x 24.8
b) Verpackung: 121.3 x 101.6
Ankauf mit Mitteln des Contemporary
Painting and Sculpture Committee
94.134a-d

Philip Guston (1913–1980)
Drawing for Conspirators, 1930
Bleistift, Tinte, Buntstift und
Wachsmalstift auf Papier, 57.2 x 36.8
unregelmäßig
Ankauf mit Mitteln der Hearst Corporation
und der Norman und Rosita Winston
Foundation, Inc. 82.20

Ink Drawing, 1952, 1952
Tinte auf Papier, 47.3 x 60
Ankauf mit Mitteln der Friends of the
Whitney Museum of American Art 61.23

Dial, 1956
Öl auf Leinwand, 182.9 x 193 Ankauf 56.44

Close-Up, 1969
Synthetischer Polymer auf Leinwand,
106.7 x 121.9
Musa Guston Nachlaß 92.106

Cabal, 1977
Öl auf Leinwand, 172.7 x 294.6
Geschenk zum fünfzigjährigen Bestehen
des Museums von Mr. und Mrs. Raymond J.
Learsy 81.38

Untitled, 1980
Tinte auf Pappe, 50.8 x 76.2
Ankauf mit Mitteln von Martin und Agneta
Gruss und Mr. and Mrs. William A.
Marsteller 81.6

Jenny Holzer (geb. 1950)
Studies for Unex Sign #1, 1983
Insgesamt: 55.9 x 44.8 x 1.9
Geschenk der Künstlerin 85.54.1-22

Edward Hopper (1882–1967)
New York Interior, ca. 1921
Öl auf Leinwand, 61 x 73.7
Nachlaß von Josephine N. Hopper 70.1200

Stairway, 1949
Öl auf Holz, 40.6 x 30.2
Nachlaß von Josephine N. Hopper 70.1265

South Carolina Morning, 1955
Öl auf Leinwand, 76.2 x 101.6
Geschenk zur Erinnerung an Otto L.
Spaeth von seiner Familie 67.13

A Woman in the Sun, 1961
Öl auf Leinwand, 101.6 x 152.4
Geschenk zum fünfzigjährigen Bestehen
des Museums von Mr. und Mrs. Albert
Hackett zu Ehren von Edith und Lloyd
Goodrich 84.31

Robert Indiana (geb. 1928)
The Great American Dream: New York,
1966
Farbiger Wachsmalstift und Frottage auf
Papier, 100.3 x 66
Geschenk von Norman Dubrow 77.98

Jasper Johns (geb. 1930)
White Target, 1957
Enkaustik auf Leinwand, 76.2 x 76.2
Ankauf 71.211

Sketch for Three Flags, 1958
Kohle auf Papier, 10.6 x 24
Geschenk des Künstlers 90.9

Studio, 1964
Öl auf Leinwand, 224.8 x 369.6
Ankauf mit Teilmitteln der Friends of the
Whitney Museum of American Art 66.1

Donald Judd (1928–1994)
Untitled, 1984
Aluminium mit blauem Plexiglas über
schwarzem Plexiglas
Sechs Teile, insgesamt: 450.1 x 100 x 50,
jedes Teil: 50 x 100 x 50
Ankauf mit Mitteln der Brown Foundation,
Inc. zur Erinnerung an Margaret Root
Brown 85.14a-f

Alex Katz (geb. 1927)
The Red Smile, 1963
Öl auf Leinwand, 200 x 291.5
Ankauf mit Mitteln des Painting and
Sculpture Committee 83.3

Place, 1977
Öl auf Leinwand, 274.3 x 365.8
Ankauf mit Mitteln von Frances and
Sydney Lewis 78.23

Belinda Smiles, 1993
Öl auf Leinwand, 243.8 x 182.9
Sammlung des Künstlers

Ahn Smiles, 1994
Öl auf Leinwand, 243.8 x 182.9
Sammlung des Künstlers

Kathryn Smiles, 1994
Öl auf Leinwand, 243.8 x 182.9
Sammlung des Künstlers

Jessica Smiles, 1994
Öl auf Leinwand, 243,8 x 182,9
Sammlung des Künstlers

Franz Kline (1910–1962)
Composition, 1955
Öl und Gouache auf Papier, 26.4 x 33
Geschenk von Frances und Sydney Lewis
77.35

Untitled, 1960
Tinte auf Papier, 21.6 x 26.7
Ankauf mit Mitteln von Mr. und
Mrs. Benjamin Weiss 78.53

Joseph Kosuth (geb. 1945)
Five Words in Green Neon, 1965
Neonröhren, insgesamt: 157.8 x 204.8 x 15.2
a) Neonröhren: 17.8 x 181.9 x 5.7
b) Transformator: 11.4 x 24.1 x 15.2
c) Dokumentationsblatt: 22.7 x 30.3
Ankauf mit Mitteln von Leonard A. Lauder
93.42a-c

Roy Lichtenstein (geb. 1923)
Study for "Fastest Draw", ca. 1963
Bleistift auf Papier, 6.4 x 14.6
Geschenk von Karen and Arthur Cohen
75.35

Brice Marden (geb. 1938)
Summer Table, 1972
Öl und Wachs auf Leinwand, drei Tafeln,
insgesamt: 152.4 x 266.7,
jede Tafel: 152.4 x 88.9
Ankauf mit Mitteln des National
Endowment for the Arts 73.30

Number One, 1983–84
Öl auf Leinwand, drei Tafeln, insgesamt:
213.4 x 276.9, jede Tafel: 213.4 x 92.1
Ankauf mit Mitteln des Julia B. Engel
Purchase Fund 85.2a-c

Bridge Study, 1991
Tinte und Gouache auf Papier, 68.4 x 87.5
Ankauf mit Mitteln des Drawing
Committee und der Norman und Rosita
Winston Foundation, Inc. 92.27

Reginald Marsh (1898–1954)
Negroes on Rockaway Beach, 1934
Eitempera auf Kunstappe, 76.2 x 101.6
Geschenk von Mr. und Mrs. Albert Hackett
61.2

Robert Motherwell (1915–1991)
N.R.F. Collage, Number 1, 1959
Öl und Collage auf Papier, 72.1 x 56.8
Ankauf mit Mittel der Friends of the
Whitney Museum of American Art 61.24

N.R.F. Collage, Number 2, 1960
Öl und Collage auf Papier, 71.4 x 54.6
Ankauf mit Mitteln der Friends of the
Whitney Musueum of American Art 61.34

Bruce Nauman (geb. 1941)
Second Poem Piece, 1969
Stahl, 1.3 x 152.7 x 152.7
Geschenk von Ileana Sonnabend 92.103

**Green Corridor Looking Out on Sky &
Ocean at La Jolla**, 1971
Bleistift und Pastell auf Papier, 58.4 x 73.7
Geschenk von Norman Dubrow 77.102

Barnett Newman (1905–1970)
Untitled, 1946
Tinte auf Papier, 60.5 x 44.9
Ankauf mit Mitteln des John I. H. Baur
Purchase Fund, des Wilfred P. und Rose J.
Cohen Purchase Fund, der East Japan
Railway Company, des List Purchase Fund,
des Richard and Dorothy Rodgers Fund,
des Charles Simon Purchase Fund und des
Drawing Committee 89.25

Here III, 1965–66
Rostfreier Stahl, Cortenstahl,
279.4 x 20.3 x 7.6, Sockel: 33 x 59.7 x 45.7
Geschenk eines anonymen Spenders
69.166

Georgia O'Keeffe (1887–1986)
Drawing No. 8, 1915
Kohle auf Papier, auf Pappe aufgezogen,
61.6 x 47.9
Ankauf mit Mitteln des Mr. and Mrs. Arthur
G. Altschul Purchase Fund 85.52

Flower Abstraction, 1924
Öl auf Leinwand, 121.9 x 76.2
Geschenk zum fünfzigjährigen Bestehens
des Museums von Sandra Payson 85.47

Abstraction, (1926)
Öl auf Leinwand, 76.8 x 45.9
Ankauf 58.43

Single Lily with Red, 1928
Öl auf Kunstpappe, 30.5 x 15.9
Ankauf 33.29

Black and White, 1930
Öl auf Leinwand, 91.4 x 61
Geschenk zum fünfzigjährigen Bestehen
des Museums von Mr. und Mrs. R. Crosby
Kemper 81.9

The White Calico Flower, 1931
Öl auf Leinwand, 76.2 x 91.4
Ankauf 32.26

Black Place Green, 1949
Öl auf Leinwand, 96.5 x 121.9
Versprochenes Geschenk zum fünfzig-
jährigen Bestehen des Museums von
Mr. und Mrs. Richard D. Lombard P.17.79

Drawing IV, 1959
Kohle auf Papier, 147.3 x 62.7
Geschenk von Chauncey L. Waddell zu
Ehren von John I. H. Baur 74.67

It Was Blue and Green, 1960
Öl auf Leinwand auf Kunstpappe aufgezo-
gen, 76.4 x 101.9
Nachlaß von Lawrence H. Bloedel 77.1.37

Claes Oldenburg (geb. 1929)
U.S.A. Flag, 1960
Muslin soaked in plaster über
Drahtrahmen, bemalt mit Tempera,
61 x 76.2 x 8.9
Sammlung von Claes Oldenburg and
Coosje van Bruggen, New York

Shirt, 1960
Bemalter Gips, Musselin und Draht,
78.6 x 62.2 x 12.1
Geschenk von Andy Warhol 75.54

Braselette, 1961
Bemalter Gips, Musselin und Draht,
104.1 x 76.8 x 10.2
Geschenk von Howard und Jean Lipman
91.34.5

The Black Girdle, 1961
Bemalter Gips, Musselin und Draht,
118.1 x 101.6 x 10.2
Gift of Howard and Jean Lipman 84.60.2

French Fries and Ketchup, 1963
Vinyl und Kapok, 26.7 x 106.7 x 111.8
Geschenk zum fünfzigjährigen Bestehen
des Museums von Mr. und Mrs. Robert M.
Meltzer 79.37

Plan for Wall Switches, 1964
Tinte und Wachsmalstift, 72.7 x 59.4
Ankauf mit Mitteln aus dem Neysa McMein
Purchase Award 65.45

Soft Toilet, 1966
Vinyl, Plexiglas und Kapok auf bemaltem
Holz, insgesamt: 144.9 x 70.2 x 71.3
Geschenk zum fünfzigjährigen Bestehen
des Museums von Mr. and Mrs. Victor W.
Ganz 79.83a-b

**Proposal for a Cathedral in the Form of
a Colossal Faucet, Lake Union,
Seattle**, 1972
Wasserfarbe, Bleistift und Buntstift auf
Papier, 73.7 x 58.1
Ankauf mit Mitteln von Knoll International,
Inc. 80.35

Jackson Pollock (1912–1956)
Untitled ca. 1933–39
Bleistift und farbiger Wachsmalstift auf
Papier, 38.1 x 25.4
Ankauf mit Mitteln des Julia B. Engel
Purchase Fund und des Drawing
Committee 85.16

Untitled, ca. 1933–39
Bleistift und farbiger Wachsmalstift auf
Papier, 38.1 x 25.4
Ankauf mit Mitteln des Julia B. Engel
Purchase Fund und des Drawing
Committee 85.17

Untitled, ca. 1939–42
Bleistift und farbiger Wachsmalstift auf
Papier, 35.6 x 27.9
Ankauf mit Mitteln des Julia B. Engel
Purchase Fund und des Drawing
Committee 85.18

Untitled, ca. 1950
Tinte auf Papier, 43.8 x 56.2 unregelmäßig
Geschenk eines anonymen Spenders
74.129

Robert Rauschenberg (geb. 1925)
Untitled, 1958
Bleistift und Wasserfarbe auf Papier,
61.6 x 91.8
Geschenk von Mr. and Mrs. B. H. Friedman
72.2

Untitled (Drawing for cover of Art in America vol. 50, no. 1, 1962), 1961
Zeitungsausschnitte, Bleistift, Wasserfarbe und Wachsmalstift auf Papier, 39.8 x 50.8
Geschenk von Howard and Jean Lipman 84.64

Charles Ray (geb. 1953)
Boy, 1992
Bemaltes Fiberglas, Stahl und Stoff, 181.6 x 68.6 x 86.4
Ankauf mit Mitteln von Jeffrey Deitch, Bernardo Nadal-Ginard and Penny und Mike Winton 92.131a-i

Ad Reinhardt (1913–1967)
A Page of Jokes, 1946
Tinte und Papier, 24.8 x 41.3
Geschenk eines anonymen Spenders 76.50

How to Look at a Spiral, 1946
Tinte und Papier, 33 x 26
Geschenk von Rita Reinhardt 76.49

Museum Landscape, 1950
Tinte und Papier, 24.1 x 58.1
Geschenk des Künstlers 66.141

Museum Racing Form, 1951
Tinte und Papier, 20.6 x 54.6
Geschenk eines anaonymen Spenders 76.47

Art of Life of Art, 1952
Tinte und Papier, 25.4 x 62.2
Geschenk eines anonymen Spenders 76.48

Our Favorites, 1952
Tinte und Papier, 37.5 x 54.6
Ankauf mit Mitteln des John I. H. Baur Purchase Fund, von Mr. und Mrs. B. H. Friedman, von Mr. und Mrs. Morton L. Janklow und Mr. und Mrs. Rudolph B. Schulhof 76.52

Foundingfathersfollyday, 1954
Tinte und Papier, 30.5 x 50.8
Geschenk eines anonymen Spenders 76.46

Portend of the Artist as a Yhung Mandala, 1955
Tinte und Papier, 51.4 x 34.3
Geschenk eines anonymen Spenders 76.45

Martha Rosler (geb. 1943)
The Bowery in Two Inadequate Descriptive Systems, 1974–75
45 Silbergelatinedrucke auf 24 Pappen aufgezogen, jede Tafee 30 x 60
Ankauf mit Mitteln von John L. Steffens 93.4.1-24a-b

Edward Ruscha (geb. 1937)
Trademark Study 5, 1962
Tinte und Wasserfarbe auf Papier 27.1 x 36.4
Geschenk von Emily Fisher Landau 87.62

Securing the Last Letter ("Boss"), 1964
Öl auf Leinwand, 149.86 x 139.7
Emily Fisher Landau Collection, New York

Motor, 1970
Schießpulver und Pastell auf Papier, 58.4 x 73.7
Ankauf mit Mitteln des Lauder Foundation-Drawing Fund 77.78

Plenty Big Hotel Room (Painting for the…), 1985
Öl auf Leinwand, 213.6 x 152.4
Emily Fisher Landau Collection, New York

Drugs, Hardware, Barber, Video, 1987
Acryl auf Leinwand, 182.88 x 182.88
Emily Fisher Landau Collection, New York

Gasoline Stations, 1989
Portfolio von 10 Silbergelatinedrucken, jedes Blatt 49.53 x 58.42
Emily Fisher Landau Collection, New York

Ben Shahn (1898–1969)
The Passion of Sacco and Vanzetti, 1931–32
Tempera auf Leinwand, 214.6 x 121.9
Geschenk von Edith and Milton Lowenthal zur Erinnerung an Juliana Force 49.22

Charles Sheeler (1883–1965)
River Rouge Plant, 1932
Öl auf Leinwand, 50.8 x 61.3
Ankauf 32.43

Richard Tuttle (geb. 1941)
Equals, Harmony, Hill, 1965
Tinte auf Pappkarton, 3 Blätter, jedes: 12.7 x 12.7
Geschenk von Jack Tilton Gallery 90.1a-c

Untitled, 1965
Wasserfarbe und Bleistift auf Papier, 34.9 x 27.9
Geschenk von Eric Green 78.61

Untitled, 1967
Wasserfarbe auf Papier, 34.9 x 26.7
Geschenk von Eric Green 78.62

Dane Grey, 1973
Tinte und Bleistift auf Papier, 35.6 x 27.9
Ankauf mit Mitteln der Familie Albert A. List 74.19

Orange Plot, 1974
Tinte und Filzstift auf Papier, 35.6 x 27.9
Ankauf mit Mitteln der Familie Albert A. List 74.20

Sirakus, 1974
Tinte auf Papier, 35.6 x 27.9
Ankauf mit Mitteln der Familie Albert A. List 74.21

Bill Viola (geb. TK)
The Greeting, 1995
Videoklanginstallation, Maße variabel
Teilweises und versprochenes Geschenk eines anonymen Spenders P.4.95

Andy Warhol (1925–1987)
Bow Ties, 1960
Wasserfarbe und Tinte, 53.3 x 72.4
Ankauf 65.37

Ginger Rogers, 1962
Bleistift auf Papier, 60.3 x 45.7
Ankauf mit Mitteln des Lauder Foundation-Drawing Fund 79.29

Lawrence Weiner (geb. 1942)
Here, There & Everywhere, 1989
Wandinstallation, Maße variabel
Ankauf mit Mitteln des Contemporary Painting and Sculpture Committee 94.136

Jean-Christophe Ammann has been director of the Museum für Moderne Kunst in Frankfurt since 1989; prior to that he was director of the Kunstmuseum Luzern and the Kunsthalle Basel. In 1972 he was the co-organizer of Documenta 5 in Kassel and co-organizer of the Carnegie International in Pittsburgh 1988. In 1993 he was appointed commissioner of the German pavilion for the 1995 Biennale in Venice.

This publication was organized at the Whitney Museum by Mary E. DelMonico, Head, Publications; Sheila Schwartz, Editor; Heidi Jacobs, Copy Editor; Nerissa Dominguez, Production Coordinator; José Fernández, Assistant/Design; Melinda Barlow, Assistant; and Elizabeth Edge, intern.

Design: Bruce Mau Design, Bruce Mau and Kevin Sugden
Typesetting: Archetype
Printing: Dr. Cantz'sche Druckerei, Ostfildern
Binding: Kunst- und Verlagsbuchbinderei/Leipzig

Printed and bound in Germany

Jean-Christophe ist seit 1989 Direktor des Museums für Moderne Kunst in Frankfurt; zuvor war es als Direktor am Kunstmuseum Luzern und der Kunsthalle Basel tätig. 1972 war er Mitorganisator der Documenta 5 in Kassel und im Jahr 1988 der Carnegie International in Pittsburgh. 1993 wurde er zum Ausstellungkommissar der Biennale 1995 in Venedig berufen.

Dieser Katalog wurde am Whitney Museum durch Mary E. DelMonico, Leiterin der Abteilung für Publikationen; Sheila Schwartz, Lektorin; Heidi Jacobs, Lektoratsassistentin; Nerissa Dominguez, Herstellungsplanung; José Fernández, Assistent/Graphik-Design; Melinda Barlow, Assistent; und Elizabeth Edge erstellt.

Design: Bruce Mau Design, Bruce Mau and Kevin Sugden
Typesetting: Archetype
Druck: Dr. Cantz'sche Druckerei, Ostfildern
Bindung: Kunst- und Verlagsbuchbinderei/Leipzig

Gedruckt und gebunden in Deutschland.